Bernhard Gutmann

AN AMERICAN IMPRESSIONIST

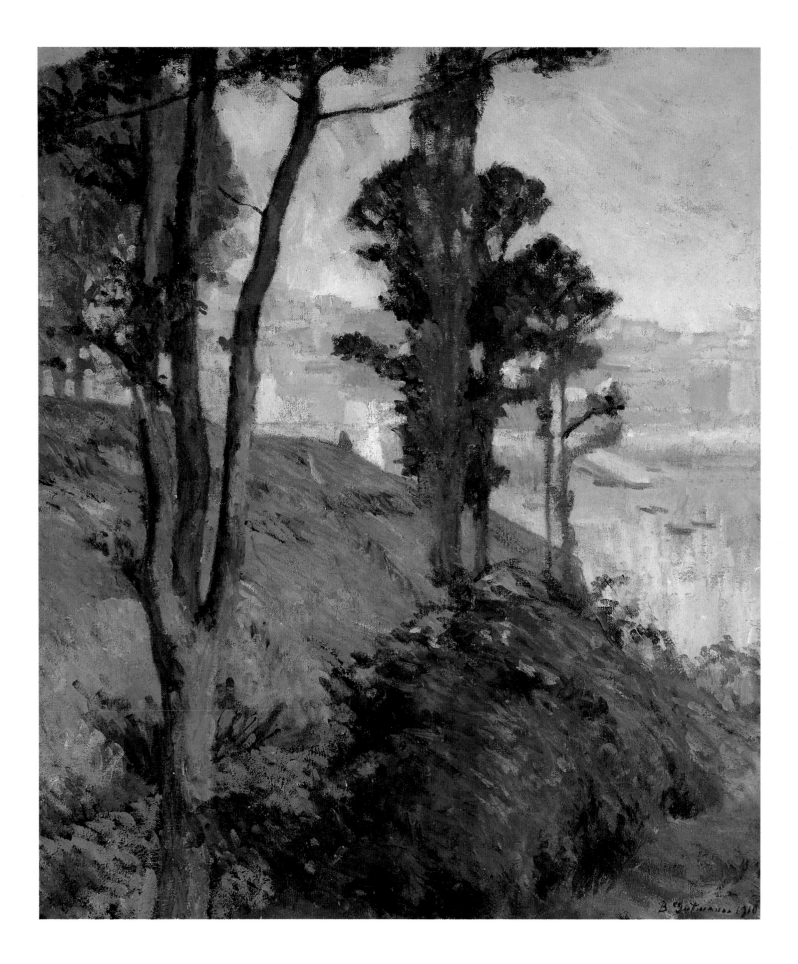

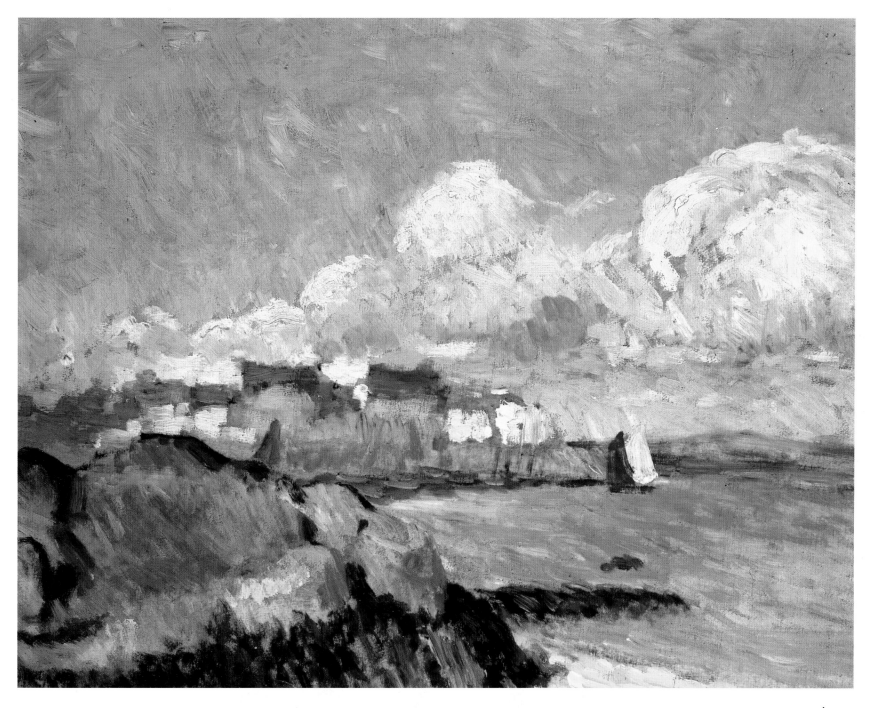

BAY OF DOUARNENEZ, BRITTANY, *n.d.*
Oil on wood, 10½ × 13¾ in. (26.7 × 34.9 cm)
Private collection

Opposite:
DOUARNENEZ(?), *1910*
Oil on canvas, 21⅝ × 18 in. (54.9 × 45.7 cm)
Private collection

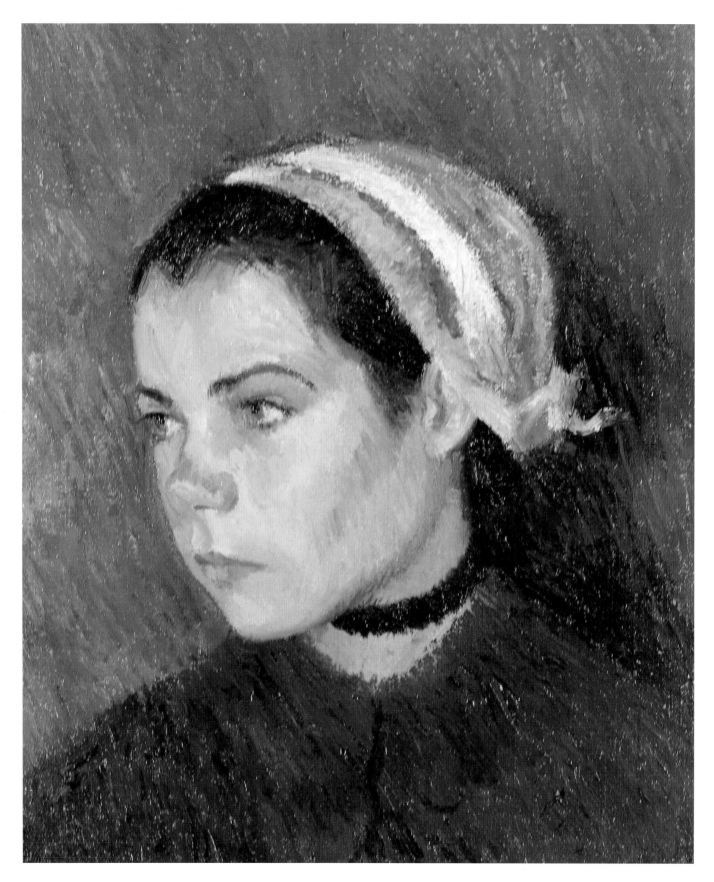

BRETON GIRL, *1909*
Oil on canvas, 16 × 13 in. (40.6 × 33 cm)
Private collection

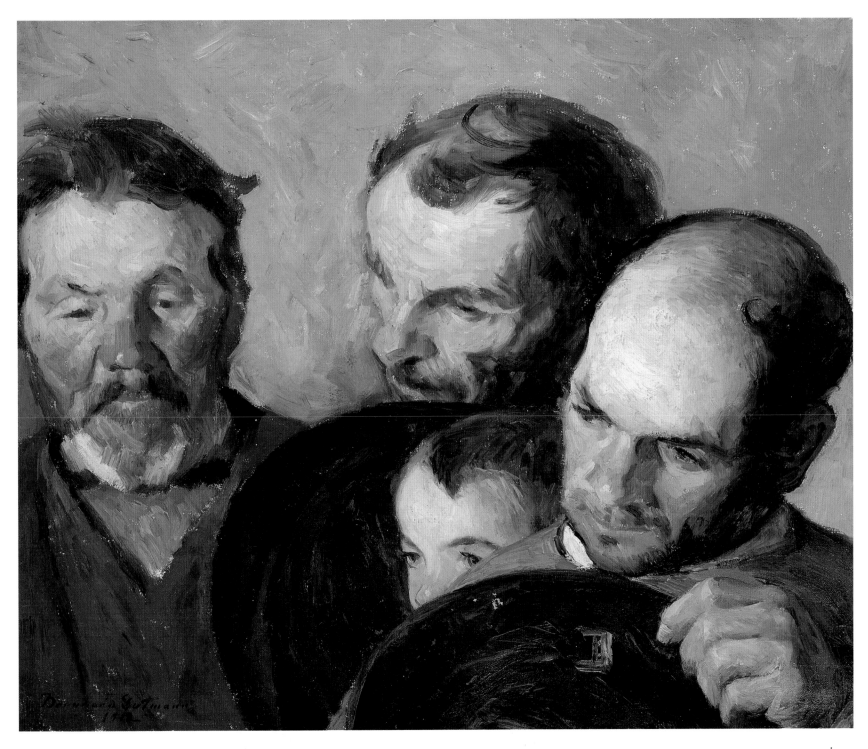

HEADS OF THREE MEN AND A BOY, *n.d.*
Oil on canvas, 18 × 21½ in. (45.7 × 54.6 cm)
Private collection

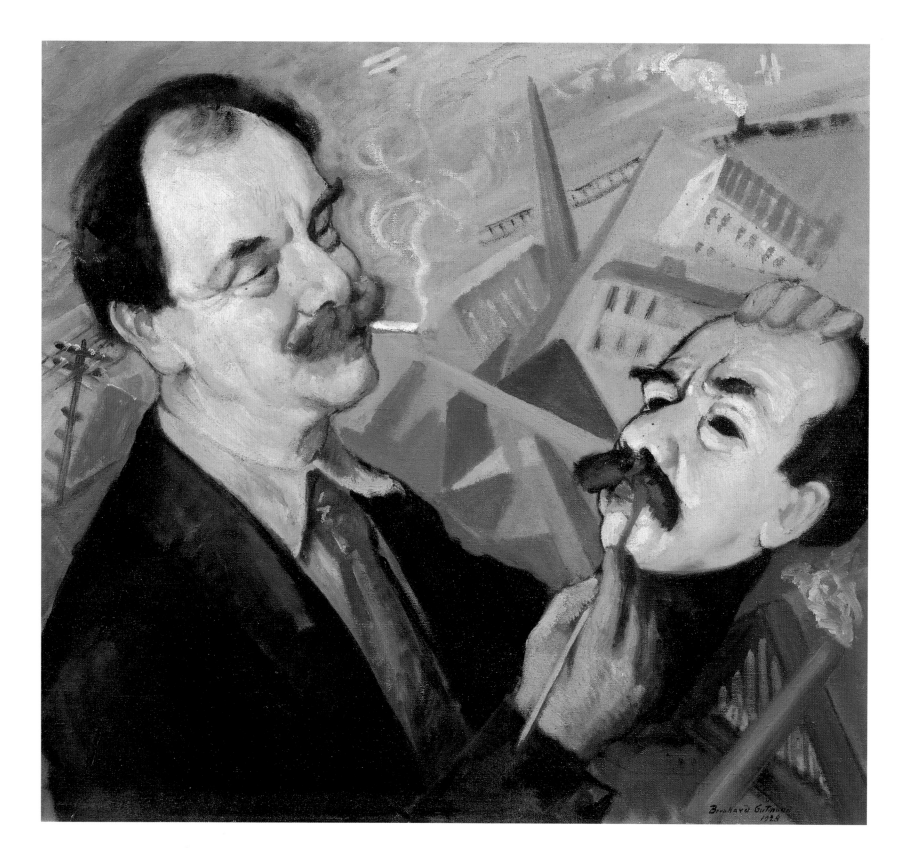

Bernhard Gutmann

AN AMERICAN IMPRESSIONIST

1869–1936

by Percy North

PREFACE BY

William H. Gerdts

Christian Title, Bernhard Gutmann Collection Curator

ABBEVILLE PRESS PUBLISHERS
NEW YORK LONDON PARIS

LADY, WHITE MANTEL, *n.d.*
Oil on wood, 7¼ × 9⅜ in. (18.4 × 23.8 cm)
Private collection

WOMAN WITH ZINNIA BOUQUET, *n.d.*
Oil on wood, 10⅜ × 13¾ in. (26.4 × 34.9 cm)
Private collection

TOLEDO ROOFTOPS, *n.d.*
Oil on wood, 15 × 18⅛ in. (38.1 × 46 cm)
Private collection

BAY VIEW, ROCKY CLIFF, *n.d.*
Oil on canvas, 23 × 25 in. (58.4 × 63.5 cm)
Private collection

Front cover: detail of *Lady in Chinese Silk Jacket,* 1909. See page 69.
Back cover: Vase, n.d. See page 68.
Frontispiece: Bernhard Gutmann, *Two Natures (Self-Portrait),* 1928. Oil on canvas,
23 × 25 in. (58.4 × 63.5 cm). Theodore Lehmann II.
Page 174: Self-Portrait, n.d. See page 78.

Project Editor: Abigail Asher
Text Editor: Alice Gray
Designer: John D. Berry,
 Marquand Books, Inc.
Production Manager: Lou Bilka

First edition

10 9 8 7 6 5 4 3 2

Library of Congress Cataloging-in-Publication Data
North, Percy, 1945–
Bernhard Gutmann : an American Impressionist / by Percy North ; introduction by William H.
Gerdts ; Christian Title, Bernhard Gutmann Collection, curator.
 p. cm.
 Includes bibliographical references and index.
 ISBN 1-55859-611-9
 1. Gutmann, Bernhard, 1869–1936—Criticism and interpretation. I. Title.
ND237.G82N67 1995
759.13 DC20 95-15263

Table of Contents

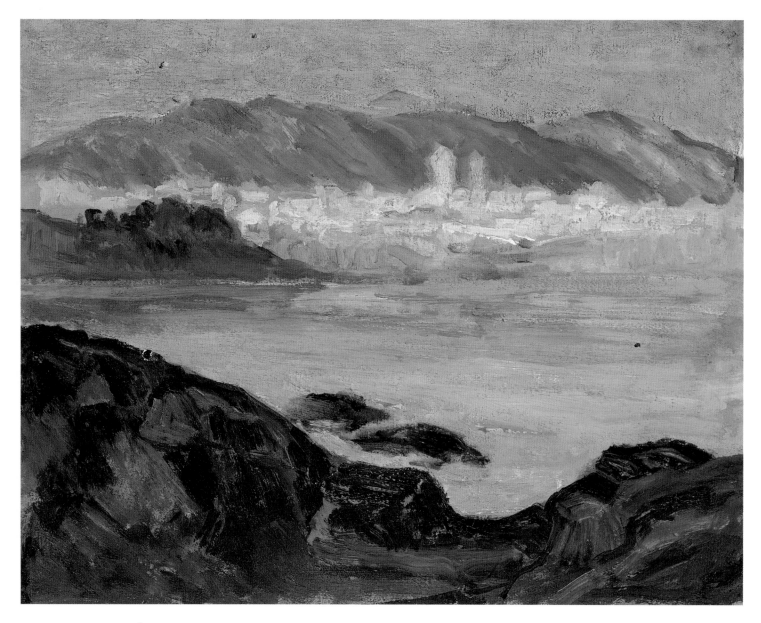

SANTA CATALINA, *n.d.*
Oil on wood, 8 × 10 in. (20.3 × 25.4 cm)
Private collection

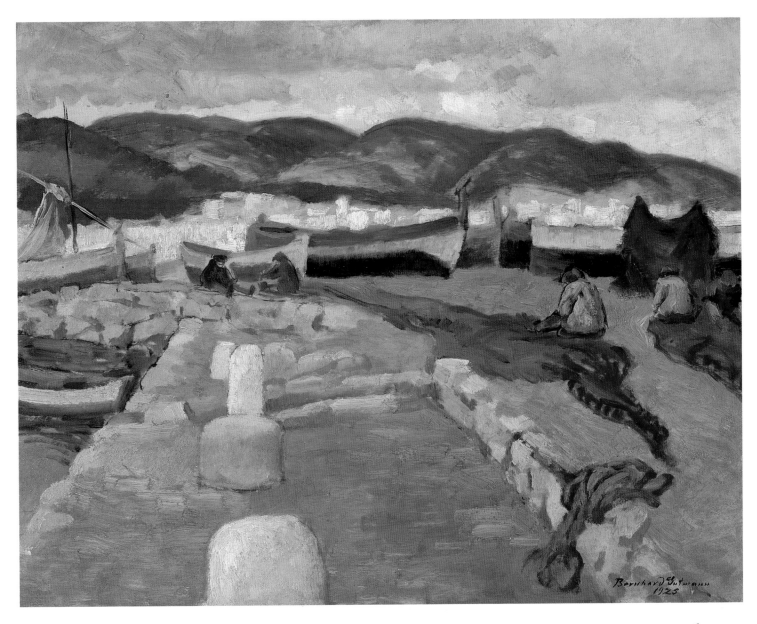

SANTA CATALINA, MALLORCA, *1926*
Oil on wood, 14⅞ × 18⅛ in. (37.8 × 46 cm)
Private collection

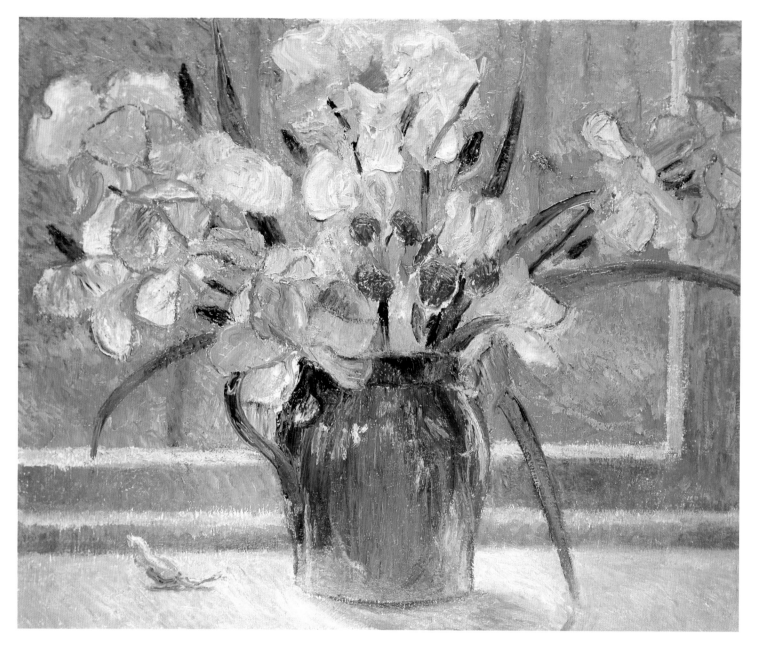

IRIS, *n.d.*
Oil on canvas, 20 × 24 in. (50.8 × 61 cm)
Michael Feddersen

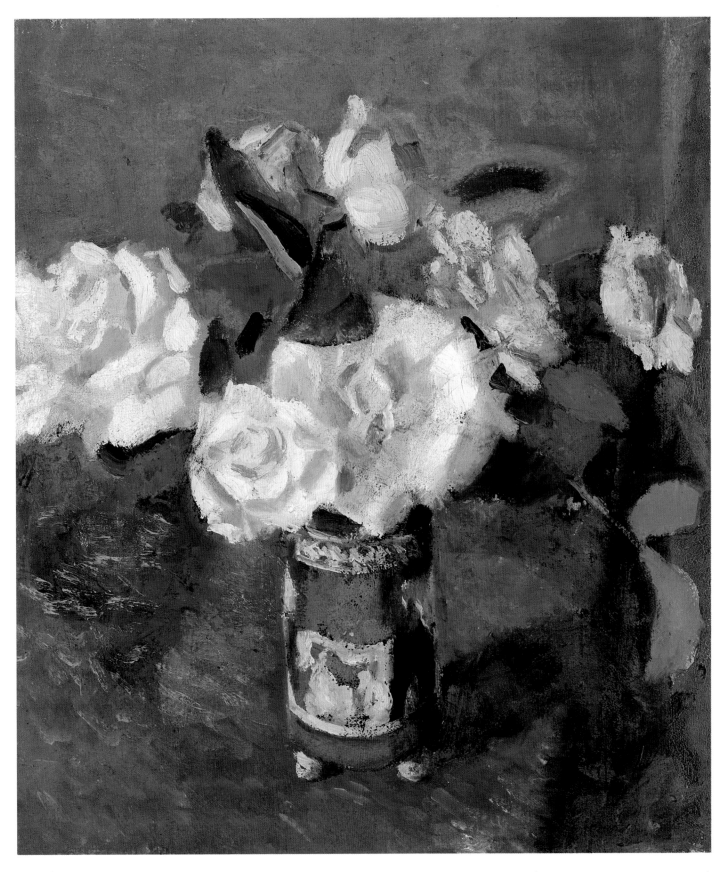

STILL LIFE/PINK ROSES IN BLUE VASE, *n.d.*
Oil on canvas, 17 × 14¼ in. (43.2 × 36.2 cm)
Private collection

Preface

WELCOME BACK, Bernhard Gutmann! Long overlooked, this German-American painter and printmaker truly deserves a place in the history of early twentieth-century American modernism. While Gutmann was never at the forefront of American artistic developments, he was certainly a recognized figure in the critical and commercial art world. Gutmann participated in the historic Armory Show in New York in February 1913, and the following year his work appeared in the biennial exhibition of contemporary American paintings held at the Corcoran Gallery of Art in Washington, D.C. Gutmann's paintings and etchings were shown numerous times in New York at the annual exhibitions sponsored by the National Academy of Design, the Society of Independent Artists, and the Salons of America. His work was also exhibited at the Brooklyn Society of Etchers and at the Art Institute of Chicago, and he had a number of one-person exhibitions at the leading New York galleries during the 1910s, 1920s, and 1930s. Two years after his death in 1936, Gutmann's achievements were honored in a posthumous exhibition held in the Vanderbilt Art Gallery of the American Fine Arts Society. The association was home to the Art Students League, and as such was one of the several centers of the New York—and indeed, the national—art world of the time.

I was introduced to the work of Bernhard Gutmann in 1988, when four of his paintings—*Breton Lacemakers* (fig. 45), *Flowers,* or *On the Terrace* (fig. 64), *The Little Lady* (1915), and *Union Square during Storm* (fig. 51)—were included in an important exhibition held at the Grand Central Art Galleries in New York called *Impressionism and Post-Impressionism: Transformations in the Modern American Mode, 1885–1945.* This pioneering exhibition was particularly perceptive in its investigation of American Post-Impressionism, which

had previously been explored only once, in the exhibition *The Advent of Modernism: Post-Impressionism and North American Art, 1900–1918,* held at the High Museum of Art in Atlanta in 1986.

The most outstanding and engaging work included in the exhibition at Grand Central was that of Bernhard Gutmann, who, along with August Mosca, was one of only two artists represented by four paintings in this show. Moreover, a detail of Gutmann's *Breton Lacemakers* was reproduced on the cover of the exhibition catalog. This was a fitting tribute, as *Breton Lacemakers* (under its earlier title of *Five Girls by the Sea*) was one of the most celebrated pictures included in the artist's one-person show held at the Arlington Art Galleries in March 1914. Indeed, this painting was instrumental in Gutmann's initial recognition as a proponent of the Post-Impressionist aesthetic. Today, *Breton Lacemakers* is part of the permanent collection of the Terra Museum of American Art in Chicago.

Gutmann's distinction within the relatively newly mined territory of American Post-Impressionism was succinctly recognized by James D. Cox, general director of Grand Central. In his foreword to the catalog, Cox wrote, "we feel we have made some major 'discoveries.' Among the most interesting, Bernhard Gutmann — who in the future will be regarded as an American Gauguin. We strongly feel that when his paintings are comprehensively researched and exhibited (the majority of which have been in a private trust since 1915), he will be regarded as a major American Post-Impressionist."

At almost the same time that I discovered Bernhard Gutmann, the Post-Impressionist, I also uncovered a very different, earlier Gutmann: a German immigrant, a pioneer in art education, and an important regional painter. I came across Gutmann this time while surveying the artistic developments native to rural western Virginia, in the vicinity of Lynchburg. Gutmann arrived there from Hamburg in 1892, and was so fondly remembered that one of his most influential pupils, Sallie Lee Mahood, wrote that "much of the enthusiasm for and success in art in Lynchburg is due to one man, a German by the name of Bernhard Gutmann." This was not entirely true; flower painting was taught in the city as early as 1810 by Mrs. William Owen, while Harvey Mitchell painted portraits there at mid-century, and the landscape painter Flavius J. Fisher lived there from 1866 to 1873. Art had also been included in the Lynchburg Agricultural and Mechanical Society fairs since 1858, and the first of several art loan exhibitions took place in Lynchburg in 1881.

Gutmann's fame in Lynchburg is associated with the founding of Randolph-Macon Woman's College in 1893, a year after his arrival. Art was taught there by Louise J. Smith, who had just returned from studying in Paris. Smith shared a studio and model with two of her Randolph-Macon students, Sallie Mahood and Lillian Terrell. After admiring a painting of Gutmann's in a store window, they sought out the German immigrant painter.

Soon Gutmann's studio at 702 Church Street was filled to overflowing, and by March 1895 the class had expanded into the Lynchburg Art League. By September of that year, Gutmann had convinced the supervisor of schools that art should be taught in the public schools, and he was installed as the first supervisor of drawing, as well as instructor of art in the Lynchburg high school. It was then that Gutmann also wrote a series of art manuals; he also held sessions with teachers to instruct them in both drawing and methodology. At Randolph-Macon, Gutmann substituted for Louise Smith, who was continuing her studies in Paris. Gutmann made several additions to the college's curriculum, such as courses in illustrative drawing, the history of art, and china painting. As Ruth Holmes Blunt wrote in *The Lynchburg Art Club and Its Affiliates,* "Mr. Gutmann seemed to be capable of running a three-ring circus, being the star performer in each ring."

It was soon a six-ring circus. In early 1897 Gutmann painted a mural for the college's first library called *Wisdom Instructing Youth,* and in May he held an exhibition of approximately fifty of his paintings and one hundred of his studies and sketches in the art studio of the college. In 1898 Gutmann prepared illustrations for a new history of Virginia, foreshadowing his involvement in illustrative work in New York, where he moved the following year.

Gutmann's departure was mourned when he left Lynchburg in September 1899, though his legacy remained there. A *Self-Portrait* from this period belongs to the Lynchburg Art Club, and a number of his other works were acquired by local collectors; some of these were eventually given to the E.C. Glass High School, where Gutmann had taught. In addition, a number of Gutmann's pupils took his place teaching at the high school or supervising the elementary public school grades.

Gutmann returned to Lynchburg in December 1925 to present an exhibition of his paintings and give a lecture, "Individualism in Art." Gutmann's art in the 1920s was very different from what Lynchburg residents had seen some three decades earlier, but both the artist and his work were well received; one of his Brittany pictures, *The Breton and Child* (n.d.), was acquired by the Lynchburg Women's Club. Gutmann's reappearance also gave impetus to the revival of the Lynchburg Art Club, which had been relatively inactive in recent years. Gutmann continued to exhibit his paintings in Lynchburg; in 1927 his *Blue Teacup* (n.d.) was included in a show of work by members of the Lynchburg Art Club, which later went on view in early 1934 at the University of Virginia in Charlottesville. In 1955 Gutmann's daughters presented a prized flower study, *Red and Gold* (1934), to the E.C. Glass High School.

Among Gutmann's many travel destinations, Spain especially inspired him. In going to Spain, Gutmann was following in the footsteps of countless American painters. George Hall and Samuel Colman were among the first to visit Spain and to achieve notoriety for Spanish themes in their work, begin-

ning in the 1860s. After them came such noted figures as Thomas Eakins, John Singer Sargent, Mary Cassatt, and William Merritt Chase. The island of Mallorca particularly influenced Gutmann, who lived and worked there in 1923–24. However, Gutmann was hardly a pioneering colonist on Mallorca; numerous other American painters visited and depicted scenes on the island during the 1920s, including William J. Potter, Grace Ravlin, Anna Lynch, Earl Horter, Paul Simon, and George O. ("Pop") Hart. The 1930s brought even more American painters to Mallorca, including Carl Preussl, James Clymer, Agnes C. Tait, and Loretta Howard. Nevertheless, Gutmann's sojourn in Mallorca probably remains the most significant of any American artist's pilgrimage to the island; he painted a *Baptism of Christ* for the church in the small town of Deya, situated in the mountains north of Palma, the island's capital.

In the United States, Gutmann was most closely associated with the Silvermine art colony, which was started around 1907 in a section of the Connecticut coastal town of New Canaan known as Silvermine, or, originally, Silver Mine. This was one of a series of artists' colonies that began to develop in communities along the Connecticut shore beginning in the 1890s, including Mystic, Noank, Old Lyme, Westport, Cos Cob, New Canaan, and Greenwich. The colony began to hold exhibitions in the studio of resident sculptor Solon Borglum in 1907, and the original group included Addison T. Millar, Richard Gruelle from Indianapolis, Howard Hildebrandt, Henry Salem Hubbell, Charles Reiffel from Buffalo, and the figure painter, Hamilton Hamilton, who later became a good friend of Gutmann's. Probably the best-known painter of the colony was Daniel Putnam Brinley, who was associated with Alfred Stieglitz's Little Galleries of the Photo-Secession, known as 291, in New York, and who was active in the evolution of the famous 1913 Armory Show. Gutmann moved to Silvermine in 1913; by 1915 he was exhibiting with Borglum's Silvermine Group (and with the quite separate New Canaan Society of Artists also, at least in 1916).

The Silvermine Group evolved out of "The Knockers," a club Borglum started that held weekly artistic discussions. The Silvermine Group held its last exhibition in 1920; two years later Gutmann was involved with the founding of the Silvermine Guild of Artists, and after several years in Europe, he returned to become president of this organization. Neither the earlier Silvermine Group nor the more formal guild were at all programmatic as to preferred styles or subjects; they were simply accomplished painters and sculptors who wanted to exhibit their work in a professional setting that reflected the changing tenor of contemporary art. Bernhard Gutmann was a pivotal figure in this artistic community. He also played a compelling part in the larger art world of his day, as this publication fully confirms.

WILLIAM H. GERDTS

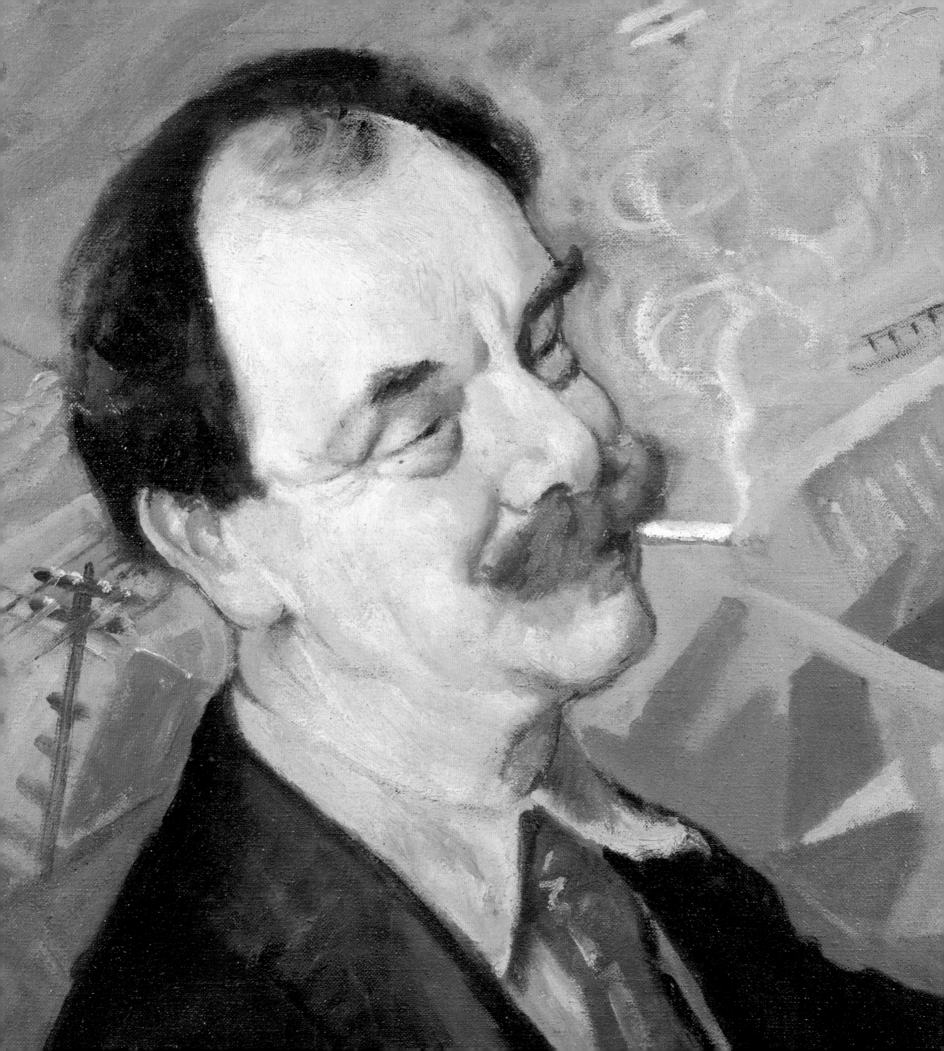

Introduction
THE TWO NATURES OF BERNHARD GUTMANN

ACCLAIMED DURING HIS LIFETIME as a painter of Impressionist and Post-Impressionist landscapes, still lifes, figure paintings, and genre scenes as well as a graphic artist, an illustrator, an inspiring teacher, and a significant influence on the development of regional art centers in Virginia and Connecticut, Bernhard Gutmann (1869–1936) achieved a position of prominence that has not been unacknowledged in the annals of American art history. Gutmann was actively working and exhibiting during the first three decades of the century and showed his work in major exhibitions and in important museums. In 1938, two years after his death, a retrospective of his work was held at the Vanderbilt Art Gallery, accompanied by a catalog with a laudatory introduction written by his brother-in-law Ashton Sanborn, the secretary of the Museum of Fine Arts, Boston. After 1938, however, Gutmann's work went largely unnoticed because it remained in a few private collections, making it inaccessible to the public. Gutmann's reputation faded until his name was unfamiliar even to most art historians. This artistic disappearing act—by a painter who created an extensive and engaging body of work—occurred not simply because Gutmann's style fell out of fashion but in part because of the artist's own professional choices and personal circumstances. Torn by conflicting tendencies to express his elation and despair and by his struggle to reconcile his more conservative artistic style with the growing radicalism of early modernism, Gutmann chose a path that led to a career whose richness and importance was overshadowed after his death and is only now beginning to unfold.

A German immigrant who settled in Lynchburg, Virginia, before moving to New York City in 1899, where he established a fine-art printing company

Opposite and above:
(details)
99. TWO NATURES (SELF-PORTRAIT), *1928*
Oil on canvas, 23 x 25 in. (58.4 x 63.5 cm)
Theodore Lehmann II

with his brother Hellmuth, Gutmann largely avoided the struggle for survival in the artistic marketplace through his marriage to Bertha Goldman in 1907. Gutmann found every artist's dream of a beneficent patron in his father-in-law, lawyer Julius Goldman, the són of Marcus Goldman, the founder of the investment banking firm Goldman-Sachs. Goldman provided the Gutmann family with an annual income that relieved the artist from his duties at the Gutmann and Gutmann printing company. From the time of his marriage, therefore, Gutmann was able to immerse himself in his own artwork without having to depend upon steady employment or the vagaries of the art market. Gutmann and his family were also able to travel to Europe, where the artist returned to seek inspiration.

Gutmann's exhibition history presents a curious paradox. Gutmann exhibited his work at prominent galleries in New York and Paris as well as at the Art Institute of Chicago, the Brooklyn Museum, the Pennsylvania Academy of the Fine Arts, and the Corcoran Gallery of Art, but his paintings did not enter any of these permanent collections. Even today, the majority of Gutmann's work remains in a handful of private trusts and collections; only *Breton Lacemakers* in the Terra Museum of American Art is easily accessible to the public. Because Gutmann's paintings have been so rarely seen and studied since his death, many of them are not definitively dated, and an exact chronology of the artist's work has not been made. Many of Gutmann's paintings, however, can be dated by style and locale.

The works that Gutmann chose to exhibit also affected the course of his career. Although he participated in the most important and influential exhibitions of his time—including the 1913 Armory Show, the 1915 Panama-Pacific International Exposition in San Francisco, and the 1917 and 1918 Society of Independent Artists exhibitions in New York—Gutmann did not submit his most compelling works to these exhibitions. Instead of sending his powerful Post-Impressionist landscapes, Gutmann sent his most conservative and traditional works to those venues where his most inspired and challenging work might have been appreciated. Gutmann's earliest submissions to major exhibitions were portraits of his infant daughter and images of Breton peasants; such subjects had been explored extensively during the last three decades and critics and audiences no longer found them to be original or fresh.

Gutmann's entries in the Armory Show, *In the Garden* (fig. 44), and the Panama-Pacific International Exposition, *Nude with Parrot* (fig. 57), are engaging compositions, but they are derivative of earlier Impressionist work by artists such as Claude Monet and Edouard Manet, and they lack the vitality and exuberance of his landscapes and sketches. Next to the avant-garde Cubism of Marcel Duchamp and the vibrant colorism of Henri Matisse, Gutmann's *In the Garden* was overlooked in critical commentaries of the Ar-

mory Show, and *Nude with Parrot* was overshadowed by Frederick Frieseke's *Summer* at the Panama-Pacific Exposition. Several perceptive critics wrote favorably about Gutmann's impressive landscapes when they were exhibited in New York, but Gutmann ignored their appraisals; he did not exhibit these works widely.

Born and reared in Germany, Bernhard Gutmann seemingly had a head start as an artist over his American contemporaries because he was trained at the celebrated European art academies to which artists flocked during the nineteenth century. European study and travel had been considered prerequisites for aspiring American artists even before Gutmann attended the academies at Düsseldorf and Karlsruhe. As Impressionism became increasingly popular at the end of the nineteenth century, more and more Americans gravitated to the ateliers in Paris and made pilgrimages to the idyllic pastoral villages in France and Holland where contemporary European masters such as Paul Gauguin had found inspiration. Like many aspiring artists, Gutmann traveled to Holland in search of picturesque subjects. By the time he left Germany for the United States in 1892, Gutmann had assimilated the rigorous academic style taught in the German academies and was familiar with the plein air painting techniques of the Impressionists. He arrived in the United States during a massive wave of immigration when America was on the brink of a technological revolution, but he settled in Lynchburg, Virginia, isolated from important cultural and intellectual currents.

Gutmann began his career as a successful American painter, teacher, illustrator, and graphic artist in Lynchburg. Appointed the first superintendent of drawing in the Lynchburg public schools in 1895, Gutmann shaped and inspired the cultural life of the city through both his teaching and his organization of the Lynchburg Art League, which survives as the Lynchburg Art Club. Gutmann continued to nurture the growth of regional art after he moved to Connecticut in 1913, where he was instrumental in the founding of the still-flourishing Silvermine Guild of Artists, and in the development of the guild's ceramic program.

In Lynchburg, Gutmann explored artistic subjects and techniques characteristic of his traditional German academic training. His relocation to New York in 1899 opened his eyes to Impressionism, and he began to redefine his style. Although he shared the Impressionists' fascination with light and color, Gutmann did not embrace the floating formlessness of their compositions, nor did he devote himself to depicting only subjects of modern life. Generally bypassing the sparkling divided hues of Impressionism, Gutmann adopted broad, high-keyed strokes of color taken directly from the tube, a technique first used by Post-Impressionist painters such as Paul Gauguin and Vincent van Gogh during the 1880s and 1890s.

The color strategies of Post-Impressionism (the term was first coined in

1910 by the English painter and critic Roger Fry to designate artistic developments extrapolated from the color theories of Impressionism) were the most experimental techniques that Gutmann essayed in his painting. Although still popular in the United States during the first decades of the century, Impressionism—and Post-Impressionism—had already been eclipsed in Europe by a number of new stylistic currents, such as Cubism and Futurism. Gutmann was exposed to these early modernist movements while living in Europe from 1907 to 1912, but he was not favorably drawn to the influence of the new avant-garde. Back in the United States, Gutmann adhered to those subjects and themes popular among the older American Impressionists such as Childe Hassam and J. Alden Weir, who were working in Connecticut where he settled on his return. Like them, Gutmann rendered the sunny aspects of life, filling his canvases with idyllic vistas of the surrounding countryside, intimate glimpses of aesthetically arranged interiors, beautiful still lifes, and staged genre scenes featuring family members.

Gutmann held tenaciously to the rigorous discipline of his academic training, doing careful drawings and preparatory sketches for finished works, despite his attraction to the bolder use of line and color associated with Post-Impressionism. He always began his work with a series of pencil sketches in notebooks, then produced oil sketches, or *pochades,* on small wooden panels before completing finished works in oil on canvas or linen. He used only the finest materials, including linen and exquisite wooden panels bought in Paris from the firm of Lefebvre-Foinet. Gutmann's small panel paintings exhibit a greater freedom and spontaneity than many of his refined canvases, and their active surfaces and vivid tones align them with the strategies and spirit of Post-Impressionism. Gutmann, however, did not consider these lively sketches to be finished works, and he submitted his more polished, less adventurous compositions for exhibition. Acclaimed for his still lifes, he was probably more innovative and successful as a landscape artist.

Bernhard Gutmann was lively, energetic, friendly, and amusing, but he could also be moody and mercurial, and his works demonstrate a deeply rooted ambiguity: they may be joyful or macabre, rural or urban, purely Impressionist or influenced by the later Post-Impressionist aesthetic, American or European in sensibility. The polarities in Gutmann's temperament reflect compelling conflicting currents in his work. The sunnier aspects of Gutmann's nature were expressed in his pastoral landscapes, domestic scenes, and bountiful still lifes, while his accompanying melancholy surfaced in darker, brooding compositions filled with themes of death and decay. These somber works became increasingly prevalent in Gutmann's later years, when the artist—and the entire country—was mired in depression.

A late self-portrait, painted when he was fifty-nine, depicts the dilemmas that so profoundly affected Gutmann and serves as a metaphor for his career. *Two Natures (Self-Portrait)* (fig. 99) presents a smiling, cigarette-smoking Gutmann painting the finishing touches on a frowning mask of his own face. Behind the artist is a cityscape of buildings, railroad tracks, and telephone poles that disintegrates as if it is being toppled by an earthquake. Occupied by his work, the painter is oblivious to the pandemonium around him. While the figure is carefully rendered in a realist style, the background is defined by geometric Cubist planes and dynamic Futurist lines. Gutmann is clearly demonstrating that he has remained a painter of identifiable natural elements, even when surrounded by new, more abstract artistic movements—and by a turbulent, collapsing world. The conceit Gutmann has created shows a portrait of himself smiling, while the happy image of the artist is shown painting a morose, despondent likeness of himself.

A compositional diagram that Gutmann made for a friend, labeled *Optimist and Pessimist,* explains the artist's theory about depicting the polarities of human emotion, which he so powerfully illustrates in *Two Natures (Self-Portrait).* According to Gutmann's diagrams, upward-sweeping lines signify happiness while those that curve down indicate sadness. These expressive linear patterns also animate works by Georges Seurat, with which Gutmann was probably familiar.

Two Natures (Self-Portrait) reflects both the innate duality of human nature and the artist's own confusion about his rapidly changing world. Being completely immersed in his art, Gutmann allowed himself the luxury of ignoring the exigencies of daily life; it became difficult for him to comprehend and assimilate the enormous social, political, and artistic upheavals taking place during the early decades of the twentieth century. Gutmann struggled to balance the old world and the new, holding fast to his belief in the primacy of art as a personal, poetic expression of nature while trying to find eternal meaning in his contemporary experience and a place in his adopted home. His legacy is a vivid and eloquent record of an artistic odyssey recorded in a remarkable body of late Impressionist and Post-Impressionist work that richly deserves reintroduction.

1

Becoming an Artist

"THERE EVERYTHING IS NEW, one adapts to the situation, starts from the beginning and will become something proper. That's what I hope,"[1] wrote Bernhard Gutmann on June 6, 1892, as he contemplated moving to the United States. With great hopes for a promising future, the artist was to leave Hamburg, Germany, the city of his birth and childhood, to seek his fortune in the new world.

Bernhard Gutmann was born in 1869, the youngest of eight children whose mother died when he was two years old. Bernhard went to boarding school in Wolfenbuttel with his brother Hellmuth before attending the Johannesmus Educational School in Hamburg, where he studied drawing for two and a half years and joined the art students' St. Luke's Club. Gutmann's artistic training began with elementary exercises in sketching blocks of wood and progressed to plaster casts. In the evenings the art student took additional classes so that he could learn anatomy by drawing from live models.[2] At the age of twenty Gutmann enrolled in the internationally renowned Royal Prussian Academy of Art in Düsseldorf, where he joined a secret society of male art students. The Düsseldorf Academy, which had been popular with American students during the mid-nineteenth century, was known for its emphasis on the detailed representation of nature. By the time Gutmann arrived in 1890, however, American artists no longer favored the traditional Düsseldorf program; the academies in Paris had become the training center of choice.

An indifferent student at boarding school, known for his pranks rather than his scholarship, Gutmann blossomed in the drawing classes at the Düsseldorf Academy under the tutelage of Professor Heinrich Lauenstein.[3] Gutmann's skillful studies of a plaster mask, skull, and classical Venus earned him

(detail)
2. BERNHARD GUTMANN PLAYING CHESS IN HIS LYNCHBURG STUDIO, *c. 1895–96*
Photograph

Opposite:
1. GUTMANN IN HAMBURG, *c. 1891*
Photograph

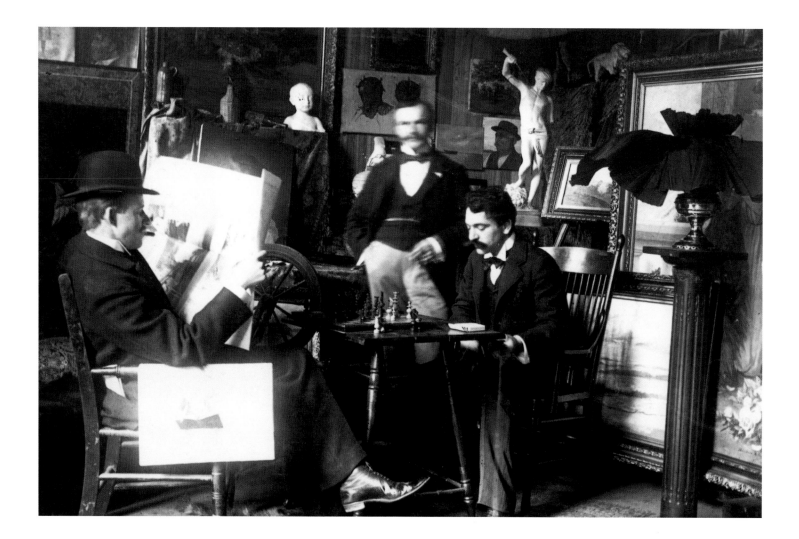

2. GUTMANN PLAYING CHESS IN HIS
LYNCHBURG STUDIO, *c. 1895–96*
Photograph

the privilege of entering the advanced portrait classes. In the fall of 1891, however, Gutmann transferred to the State Academy of Fine Arts in Karlsruhe because he "no longer liked the art direction in Düsseldorf, there was more drawing than painting, whereas, in Karlsruhe both were joined."[4]

Gutmann produced his first painting, *Leisure Hours in the Studio*,[5] in the studio of marine painter Karl Boehme[6] while studying in Karlsruhe in 1891. Although the painting's whereabouts are now unknown, it was vividly described in a local newspaper when it was exhibited at the Lynchburg Art League in 1897. According to the newspaper review, the painting depicts three artists playing a game of cards in a corner of a studio filled with curiosities and objects, including a wine jar placed near the cardplayers.[7] The image sounds strikingly similar to later photographs of Gutmann's own studio in the United States; and the male camaraderie depicted in the painting was certainly an essential component of this high-spirited and adventurous artist's life. The subject of cardplayers had been explored by Paul Cézanne (1839–1906) in several works painted during the 1880s, but while Cézanne had focused on the figures

themselves, Gutmann drew attention to the setting, trying to render his vision of the nature of the artistic life — which, as a young man, he saw as more pleasurable than demanding. In his "Memories" of his academic years, Gutmann described his social activities in considerably greater detail than his scholarly or artistic ones. He was especially enthusiastic about the "Paint-Box Ball" he attended in Düsseldorf, where one of the *tableaux vivants* represented an Impressionist painter dreaming in his studio.[8]

Gutmann does not refer to Impressionism — or discuss any painting technique — in his journal, other than to describe painting out-of-doors in Holland, but he was certainly familiar with Impressionism during his years as an art student. The few extant examples of his early painting show him working in the dark, realist manner popularized by the Düsseldorf school. It was not until after Gutmann moved to New York at the turn of the century that more modern elements appeared in his work and he began developing the late Impressionist and Post-Impressionist techniques that characterize his mature style.

After leaving the academy in Karlsruhe, Bernhard found it difficult to support himself as an artist, though he had won a portrait commission from a titled German while he was still a student.[9] Unemployed in Hamburg, Bernhard wandered the streets sketching picturesque sights, a habit he had begun to cultivate as a student and which he continued to enjoy throughout his life.[10] His father cautioned him that he would have to master a trade in order to earn a living, but the determined artist continued searching for ways to develop and market his talents.

In April 1892 Gutmann sailed to Holland with a friend for six weeks of sketching and painting in museums and in the picturesque Dutch countryside. Following the example of other, established artists Gutmann painted serene pastoral Dutch scenes, such as a cow in a stall and a farmer. The bucolic, escapist subjects that fill Gutmann's Dutch sketchbook were also popular among American artists such as Gari Melchers (1860–1932)[11] and George Hitchcock (1850–1913),[12] who were studying and working at the time in France and Holland. In Haarlem, Gutmann copied the works of Frans Hals (c. 1580–1666) in the Frans Halsmuseum in an effort to improve his own painting technique. Hals's active, textured brushwork was admired by young, progressive artists, who interpreted Hals's brushstrokes as a vehicle of personal expression. Gutmann also began painting out-of-doors while in Holland, and he quickly became acquainted with its difficulties:

We went into the flower fields and painted whatever we could. Then suddenly there was a gust of wind and a rumbling and my easel and study fell into the sand. I had nothing left to do but scrape off all the paint.[13]

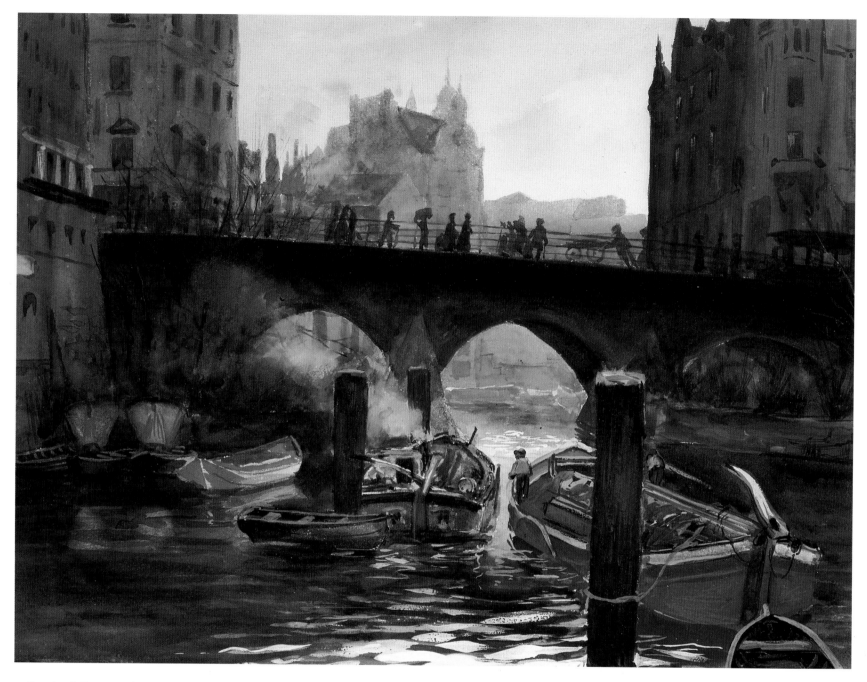

3. *Bernhard Gutmann (1869–1936)*
CANAL SCENE [HAMBURG?], *n.d.*
Gouache, 12 x 14 in. (30.5 x 35.6 cm)
Joseph Ambrose

During his Dutch sojourn Gutmann received an important letter from his father explaining that two of his brothers, one in America, the other in Australia, had offered to pay his passage to their adopted countries. The adventurous young painter was intrigued by these choices and, seeing few prospects for employment at home, decided to seek his fortunes abroad. Gutmann quickly determined that America would be the better place to pursue an artistic career, and in addition to his brother Ludwig, who was paying his fare, he had another sibling, Hellmuth, living in New York to whom he was very close. So after returning to Hamburg from Holland in June 1892,[14] Gutmann left for the New World. The twenty-three-year-old arrived in New York with little ability to speak English and explored the city for two weeks before leaving for Lynchburg, Virginia, where he joined Ludwig as an electrician working for the Piedmont Electrical Illuminating Company. Of the bustling, busy city, Gutmann wrote,

> New York seemed like a colossal temple. . . . Once when I went out to see the art galleries, I intended to walk to every one. I came as far as Central Park and then I was so tired that I took the next street car to come back home. . . . In any event New York made an enormous impression on me.[15]

Gutmann passed through Washington on his train voyage and noted, "I saw the Capitol which, next to the Cologne Cathedral, made the greatest impression of any building on me, except for the dome which looks like a bishop's hat and threatens to drill the building into the ground."[16]

Though Gutmann was profoundly intrigued by his first encounters with black people in Lynchburg, the small southern city was a disappointment after the excitement of New York.[17] To his dismay Gutmann found that "There is no talk of art whatsoever in this little town."[18] Feeling adrift in a barren cultural environment, and unfamiliar with local customs and attitudes, Gutmann felt isolated and despondent. His social alienation, exacerbated by his lack of interest in church activities—around which southern social life revolved—precipitated an artistic crisis:

> Thus, I had pretty well decided to hang up painting or everything which belongs to it. However, that is easier said than done and one day when it was no longer so hot I surprised myself in that I sketched a Negro. They are really so picturesque and have immensely expressive and artistic faces. Naturally one does not understand my taste here. According to Americans of the south the Negroes are only cattle and they do not excuse me if I am simply enthused about these people and say that there is just as much human in the black man as in the white.[19]

4. "NEGRO STREET, LYNCHBURG, VA.,"
1895
Pencil on paper, 8 x 6½ in. (20.3 x 16.5 cm)
DeVille Galleries, Los Angeles

Gutmann drew sympathetic portraits of the black people he met in Lynchburg and in the nearby town of Bedford, producing a volume of sketches of African-American genre scenes that he printed privately, hoping to earn additional income. The market for domestic images of African-Americans in the South in the 1890s, however, was severely limited: few white people were interested in images of blacks, and the black people Gutmann drew and painted did not have the money to purchase his works. Although he was initially surprised by the reaction to his sketches, Gutmann gradually adjusted his outlook to accommodate the prevailing ideologies of his adopted home. He was at least able to recoup printing costs by selling two volumes of the sketches, one to an American buyer and another to a German.[20]

Even though he was culturally isolated in Virginia, Gutmann became actively involved in art during his years in Lynchburg. He had copper plates sent (probably from Germany) so that he could begin etching, and he experi-

mented with plaster modeling. By 1898 he organized a chafing dish club with members of the local German community, which met on Saturday nights in his studio for camaraderie, cuisine, and conversation; Gutmann provided decorated menus. Gutmann also wrote a great deal during his years in Lynchburg; his written English was surprisingly fluent even early on.

Although Gutmann initiated his naturalization process shortly after arriving in the United States, only a year later he felt discouraged by Lynchburg and intended to join one of his friends from art school in Capri, Italy. However, financial insolvency kept Gutmann in Virginia, and he became an American citizen in 1897. This fate proved auspicious for both the artist and his first American home; Gutmann invigorated the cultural life of Lynchburg through his energy and creativity. Long after he moved away—even after his death— Gutmann was remembered in Lynchburg as a major progressive cultural force in the city.[21]

In 1894 Gutmann took advantage of an historical local event, the death of Confederate Civil War general Jubal A. Early, to promote his work. Gutmann made a drawing of the general on his deathbed, then negotiated an arrangement with United States senator John W. Daniel, who wanted a death mask of the general. Gutmann offered to make the death mask, and Daniel agreed to buy the drawing along with it.[22] Upon completion, the mask, deathbed drawing, and sketches of Early's home and hearse were exhibited in H. Silverthorn's jewelry establishment in Lynchburg.[23] This led to the start of Gutmann's career as a successful illustrator: five of his drawings of Early and his house were selected to accompany an article on the general in *Southern Magazine* (fig. 6).[24]

Despite his disappointment about Lynchburg, Gutmann had been aggressive about promoting his art; soon after his arrival there Gutmann was displaying his paintings in a bookstore on Main Street. This exhibit attracted the attention of a group of local artists, who asked Gutmann to critique their work.[25] Hoping to create a more congenial artistic atmosphere in Lynchburg —and to earn the extra money he always needed to maintain himself comfortably and pleasurably—Gutmann began giving private art lessons around 1894. This led to his founding of the Lynchburg Art League, later called the Lynchburg Art Club, in March 1895. The group, which still exists today, was organized to foster and sustain support for art in the community, and to provide classes and exhibition spaces for its members. The league secured a building at 1319 Church Street, dividing it into a reading room, an exhibition space, a general studio, and private studios.

At the league the following January, Gutmann exhibited a portrait of Professor Schehlmann, who taught music at nearby Randolph-Macon Woman's College. In an article he wrote for the local newspaper Gutmann said, "a good portrait ought to show you not only the object—the outside—but you must

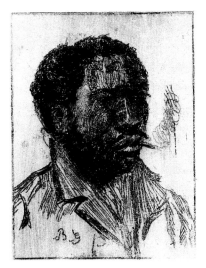

5. UNTITLED (SKETCH OF A BLACK MAN), *n.d.*
Pencil on paper, 8 x 6½ in. (20.3 x 16.5 cm)
DeVille Galleries, Los Angeles

Drawing by B. Gutmann, from photograph.

General Jubal A. Early—1863.

GENERAL JUBAL ANDERSON EARLY.

read the character, his whole history in his face."[26] Although portraiture was not the primary focus of Gutmann's oeuvre, he produced numerous likenesses of himself, his family, and friends throughout his career. Interestingly, Gutmann usually painted portraits as gestures of friendship rather than as commissioned works. A bust-length self-portrait done in Lynchburg shows Gutmann in a dark, heavily modeled manner that clearly reflects his Düsseldorf training. The rigid, almost photographic frontal pose masks his genial personality under an aura of seriousness; later self-portraits reveal the more relaxed, playful, and lively side of his character. During this period Gutmann also produced a portrait of local military celebrity General Thomas Munford, for whom he had drawn some military maps, and he made a number of sketches of his friends and students (figs. 8, 9).

The year 1895 was a turning point for Gutmann's career. Public school superintendent Edward C. Glass was so impressed by a drawing demonstration Gutmann gave at a local high school—and by the painter's assertion that art was a necessary component of education—that Glass appointed him to be the first supervisor and instructor of drawing in the Lynchburg public schools.[27] Gutmann demonstrated a practical as well as a visionary approach to teaching. Familiar with American industry from his days working at the Piedmont Electrical Illuminating Company, Gutmann took his students to local factories to sketch various machines, beginning at the Glamorgan cast-iron works, where students were shown the entire process of cast-iron production, from carefully measured drawings through wooden patterns to final casts. Gutmann fostered his students' interest in industrial design while encouraging their awareness of how product design, like advertising design, could be used to increase sales.[28] Manuals that Gutmann wrote outlining his course procedures were used in a number of public schools in Virginia, and selections were published in the *North Carolina Journal of Education* in 1898 and 1899.[29]

In the fall of 1895 Gutmann was also selected to substitute for Louise Smith, the art teacher at the recently opened Randolph-Macon Woman's College, who was on leave in Paris. In addition to the drawing and painting classes that had been taught by Smith, Gutmann added courses in modeling, art history, and painting on china.[30]

During the summer of 1896 Gutmann allowed himself the luxury of a travel vacation. By working two full-time jobs, he had managed to pay off his debts and save enough money to attend the Chicago wedding of one of his three brothers living in America. He decided to explore the country and travel to Chicago via Saint Louis by train. Arriving in Saint Louis in June, just as the Republican presidential convention was taking place, he was surprised by the crowds of people. As usual he went in search of art, but was not very impressed by what he found.[31] Gutmann was far more intrigued by Chicago. In his journal he mentions the lake, the parks filled with monuments, and the

Opposite:
6. ILLUSTRATION OF GENERAL JUBAL ANDERSON EARLY, *1894*

7. UNTITLED (PAINTER AT HIS EASEL), *1889*
Pencil on paper, 8 x 6½ in. (20.3 x 16.5 cm)
DeVille Galleries, Los Angeles

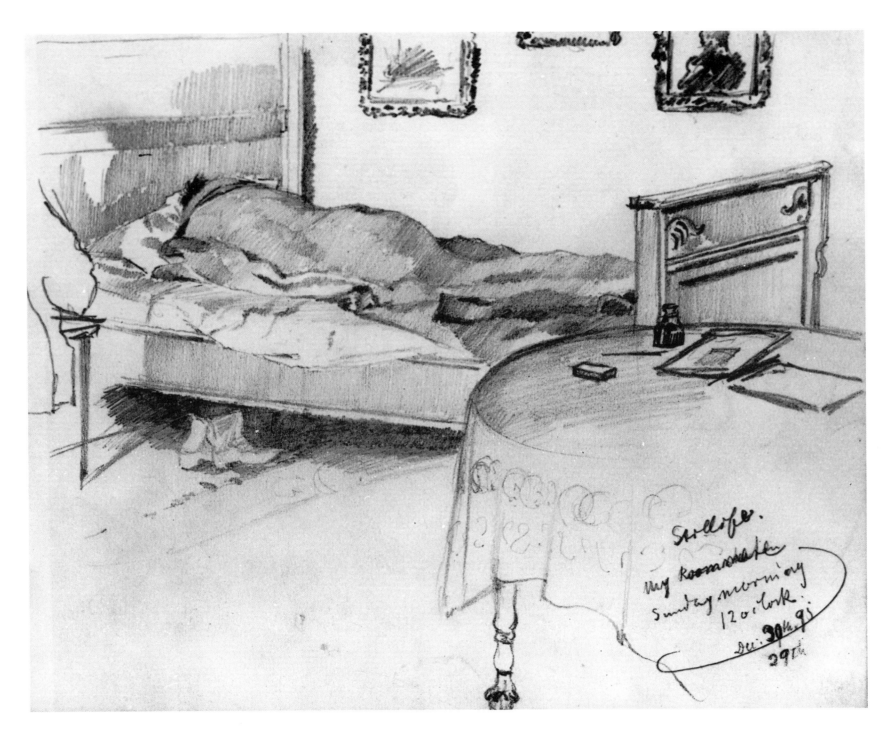

8. "MY ROOMMATE SUNDAY MORNING
12 O'CLOCK," *1895*
Pencil on paper, 6½ x 8 in. (16.5 x 20.3 cm)
DeVille Galleries, Los Angeles

9. "R.M.W.C. [RANDOLPH MACON WOMAN'S COLLEGE]," *1896*
Pencil on paper, 6½ x 8 in. (16.5 x 20.3 cm)
DeVille Galleries, Los Angeles

remains of the 1893 World's Columbian Exposition, noting that the art gallery and the German building were still well maintained.[32] Describing the Art Institute, Gutmann observed that

[the museum] has a few exceptional pictures which are, however, so covered in glass that one cannot properly enjoy them due to the reflections. Everything is colorfully hung in a confused manner without order. One can see that the entire collection was put together in a short amount of time.[33]

From Chicago, Bernhard traveled via Canada and Niagara Falls to visit his brother Hellmuth and a cousin in New York. Gutmann was particularly impressed by the spectacle of the falls:

Niagara Falls made an overwhelming impression on me. The whirlpool above the falls looks like a gigantic struggle which takes place under water from which the water escapes and risks the powerful leap into the depths where it arrives being beaten through painful roaring, but is free.[34]

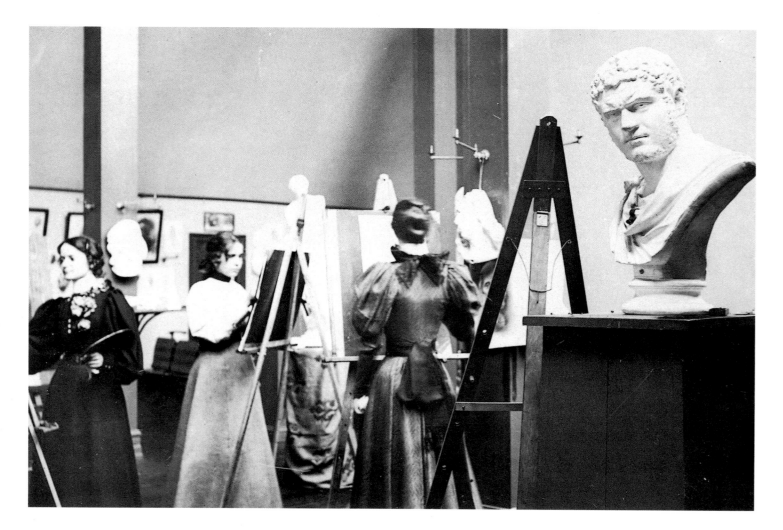

10. "ATELIER IN R.M.W. [RANDOLPH
MACON WOMAN'S] COLLEGE," *1896*
Photograph
Joyce and Christian Title

The fascination with nature as a force of struggle was a favorite subject of nineteenth-century German Romantic painters, and appealed strongly to Gutmann's own artistic sensibility; the power of natural forces became a theme in his later work.

When Gutmann returned to Manhattan he saw "significantly more...in New York than four years earlier."[35] At the Metropolitan Museum he saw "a most awful Turner, which strengthened my belief that Ruskin is far better."[36] Gutmann's journal confession clearly indicates his preference for refined, polished technique over dramatic flourish and abstract design. As Gutmann's own work progressed, however, his style would become looser, even while he maintained a traditional academic approach. Before returning south, the high-spirited young artist went to four of New York's seaside amusement parks, including Coney Island.

When he returned to teaching in the fall of 1896, Gutmann gave an art history lecture at Randolph-Macon in which he presented some progressive ideas about women's social status. In his lecture, "Woman in Art," Gutmann discussed female figures who had succeeded as artists, including the contempo-

rary sculptress Harriet Hosmer (1830–1908) and the painter Rosa Bonheur (1822–1899), whose *Horse Fair* he had recently seen at the Metropolitan Museum. Despite his acceptance of prevalent stereotypes that were used to discredit women's intelligence, Gutmann expressed very modern views of women's changing social roles and of their potential as artists. In the transcript for the lecture he concluded,

> I wish to say that in spite of the less than average weight of the brain, women can accomplish just as much as men. If they have not done so heretofore it is because a woman's sphere has been considered the home and house work, it was against the pride of the family to see the daughter work, study or labor. Today however, we are in a social evolution in which women are to be free of all these ancient restrictions and superstitions of the middle ages. Free from these encumbrances she will quickly advance and I am convinced and pleased to say to you that I am confident that successful women in art will not be exceptions.[37]

Under Gutmann's direction, his students produced illustrations for a manual on the Randolph-Macon honor code, to which the artist contributed one of his own drawings. In May 1897, at the end of his tenure at Randolph-Macon, Gutmann staged a retrospective exhibition of fifty paintings and about one hundred sketches and studies dating from his student years in Germany through his final year of teaching at the college. The exhibition featured scenes of Lynchburg, including the interior of a warehouse and a vista of the town from a nearby hillside.

In 1897 Gutmann also painted a mural-sized work for the library at Randolph-Macon, entitled *Wisdom Instructing Youth.* Sadly, this eight-by-sixteen-foot painting, originally framed in red lacquer, has disappeared.[38] In her history of the Lynchburg Art Club, author Ruth Holmes Blunt describes this painting as a mythological allegory featuring five female students and a venerable male professor, set in an idyllic autumn landscape with a columned portico and a river view in the background.[39] In a journal entry, Gutmann further explained that music, painting, science, and love (in the form of Cupid) were represented in the work.[40] The use of female figures as symbolic bearers of myth reflects not only Gutmann's European artistic heritage, but also popular tendencies in American art of the 1890s. Heroic female figures were especially popular in large decorative works, such as the murals that were done by Edwin Blashfield and Kenyon Cox for the newly inaugurated Library of Congress. Allegorical paintings had also dominated the building decorations at the 1893 World's Columbian Exposition in Chicago, the remnants of which Gutmann had seen in 1896. However, by the end of the decade the use of such academic subject matter was not in vogue among those working at

11. BERNHARD GUTMANN IN LYNCHBURG,
n.d.
Photograph

the forefront of American art. In New York a group of artists including Childe Hassam, Edmund Tarbell, J. Alden Weir, and William Merritt Chase resigned from the well-respected Society of American Artists (itself an off-shoot of the National Academy of Design) in 1897 to form an independent exhibition society. Designated "The Ten," these American Impressionists exerted an increasing influence on American art, forging a new movement away from meditations on an imagined past to more naturalistic views of modern life.

On Thursday, November 4, 1897, shortly before his twenty-eighth birthday, Gutmann became a naturalized citizen of the United States. During the following year Gutmann's artistic horizons expanded beyond Virginia: his painting *Church Interior* was included in the annual exhibition of American painting at the Art Institute of Chicago, thus signaling the beginning of Gutmann's wider recognition.

On January 24, 1898, the Lynchburg Art League held a day-long exhibition featuring a number of Gutmann's paintings, including *Vanitas, Solitude, Game Called, Backyard Bay, A la Plain [sic] Air, Shadow,* and *Sunrise on the Ocean.*[41] Although these works cannot be identified among his existing oeuvre, their titles suggest still lifes, landscapes, and genre scenes, and a few of them indicate that Gutmann was continuing to paint out-of-doors, despite his hapless experience in Holland. Gutmann exhibited several more times with the Lynchburg Art League during the remainder of his residence there, and even after he left Virginia he sent works to the city for exhibition with the group. On December 4, 1925, he returned to Lynchburg as a nationally acclaimed artist and presented a lecture titled "Individualism in Art" in conjunction with an exhibition of his work sponsored by the Lynchburg Women's Club.[42]

Following the successful publication of his drawings of General Early in 1894, Gutmann continued working as a professional illustrator, an occupation that would later sustain him in New York. He also produced a series of drawings for an article called "German Student Life," a subject with which he was intimately familiar.[43]

Not surprisingly, the scenes depict male students studying, drinking beer from tankards, and fencing, some of Gutmann's favorite activities during and after his own student years. Gutmann created his first book illustrations for Mary Tucker Magill's *Virginia History for the Young,* a text used in local public schools. Gutmann's illustrations of elite social scenes such as *Dinner at Governor Berkeley's* and *Reception by the Burgesses to the Governor and His Family* were probably dictated by the author and were featured in the January 1898 Lynchburg Art League exhibition.

During his teaching years, Gutmann augmented his salary with summer employment. In 1898 and 1899 he taught in the summer program at the Nor-

mal School in Charlottesville and in the summer teachers' program in Bedford, Virginia. Despite his success as an instructor, Gutmann felt that he himself was still a student in need of further training, and he remained determined to save enough money to continue his artistic education.

Gutmann finally escaped the restrictive milieu of Lynchburg in the fall of 1899, when his brother Hellmuth convinced him to relocate to New York with its livelier art scene. Although he was uncertain about how he would earn a living, Gutmann expressed confidence in his abilities; before he embarked on his journey north, he inscribed the German aphorism "Never has heaven wrongly deserted a journeyman"[44] in his journal.

Several of Gutmann's paintings from his years in Lynchburg remain there in public collections, including a small self-portrait that belongs to the Lynchburg Art Club. Gutmann donated his portfolio of drawings of African-Americans as well as several paintings to the high school named for Superintendent E.C. Glass, who had given Gutmann his first teaching position—and his first opportunity to earn a living using his art training. A later painting, *Breton Woman and Child* (c. 1910), was given to the Lynchburg Women's Club, and is now in the old Lynchburg courthouse, which has been converted into a museum.[45] The subjects of these few works represent the avenues that Gutmann would explore throughout his career: portraits, still lifes, and domestic scenes remained staples of his repertoire even as he did his best work as a landscapist. Technically they reflect his German academic training, which he would soon refine and transform into a livelier and more personal style.

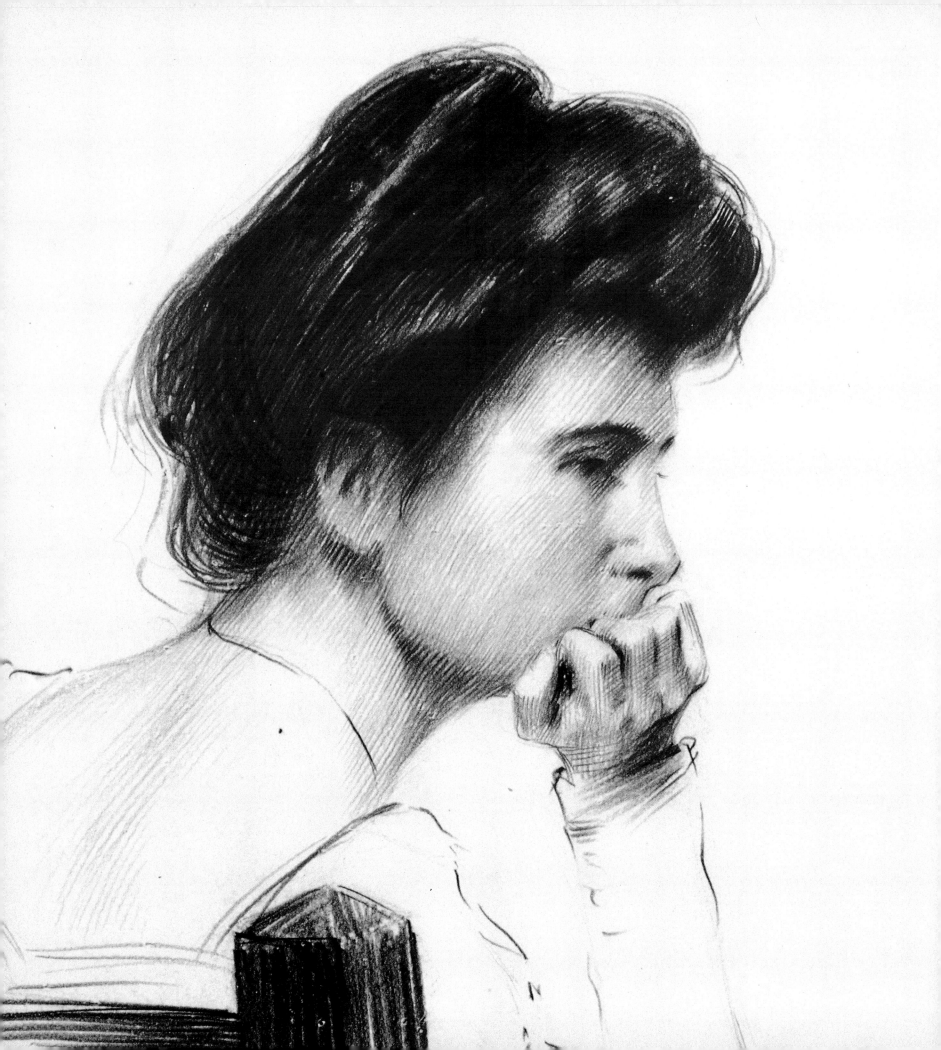

Gutmann and Gutmann

NEW YORK AND PARIS

ARRIVING IN NEW YORK at the end of the century, and at the end of his twenties, Gutmann was concerned about his ability to earn a living and to further his career as an artist. "My prospects in New York in 1899 were not as good as in 1892 since I had forgotten a lot in the south and also had no idea of practical commercial work,"[1] he confessed in his journal. Gutmann searched through newspaper advertisements for a suitable position, finally choosing advertising as the occupation that would best utilize his skills. Although he was initially rebuffed for his lack of experience, he quickly realized how to market his talents, and as soon as he appeared confident, he was hired. Gutmann discovered that the business took advantage of the workers, and he became very distressed that he was being exploited:

> Although I was new doing piece work, I earned more than the salaries all the artists earned who had been there longer and had trained there. Consequently, I was offered a salary, albeit reduced. So now, I was working at about three places until I saw red. I realized how everybody was trying to take advantage of me and so I began working for myself. I did this for three years during which I attempted to take up my long neglected studies.[2]

Although it is unclear where Gutmann continued his art studies after he settled in New York, there are indications that he spent a year or two at the Chase School of Art or at the Art Students League.[3] He later complained that he had little opportunity to pursue his painting during this period, and there are few extant examples of his work from these years.

(detail)
39. MOTHER AND BABY ELIZABETH, *n.d.*
Oil on canvas, 33⅛ x 37⅛ in. (84.1 x 94.3 cm)
Private collection

Opposite:
(detail)
15. BERTHA GOLDMAN IN CHAIR, *n.d.*
Graphite on paper, 13¾ x 9¾ in. (34.9 x 24.8 cm)
Joseph Ambrose

IN THE MIDST OF LIFE WE ARE IN DEATH

COPYRIGHT 1905, BY GUTMANN & GUTMANN, N. Y.

12. IN THE MIDST OF LIFE WE ARE IN
DEATH, *1905*
Printed postcard

Dissatisfaction with his working conditions prompted the artist to persuade his brother Hellmuth to set up a fine-art printing firm with him in 1902. Bernhard agreed to direct the artistic operation of the venture on the condition that Hellmuth would be the business manager. After several months they began to attract a considerable number of commissions. Bernhard's assignments included illustrations for books, magazine stories, sheet music, and magazine covers. On one occasion he published a postcard, *In the Midst of Life We Are in Death* (fig. 12), of a nude female figure that can also be interpreted as a skull. This macabre item is indicative of Bernhard's latent German Romanticism, which surfaced intermittently throughout his career.

Gutmann's illustrations reflect a rather colloquial early twentieth-century American taste for Art Nouveau decoration and realist narrative illustration (fig. 13). In addition to the Art Nouveau designs of women and children in luscious gardens that he produced, Gutmann also made amusing, whimsical drawings. He illustrated a slim volume called *Reflections of a Bachelor* (1903) that defines the good life in terms of male camaraderie, complete with cigars, champagne, and mandolins. He also made fun of the recently invented auto-

mobile and airplane in a postcard drawing done in 1904, the year after both
the production of Ford's first automobiles and the Wright brothers' flight at
Kitty Hawk. In Gutmann's drawing the automobile has turned into an air-
plane with the aid of a blimplike balloon, and it sails over telephone lines to the
amazement of a group of viewers on the ground. The image offers an amusing
commentary on the wonders of modern life. Gutmann's most prestigious illus-
trative work was an etching for Theodore Roosevelt's series of Western stories.[4]
President Roosevelt obligingly signed a copy of it for the artist in 1904.

By 1903 the Gutmann and Gutmann enterprise had sufficient commissions to warrant hiring additional staff. Introduced by a friend to Bessie Collins Pease,[5] Bernhard was impressed by the young woman's talent and invited her to work for them. Bessie was as displeased with doing piecework in advertising as Bernhard had been, and she readily agreed to join the firm. Soon, Bessie Pease found more than an occupation at Gutmann and Gutmann. As Bernhard noted in his journal, "In 1904 my brother was engaged to Miss Bessie Collins Pease and not long after her work improved greatly. It seemed as though she had only been waiting to be awakened by love, and then to make for herself a name that she would soon change."[6]

During the hot New York summers the brothers frequently escaped to nearby ocean resorts. At Normandy-by-the-Sea, they were introduced to the Goldman family of Manhattan. Sarah and Julius Goldman came from wealthy and well-connected German Jewish families, and had three daughters and a son more than a decade younger than the Gutmanns. The brothers paid several visits to the Goldman family and were invited to dinner on one occasion, but when the invitation was not repeated, Bernhard mentioned to his journal that he "had the notion they had merely been friendly while wanting to thank me for a favor."[7]

In January 1906 Gutmann prepared to return to Hamburg for the first time in over thirteen years to celebrate his father's eightieth birthday. Fortuitously, he booked his passage on the same boat that the Goldman family was taking to France for an extended vacation. On the ship Gutmann encountered Mrs. Goldman, "who without delay, kindly greeted me as their traveling companion, although I had not seen her for half a year."[8] Gutmann joined the Goldman family for meals and became very attached to the eldest daughter, Bertha, with whom he recalled "promenading the steamer's various decks for hours discussing important topics. After the family had left the boat in Cherbourg, I felt very lonely but I had the feeling this time, I would see Her again."[9]

In Hamburg Bernhard was met by his two remaining brothers and a sister, and was overcome by how changed they were. Moreover, he noted that the city of his childhood was so different that he was now a virtual stranger there. After glorious birthday festivities for his father, Gutmann set out to see his friends from art school. In Berlin he visited Rudolf Herzog, who dedicated a copy of *Im Fasching des Lebens Kunstler Geschichten*,[10] his book of artists' lives, to his friend Bernhard Gutmann. The artist traveled on to Karlsruhe, Cologne, and Düsseldorf, which he also found much changed. In Bremen he

visited Overbeck who in the meantime had become well-known. He dedicated a very beautiful etching to me. He had built a nice house and studio and lives a quiet and peaceful life alone at the border of the heath near Luneburg free and unaffected by any influences.[11]

Gutmann's contemporary and a fellow student at the Düsseldorf Academy, Fritz Overbeck (1869–1909) lived in the artists' community of Worpswede, near Bremen, from 1894 to 1906. He died at the age of forty, several years after Gutmann's visit. Ironically, Gutmann would soon be in a comfortable situation very much like Overbeck's and would find it less satisfying than he might have imagined in 1906.

During the same year that Gutmann returned to Germany, a group of German architectural students were forming a groundbreaking organization to promote their work. Calling themselves Die Brücke (the bridge), they intended their work to be a bridge from the past into the future. Typically German in their mastery of both painting and the graphic arts, these young artists produced startling images in lurid, jarring colors filled with emotional resonance; their work ushered in the German expressionist movement. Although there is no documentation suggesting that Gutmann actually knew about Die Brücke, the group's dual production of paintings and graphics and their coloristic fantasies would have appealed to him. However, Gutmann's lyricism was antithetical to the harshness of expressionism and more in keeping with the spirit of French and American artistic strategies.

Gutmann returned to New York in March 1906, reinvigorated by his trip. He wrote in his journal that he was even beginning to find a little more time to paint, an activity that had previously been curtailed by his responsibilities at Gutmann and Gutmann. After his brother Hellmuth married Bessie Collins Pease on July 14, 1906, Bernhard was left alone for the summer, managing all aspects of the firm.

When the Goldmans came back to New York in the fall of 1906, Bernhard and Bertha resumed their relationship. That November they became engaged, an event that marked the end of Gutmann's journal writing. At the end of "Memories" he says, "Perhaps my fiancee or wife—the change will be taking place January 31—may continue the writing." It is unfortunate that Gutmann abandoned his journal, as it offered important insights into all facets of his thinking. Although she was a graduate of Bryn Mawr College, Bertha wrote in a terse, factual manner without her husband's sensitive observations; her account of their 1929–30 Egyptian excursion is plodding in its descriptions of places and people.[12]

Gutmann's marriage to Bertha Goldman brought him not only romance but financial independence. Bertha's father endowed the couple with an income that allowed the artist to abandon his duties at Gutmann and Gutmann and entrust the firm to Hellmuth and Bessie. In return for Julius Goldman's generosity, as well as being a good husband to Goldman's eldest daughter, Gutmann was responsible for producing portraits of the Goldman family and for providing mural decorations for the Goldman family residences in Manhattan and Keene Valley, New York, in the Adirondacks. Today Gutmann's

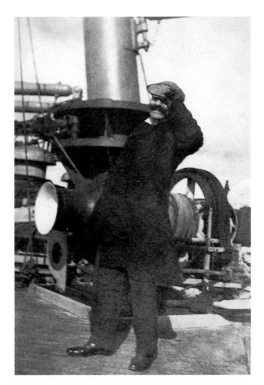

14. BERNHARD GUTMANN ON A SHIP,
c. 1906–7
Photograph

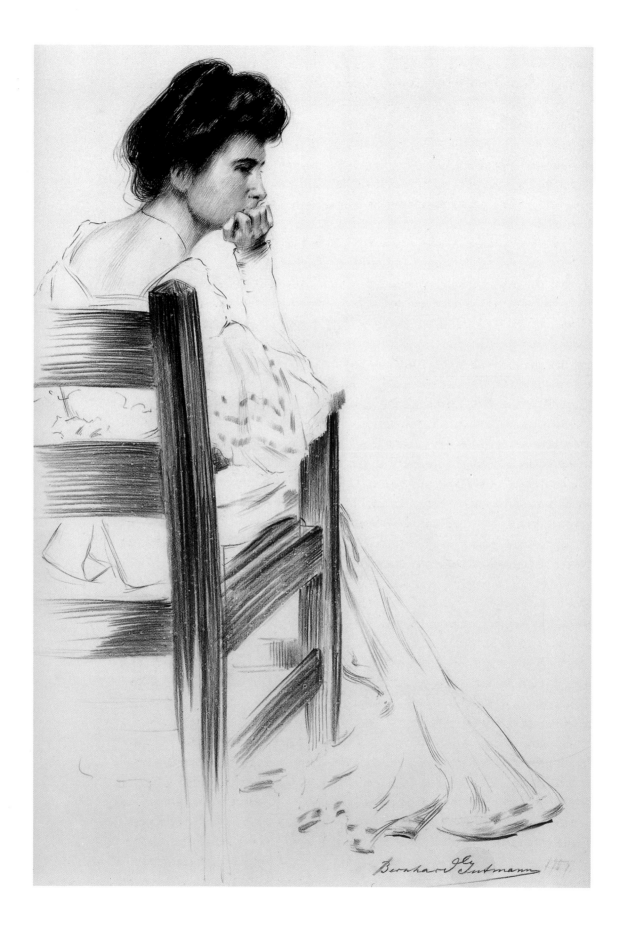

murals for the Goldman House at 132 East 70th Street have sadly vanished, perhaps under layers of paint,[13] as have the decorations for the kitchen and pantry at High Rocks in Keene Valley.

Bertha became both muse and model for her husband. An early bust-length portrait of her, probably painted for their engagement, shows a beautiful, dark-haired, pensive, and rather wary young woman wearing a dress with leg-of-mutton sleeves. The careful drawing and muted tonalities of this painting reflect Gutmann's academic training. A more dynamic and engaging image of Bertha is a full-length drawing of her seated in a chair with her hand resting on her chin, which Gutmann completed around the same time (fig. 15).

Following a wedding trip to the Berkshires, the newlyweds sailed to Europe so that the artist could seek fresh sources of inspiration. In the summer of 1907 the Gutmanns traveled through Germany, where Bernhard sketched views of Potsdam and of the villages of Steinfeld, Blankenheim, and Rubentheid. From Germany they headed to Paris, where they settled into an apartment; and from this comfortably cosmopolitan base they were free to explore the surrounding countryside.

At the turn of the century Paris was the international center of the art world, and the first decade of the 1900s was a particularly exciting time for an artist to be in Paris. In 1905 at the independent Salon d'Automne, Gutmann's contemporary Henri Matisse (1869–1954) and his friends gained notoriety as the Fauves, or "wild beasts," because of their use of vibrant colors never seen in nature. Barely a year later Pablo Picasso (1881–1973) began his explosive, revolutionary painting *Les Demoiselles d'Avignon* (1906–7), and by 1908 Picasso and Georges Braque (1882–1963) had introduced Cubism. In 1909 a group of young Italian artists published the manifesto of Futurism in the Parisian journal *Le Figaro,* announcing a movement celebrating speed, noise, and dynamism. These artists redirected thought about the nature of art and its role in the modern technological world.

Young American artists in Paris painted at the Académie Julian, just as their Impressionist forebears had done earlier. They drew from live models at open ateliers such as La Grande Chaumière, and the boldest had their work critiqued by Matisse. Gutmann, however, seems to have been more inspired by provincial France than he was by Paris or by any of the innovative artistic developments taking place there; he virtually ignored the more radical works being produced by a vanguard of artists just a decade younger than he was.

The social gathering place for intellectual Americans living in Paris was the art-filled apartment of Gertrude Stein at 27 rue de Fleurus, which the writer initially shared with her brother Leo, and later with Alice B. Toklas. Stein's Saturday evening salons were opportunities for artists to share their work and their ideas; many of those who participated are now considered the masters of modern art—Picasso, Braque, Matisse, and the Americans Marsden Hartley,

Opposite:
15. BERTHA GOLDMAN IN CHAIR, *n.d.*
Graphite on paper, 13¾ x 9¾ in. (34.9 x 24.8 cm)
Joseph Ambrose

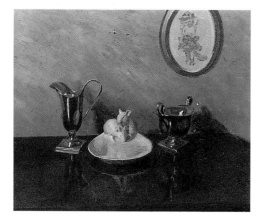

16. STILL LIFE WITH CERAMIC MICE
ASHTRAY, *n.d.*
Oil on canvas, 17 x 19¾ in. (43.2 x 50.2 cm)
Theodore Lehman II

Opposite:
17. LADY IN PINK, *n.d.*
Oil on canvas, 28 x 28 in. (71.1 x 71.1 cm)
Private collection

Alfred Maurer, Max Weber, and others. It is unlikely that Gutmann met Stein during his first stay in Paris, as his daughter Dorothea remembers his first encounter with the writer, which occurred when he was invited to lunch during the 1920s. Although she was only five years old when this meeting took place, Dorothea recalls that her father discussed Stein's personality and writing; Dorothea's memoir does not mention his reaction to Stein's magnificent collection of avant-garde paintings. Nevertheless, Gutmann's response to Stein reveals his skepticism about advanced modernist art:

My mother had been very interested in the controversial Stein writings, but my father couldn't make head or tail of them and was made nervous and depressed by her fame. . . . As black and foreboding as his mood was in the morning, so dimpled laughing and happy was it upon his return. . . . "Ach, she's vunderful!" he responded to my mother's inquiries. Others have compared her to a Buddha and Dad compared her to our Chinese one of flowing obesity. "She looks like that," he said, pointing to the white porcelain sculpture. "But what a sense of humor. I tell you, she had us in stitches and now I understand about her writing, she's pulling everyone's leg, she's got them all—bamboozled—" one of his favorite words. Mum wasn't so sure about this, but Papa was firm.[14]

One of the few existing examples of Gutmann's painting from this period, *Still Life with Ceramic Mice Ashtray* (fig. 16),[15] a study of silver objects and a ceramic ashtray made by the artist, shows that Gutmann was clearly still working in his muddy Düsseldorf mode during his first months in Paris. Soon, however, he began to adopt the brilliant hues, abstracted forms, and broad brushstrokes popular among those younger artists who were influenced by the lessons of Post-Impressionism. Gutmann's small oil sketches on wood panel, vividly colored and quickly painted with lively brushstrokes, are particularly aligned with the work of Post-Impressionist masters such as Gauguin and Vincent van Gogh (1853–1890). In his finished studio paintings, however, Gutmann alternately employed techniques derived both from his academic training and from Impressionist and Post-Impressionist strategies.

The confusion, noise, and bustle of Paris offered Gutmann little inspiration. During warm weather he escaped the city for Brittany, the still-isolated region in northwestern France where Gauguin painted images of Breton peasants during the 1880s. Like the many American artists who had followed Gauguin's lead and journeyed to Brittany in the 1890s, Gutmann explored the provincial towns of Pont-Aven, Douarnenez, and Pont-Croix, looking for primitive, picturesque scenes. The archaic simplicity of the peasants and their close relationship to the land and the sea appealed to Gutmann. His sketchbooks were soon filled with depictions of the activities, customs, and attire of

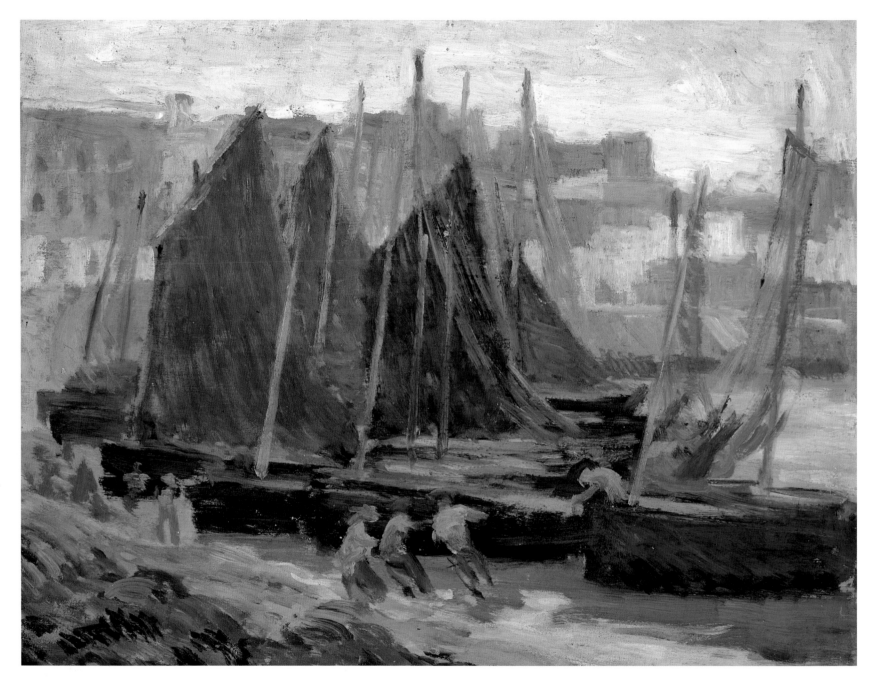

18. FISHING FLEET, BRITTANY, *n.d.*
Oil on wood, 10⅝ x 13¾ in. (27 x 34.9 cm)
Private collection

19. LACEMAKERS AND NETTERS,
BRITTANY, *n.d.*
Oil on canvas, 23⅛ x 25 in. (58.7 x 63.5 cm)
Michael Feddersen

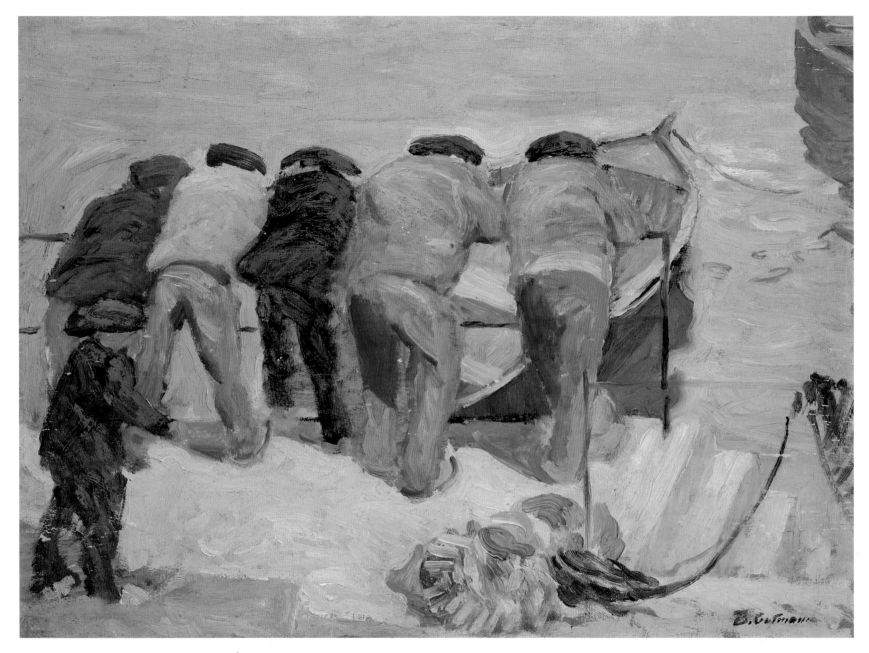

20. BRETON FISHERMEN AT WORK, *n.d.*
Oil on board, 10½ x 13¾ in. (26.7 x 34.9 cm)
Private collection

Opposite:

21. THE SEWING GIRL, *1911*
Oil on canvas, 21 x 18⅛ in. (53.3 x 46 cm)
Joseph Ambrose

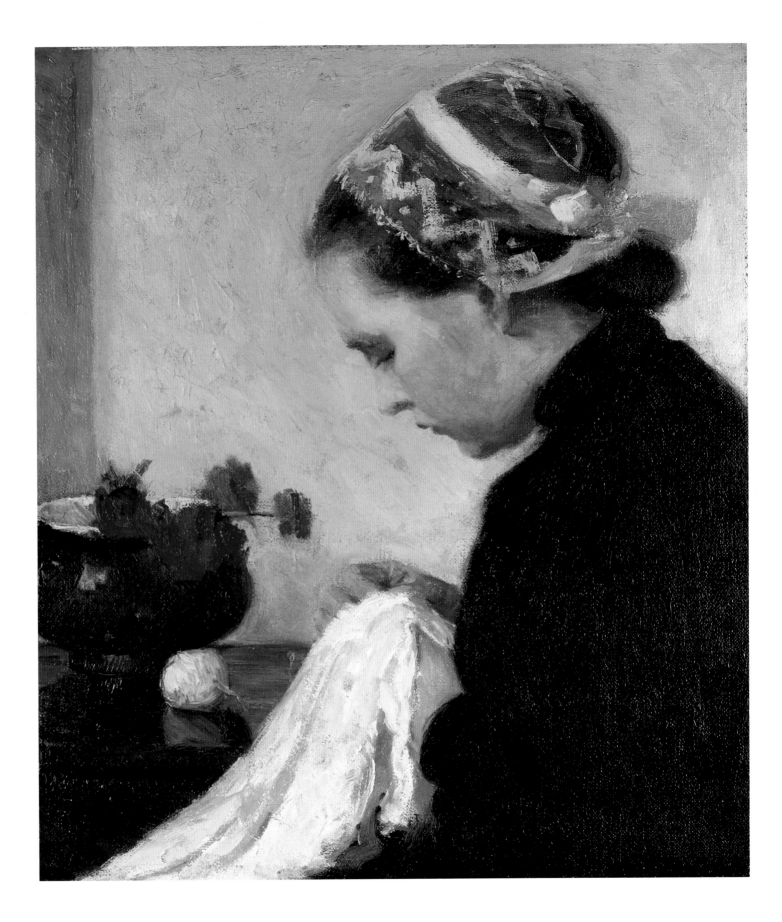

22. CABARET IN BRITTANY, *n.d.*
Oil on canvas, 23⅛ x 25⅛ in. (58.7 x 63.8 cm)
Private collection

23. PIGMARKET, BRITTANY, *n.d.*
Oil on wood, 10½ x 13¾ in. (26.7 x 34.9 cm)
Lyn and Michael Citron

the Breton peasants, and during his years in France he produced a large series of finished paintings based on his visits to the French province.

By the time Gutmann arrived in the summer of 1908, Brittany had been well mined by Gauguin and other artists; the region's particularities of costume, habit, architecture, custom, and livelihood had been extensively captured by those who had preceded Gutmann. Moreover, the advent of mass communication and other aspects of twentieth-century life were threatening the survival of communities like those of the Breton peasants. Gutmann's paintings provide a late record of the traditions of a vanishing society, as well as a close examination of an important phase in Gutmann's work. Gutmann's favorite Brittany subjects included bucolic landscapes, fishermen, boats, and women sewing. On a few rare occasions he also depicted more unusual subjects, such as a scene in a local cabaret (fig. 22) and a pig market (fig. 23).

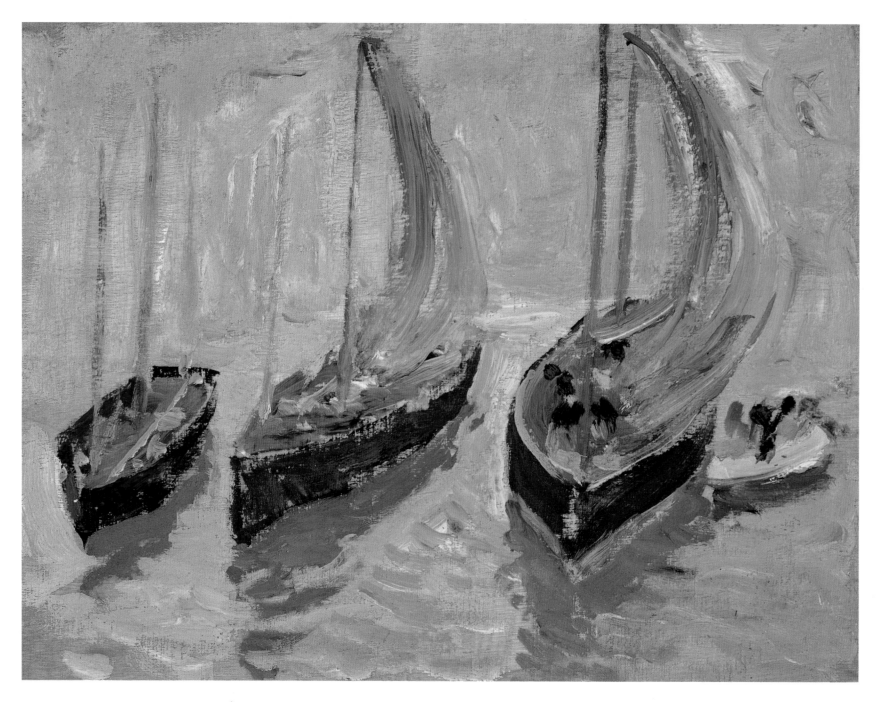

24. THREE SAILBOATS, BRITTANY, *n.d.*
Oil on wood, 5½ x 7⅛ in. (14 x 18.1 cm)
Private collection

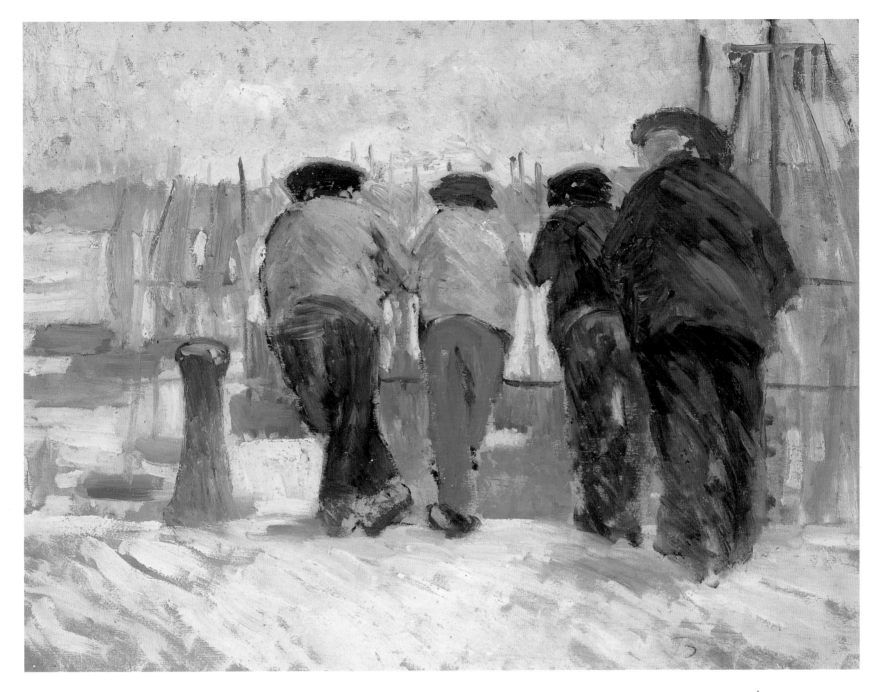

25. MEN, BRITTANY, *n.d.*
Oil on wood, 10½ x 13¾ in. (26.7 x 34.9 cm)
Private collection

26. WASHERWOMEN, PONT-AVEN, *1909*
Oil on canvas, 23⅝ x 28¾ in. (60 x 73 cm)
Lyn and Michael Citron

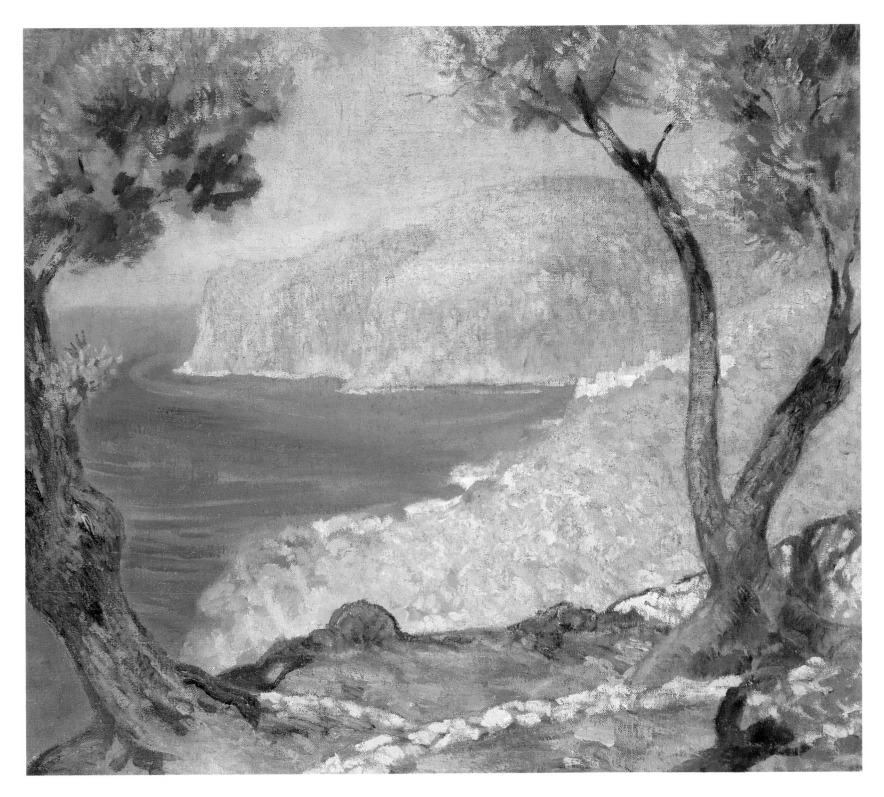

27. VIEW FROM THE BLUFFS, *1909*
Oil on canvas, 22¾ x 25 in. (57.8 x 63.5 cm)
Private collection

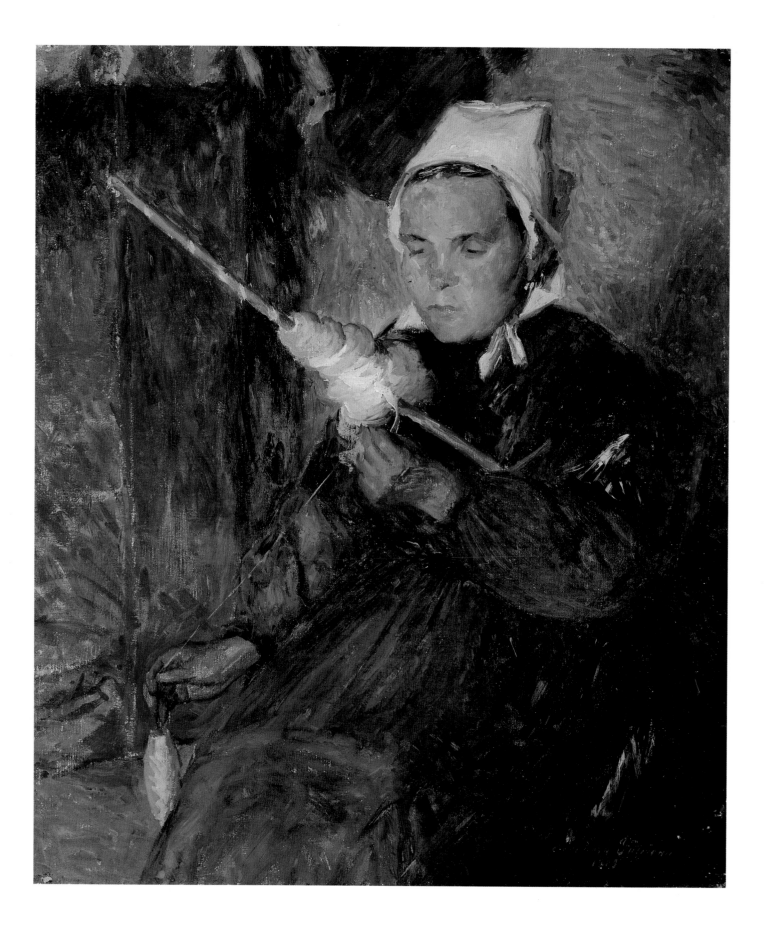

The variety of regional labor on the land and at sea figures prominently in his Breton paintings. *Washerwomen, Pont-Aven* (fig. 26) is an unusual and exciting composition for Gutmann, as it reverses the viewer's expectations about focus and light. The figures of the washerwomen are pushed into the background, so that the water and rocks are closest to the viewer; the dark foreground leads back to the highlighted women, who work along the shore at a distance.

More typical of Gutmann's depictions of Breton women are a large series of women sewing or making lace—a labor-intensive activity that particularly intrigued the artist. Unlike the seventeenth-century Dutch paintings of lacemakers by artists such as Jan Vermeer (1632–1675), which frequently featured women in enclosed spaces, Gutmann usually portrayed lacemakers out-of-doors, thereby equating their production of beautiful, intricately patterned materials with the natural beauties of their environment. *The Sewing Girl* (fig. 21), however, is more similar to Vermeer's interiors, with its focus on the profile of the young woman in her delicate lace cap. The cap demonstrates her needleworking skill, and red flowers in a dark bowl nearby illuminate the rich beauty of the young woman set off by her dark dress.

While most of Gutmann's Breton pictures isolate sexual roles to focus attention on the work of either men or women, in *Lacemakers and Netters, Brittany* (fig. 19) the two are joined in a composition that shows the similarities in these pursuits. The techniques of lacemaking and netting are separated solely by the weight of the thread and the function of the finished object. While the masculine craft of netmaking is crucial to the success of the fishermen in providing food, the women's activity provides beautiful ornaments to satisfy a social need. Equally engrossed in their work, the men and women ignore one another to concentrate on their labor.

This painting aside, however, in many of his Breton portraits Gutmann selected an approach to painting that seemed to be dependent on gender. The lively colors and textured shapes Gutmann used to construct his images of fishermen generally contrast with his refined, delicate use of color in compositions of sewing women.

Gutmann's Breton landscapes exemplify the polarities of his visual strategies. Some water and dock scenes reflect his early Hamburg paintings in their cool, muted tonalities and carefully delineated forms. By contrast, *View from the Bluffs* (fig. 27) employs the rich colorism of Post-Impressionism. Gutmann straddled both styles, alternately looking forward and backward and taking ideas from a variety of sources.

During the winter months in Paris, Gutmann transformed the summer sketches he did in the provinces into fully developed paintings. He also set up elaborate still-life compositions with exotic objects imported from China and Japan, which he had begun to collect in the manner of the nineteenth-

Opposite:
28. THE SPINNER OF PONT-AVEN, *1909*
Oil on canvas, 21⅝ x 18 in. (54.9 x 45.7 cm)
Private collection

century French Impressionists. Gutmann shared his predecessors' passion for Oriental objets d'art, but unlike the Impressionists, he was not influenced by the pictorial conventions of Japanese prints. Like a number of American painters working during the last decades of the nineteenth century,[16] Gutmann included these objects in his paintings as elegant reminders of the world's collective cultural heritage.

While Gutmann remained enchanted with the mystique of Chinoiserie and Japonisme, his Parisian contemporaries, such as Matisse, as well as younger, more avant-garde artists like Picasso, were turning to African artifacts for new sources of inspiration. Just as he chose Brittany over Paris when his peers were embracing city life, Gutmann continued to rely on the taste that had informed European artists during his student years in Germany in selecting his subjects, themes, and sources.

Gutmann's Parisian canvases of 1909 are filled with lush, sumptuous Oriental objects from his own collection. A laughing Buddha of white porcelain and a richly embroidered blue silk Chinese jacket appear in numerous settings and guises. The silk jacket is worn by an elegant model, possibly Bertha, in *Lady in Chinese Silk Jacket* (fig. 31), an image that strongly recalls the work of the nineteenth-century American painter James Abbott MacNeill Whistler (1834–1903). In this composition—as in many of those by Whistler and his American followers—the contemplative female figure examining the exuberant Buddha is portrayed as an aesthetic object, and an integral part of the still life.[17]

Gutmann also translated the exquisitely embroidered jacket into a backdrop for *Vase* (fig. 30), a still life of a flower-filled piece of blue and white Chinese porcelain; the white Buddha appears on the other side of the panel. *Vase* establishes a comparison between different modes of artistic decoration, all inspired by the natural forms of flowers: embroidery, clay modeling, and painting.

In *Tulips and Yellow Tea Service* (fig. 29) the vase appears again, now filled with tulips on a table set for tea and aperitifs. Similar subjects had been explored by Cézanne in the last two decades of the nineteenth century as studies on the nature of perception, but Gutmann was primarily concerned with the various artistic themes represented in his still lifes, rather than formal properties of objects. *Tulips and Yellow Tea Service* illustrates the infusion of Eastern cultural traditions into European life—the taking of tea, the decoration of an interior with a Chinese vase and a Japanese screen.

Gutmann's porcelain Buddha is also featured in *Oriental Still Life, Paris* (fig. 33), a study of contrasts in rich color, volumetric form, and reflective surfaces. An even larger still life contrasting cylindrical volumes, *Imari Tea Set* (fig. 32), juxtaposes a piece of painted porcelain with a round vase full of flowers. In this work Gutmann offers only a cursory depiction of the Imari design, and is more specific about the details of the flowers. Gutmann revels

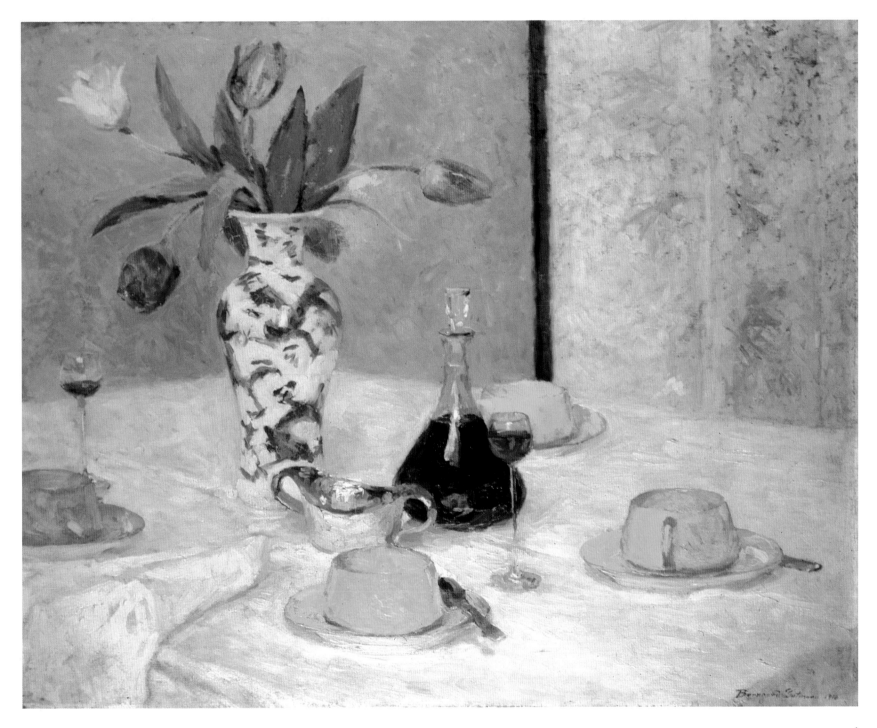

29. TULIPS AND YELLOW TEA SERVICE, *n.d.*
Oil on canvas, 23½ x 28¾ in. (59.7 x 73 cm)
Location unknown

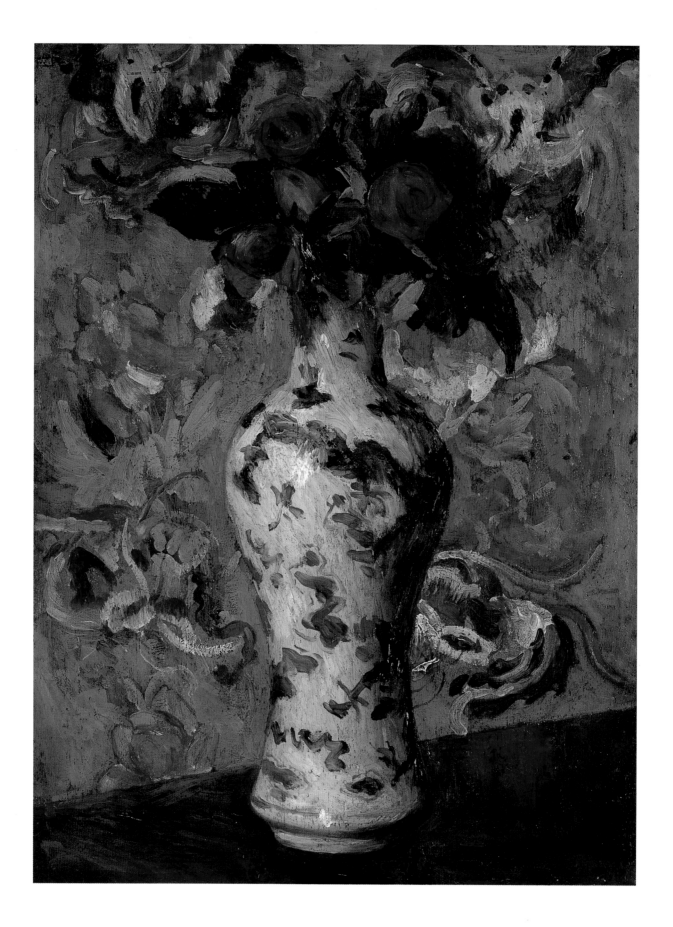

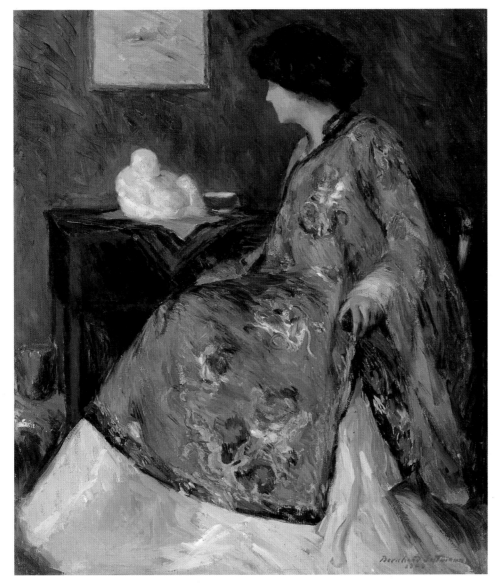

31. LADY IN CHINESE SILK JACKET, *1909*
Oil on canvas, 21⅝ x 18⅛ in. (54.9 x 46 cm)
Joyce and Christian Title

in richly textured and layered paintings, juxtaposing natural elements with decorated objects that serve as emblems of a wealth of cultural traditions.

Along with his still lifes and Breton images, Gutmann recorded a few Parisian scenes during this period. A delightful sketch of a park scene (fig. 35) displays the free brushstrokes and rich colors of Post-Impressionism, while a softer, broader view of the city, *Bird's Eye View, Paris* (fig. 34),[18] is an Impressionist interpretation of a cityscape.

Fatherhood unleashed a surprising fascination with babies in Gutmann, who was forty-one when his first child was born. Although children figure only rarely in his work prior to the birth of his daughter Elizabeth in 1911, images of her alone, with her mother, or with other guardians or playmates proliferate after her arrival. When another daughter, Dorothea Hetty, was born eight years later, Gutmann continued to depict images of infancy.

Opposite:
30. VASE, *n.d.*
Oil on wood, 13 x 9½ in. (33 x 24.1 cm)
Joyce and Christian Title

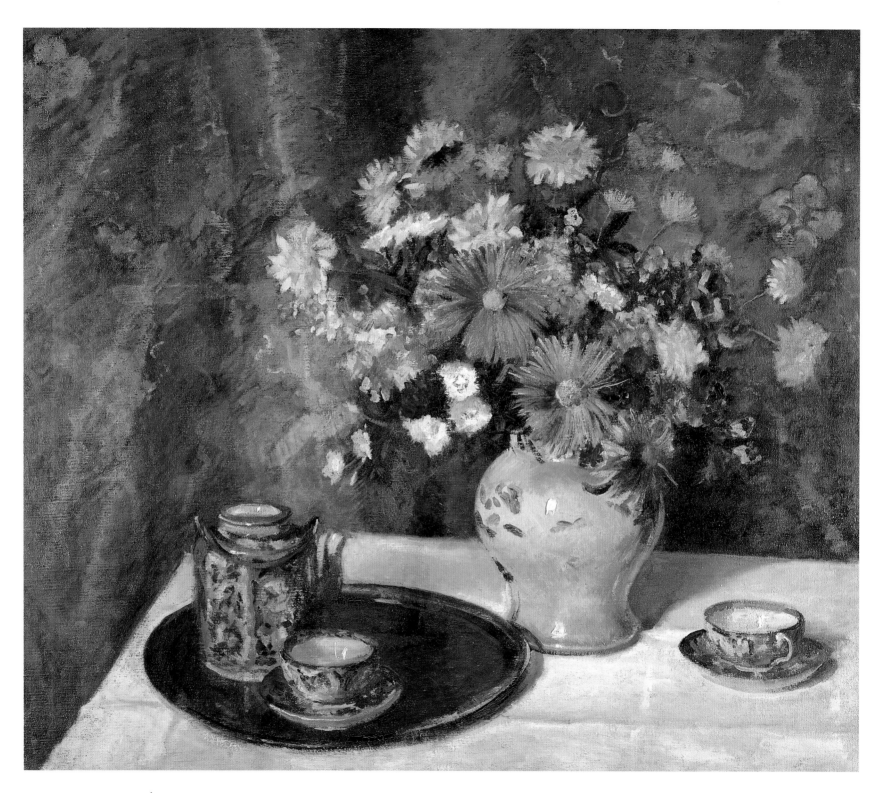

32. IMARI TEA SET, *n.d.*
Oil on canvas, 33 x 37 in. (83.8 x 94 cm)
Private collection

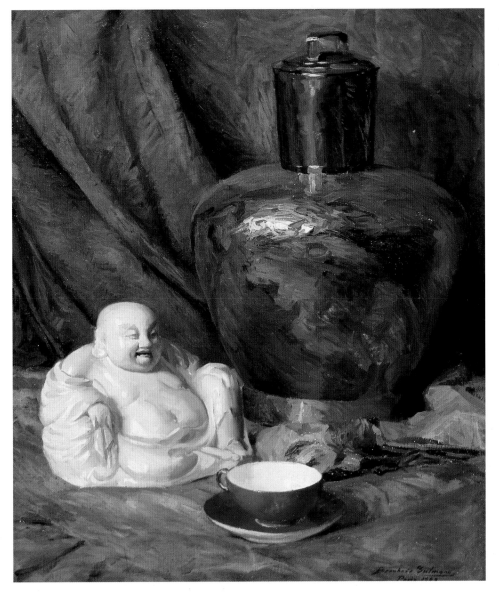

33. ORIENTAL STILL LIFE, PARIS, *1909*
Oil on canvas, 28¾ x 23¾ in. (73 x 60.3 cm)
Joseph Ambrose

Portraits of both Elizabeth and Dorothea eventually formed an integral part of his work; Gutmann was a devoted father and was eager to document his daughter's lives. Gutmann's entry in the 1911 Salon des Beaux-Arts, listed simply as *Bébé,* might have been a portrait of Elizabeth or of one of the many Breton babies that he had painted. As his first submission to a major international exhibition, *Bébé* indicates how important the subject of infancy was to Gutmann during this time. It was also a subject that appealed to popular sentimental tastes.

The artist's sister-in-law, Bessie Pease Gutmann, became a well-known graphic designer specializing in baby pictures, which sustained the Gutmann and Gutmann publishing firm for many years. Today these sweet, sentimental pictures, referred to as "Gutmann babies," continue to attract devotees. Bessie's success with these images of angelic innocence—along with his own

35. PARK SCENE, WITH BABY CARRIAGE, *n.d.*
Oil on wood, 7¾ x 10 in. (19.7 x 25.4 cm)
Joyce and Christian Title

devotion to his offspring—inspired Gutmann to keep portraying infants. In fact, a number of Gutmann's portraits of his young daughters resemble Bessie's "Gutmann babies."

Women and children were also the preferred subject matter of the renowned American Impressionist Mary Cassatt (1844–1926), who was living and working in Paris at the same time as Gutmann. Gutmann's painting *Mother and Child (White Mantel)* (fig. 37), a loving portrait of the artist's wife cradling her infant daughter, is similar to Cassatt's lyrical images of secularized Madonnas with their offspring. Depictions of babies and children also figure prominently in paintings by Gutmann's American male contemporaries William Merritt Chase (1849–1916), Robert Henri (1865–1929), and Gari Melchers. Shortly after Elizabeth's birth, the dedicated father and painter brought his family back to the United States to settle into a comfortable domesticity; this quiet existence would, however, last barely a decade.

Opposite:
34. BIRD'S EYE VIEW, PARIS (PARIS MORNING, NOV. 27, 1911), *1911*
Oil on canvas, 21¾ x 18¼ in. (55.2 x 46.4 cm)
Lyn and Michael Citron

36. CHILD'S HEAD, *n.d.*
Oil on wood, 5⅜ x 7⅛ in. (13.7 x 18.1 cm)
Joyce and Christian Title

Opposite:
37. MOTHER AND CHILD (WHITE
MANTEL), *1912*
Oil on canvas, 31¾ x 23¾ in. (80.6 x 60.3 cm)
Joseph Ambrose

38. BABY, *n.d.*
Oil on wood, 5⅜ x 7 in. (13.7 x 17.8 cm)
Joyce and Christian Title

39. MOTHER AND BABY ELIZABETH, *n.d.*
Oil on canvas, 33⅛ x 37⅛ in. (84.1 x 94.3 cm)
Private collection

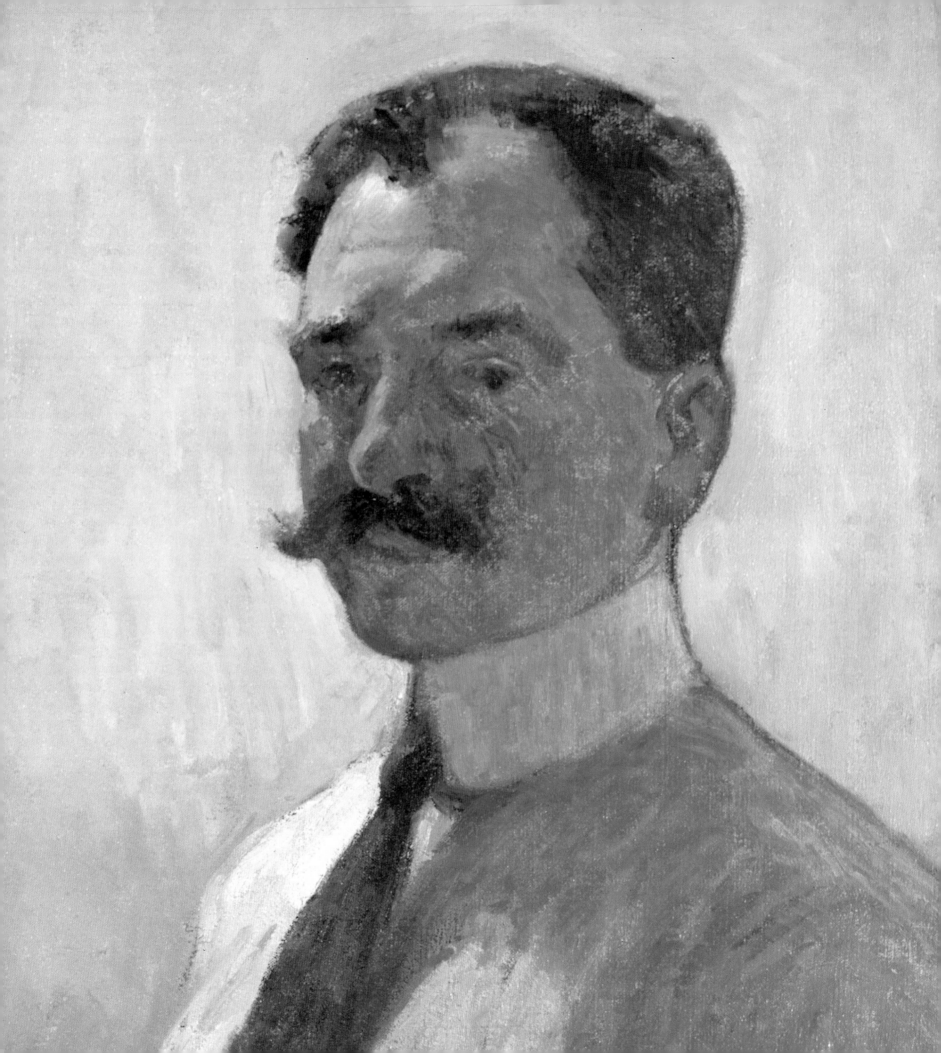

Turning Point
SILVERMINE

WHEN GUTMANN returned to the United States at the end of 1912, he was forty-two years old and ready to establish himself as a mature artist. Fiercely determined to attain recognition for his work, he soon succeeded in having his paintings displayed in major museums and important exhibitions. In 1912 he was represented in the annual exhibition at the Pennsylvania Academy of the Fine Arts by a painting titled *The Baby.* Judging from his later practice of sending favorite works to more than one exhibition, it is likely that this was *Bébé,* the painting he had recently exhibited at the Salon des Beaux-Arts in Paris. Considering the wide range of work he had produced in France, this intimate, domestic image was an unlikely choice to win him critical notice.

In 1913 Gutmann participated in three major national exhibitions.[1] Early in the year he submitted a painting to the Armory Show, the controversial exhibition that transformed art in the United States. Intended as a survey of early modernism, the International Exhibition of Modern Art at New York's Sixty-ninth Regiment Armory offered American artists the opportunity to exhibit their latest work alongside the most progressive European art. Marcel Duchamp's Cubist-inspired *Nude Descending a Staircase* (1912) was the scandalous success of the exhibition. Ridiculed in the press, Duchamp's painting provided palpable evidence that radical changes were occurring in the art world. This painting illustrated an altogether new relationship between fine art and modern technology; it was both an embodiment of and a response to the spirit of the twentieth century. The exhibition drew widespread attention (some praise, mostly shock and horror at the rebellion against accepted artistic norms), much of which was focused on the European artists, such as Duchamp and Constantin Brancusi. The American submissions were consid-

41. SUNLIT TREES, CA, *1913*
Oil on canvas, 18⅛ x 22 in. (47 x 55.9 cm)
Private collection

42. BEACH SCENE WITH STRIPED
UMBRELLA, *n.d.*
Oil on wood, 8 x 10 in. (20.3 x 25.4 cm)
Private collection

erably less avant-garde and therefore attracted less critical attention. Despite his recent return from Europe and his European origins, Gutmann was aligned with the majority of the American artists in the Armory Show as a proponent of more conservative and popular aesthetic practices. The loose brushwork of Impressionism and pure, vivid colorism of Post-Impressionism were the most modern techniques he would adopt, inclinations similar to those of many of the leaders of American modernism while they were in Paris before the outbreak of World War I.

Gutmann ignored the implications of the more radical works in the Armory Show.[2] The planar forms of Cubism appear in only one of his later paintings, the ironic *Two Natures (Self-Portrait)* (fig. 99), in which the artist lightly satirizes his career. Ever loyal to his youthful ideals, Gutmann maintained that the artist's primary responsibility was to uplift and beautify.

Gutmann's own submission to the Armory Show was *In the Garden* (fig. 44), a painting that shows him moving beyond his dark Düsseldorf palette and employing the sparkling light of Impressionism along with the brilliant color and bold brushwork of Post-Impressionism. While many of his paintings from France are more graphically exciting and daring than this one, this painting is thematically textured and multilayered. *In the Garden* features Gutmann's baby daughter Elizabeth seated at a round table that is covered with a white cloth, and which comprises half of the picture plane. The baby is

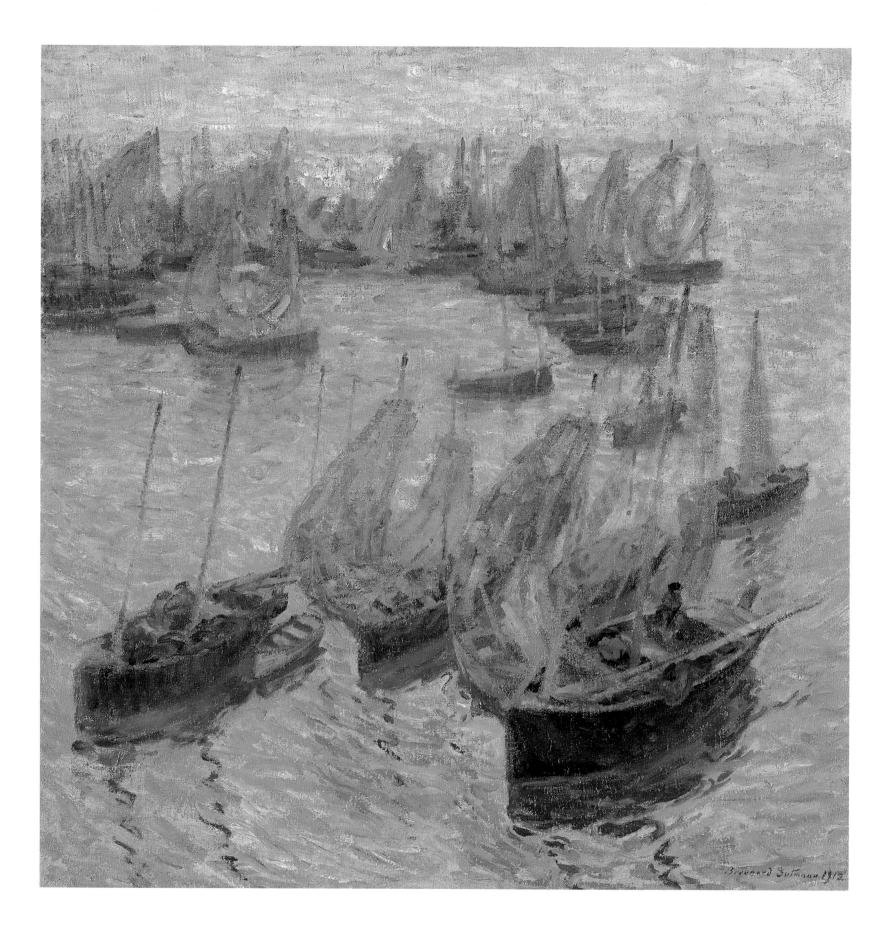

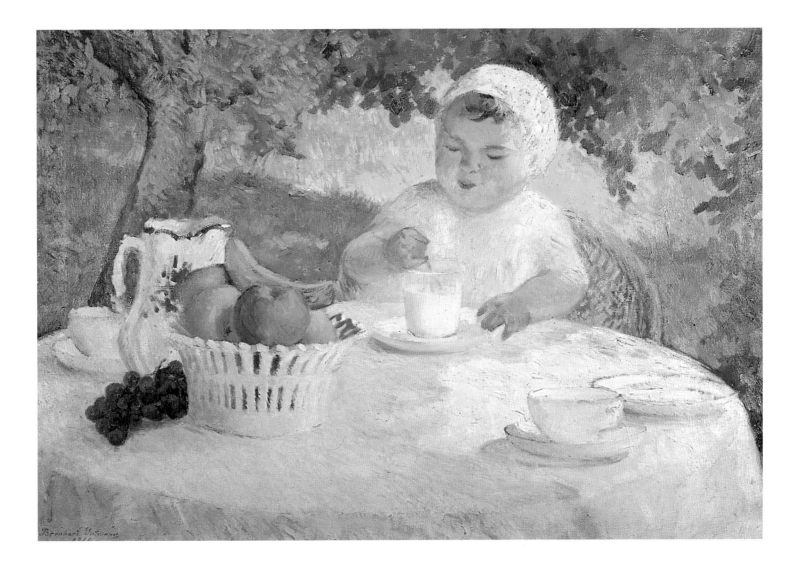

dressed in white,[3] eating from a glass bowl. The sun-flecked table and subtle shadows contrast with the vivid turquoise and yellow in the garden background. Although the ostensible subject of the painting is the child eating breakfast, the scene is also a still life: the table is covered with objects that are as captivating as the young girl. The attention to the play of light illustrates Gutmann's application of Impressionist techniques, and the vibrant colors in the garden reflect the later color theories of Post-Impressionists like Gauguin and van Gogh. Thus Gutmann's entry in the Armory Show is an amalgamation of late nineteenth-century French pictorial concerns, many of which were also being addressed by American artists such as Alfred Maurer and Arthur B. Carles, who shared Gutmann's rejection of radical forms of early modernism.

Gutmann participated again in the annual exhibition at the Pennsylvania Academy in 1913, sending two of his Brittany pictures, *Breton Lacemakers* (fig. 45)[4] and *Breton Fishing Boats* (fig. 43).[5] These two paintings create an interest-

44. IN THE GARDEN, *n.d.*
Oil on canvas, 23 x 32 in. (58.4 x 81.3 cm)
Jean Gregg Milgram

Opposite:
43. BRETON FISHING BOATS, *1912*
Oil on canvas, 29¾ x 28¼ in. (75.6 x 71.8 cm)
Joseph Ambrose

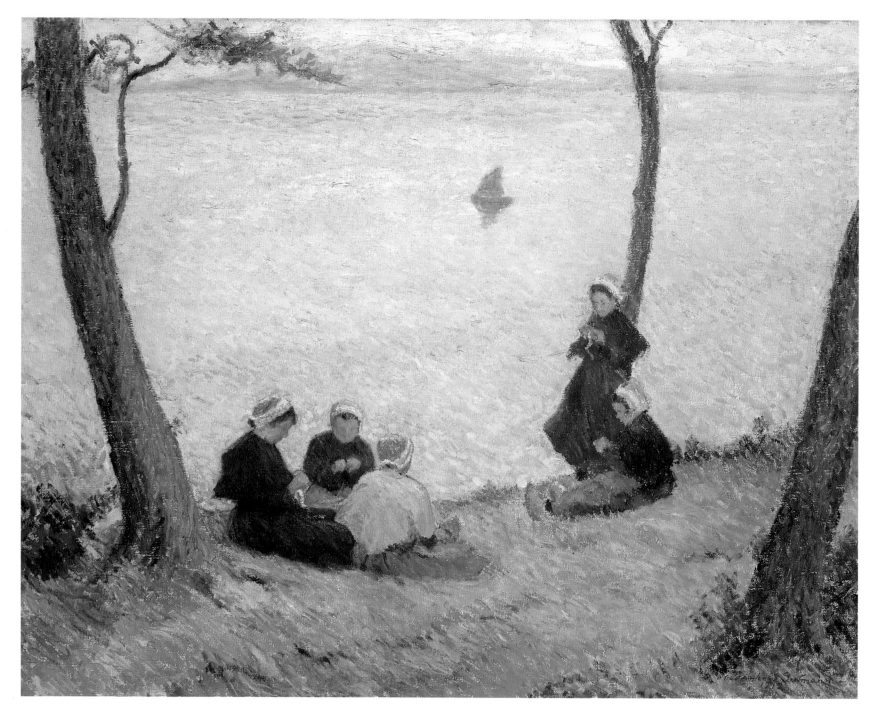

45. BRETON LACEMAKERS, *1912*
Oil on canvas, 32 x 39½ in. (81.3 x 100.3 cm)
Terra Museum of American Art, Chicago

ing juxtaposition, as they underscore distinctions between the labor of men at sea and the domestic, creative work of women on land. *Breton Lacemakers* is both a seascape and a depiction of women making lace, but the idyllic setting suggests leisure activity rather than actual work. Later the same year, Gutmann was also represented for a second time at the annual exhibition sponsored by the Art Institute of Chicago. His submission was *Fishing Boats,* probably the same painting he exhibited in Philadelphia.

Nineteen thirteen was also the year that the artist's father-in-law presented Bernhard and Bertha with a tract of land in Connecticut along the Silvermine River, where the towns of Norwalk, New Canaan, and Wilton converge. It was isolated from the noise and congestion of the city, but New York was still easily accessible by train. Moreover, the Silvermine region was a center of American Impressionist activity; artists' colonies already existed in nearby Cos Cob and Old Lyme, as well as in New Canaan.[6] The region's rolling countryside, fields bordered by stone walls, meandering streams, and picturesque houses were the favorite subjects of the many local painters. Silvermine offered Gutmann a community of like-minded artists, as well as the peace and pastoral beauty he had found in Holland twenty years before. It was also an ideal place for a young family to settle. The Gutmanns proceeded to build a large, comfortable house on their new property, where they lived from the time it was completed in 1915 until their deaths in 1936. Even today Silvermine retains its beautiful graceful contours and picturesque rural charms.

Safely shielded from the horrors of war that were beginning to haunt Europe, Gutmann saw his career begin to flourish following his participation in

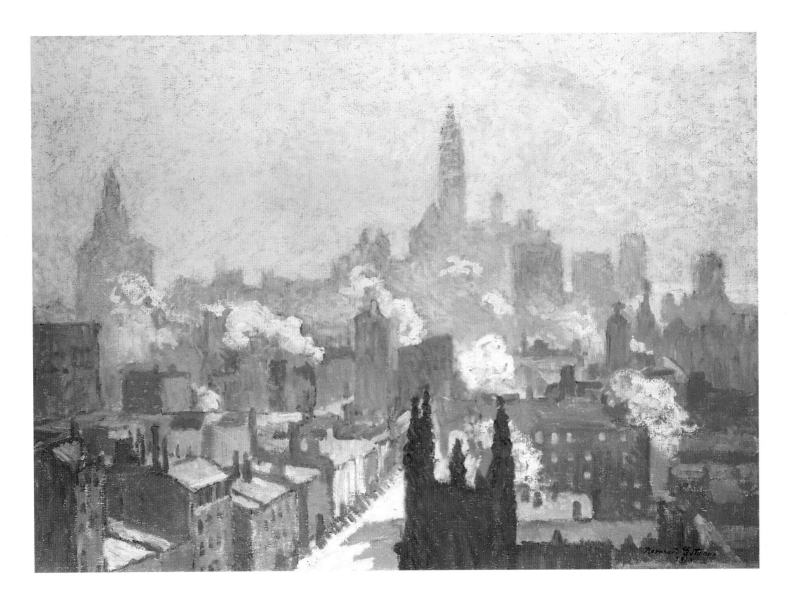

47. TWO TOWERS, NEW YORK, *1913*
Oil on canvas, 23½ x 31⅞ in. (59.7 x 81 cm)
Lyn and Michael Citron

Opposite:
48. HORSE-DRAWN ICE WAGON, *n.d.*
Etching, 10⅜ x 7⅞ in. (26.4 x 20 cm)
DeVille Galleries, Los Angeles

the Armory Show. In March 1914 thirty-five of his paintings were shown in his first solo exhibition at New York's Arlington Art Galleries.[7] The exhibition had been announced the previous month in an article about Gutmann in the prestigious journal *International Studio* and was primarily comprised of paintings Gutmann had produced in Europe, with a large selection of Breton subjects.[8] The generic titles that were listed in the exhibition brochure make it difficult to identify the specific paintings that were included, but *"Fishing Boats"* and *"Girls by the Sea"* are probably the same paintings (*Breton Fishing Boats* and *Breton Lacemakers*[9]) that Gutmann had exhibited the previous year.

The Arlington exhibition was really a retrospective, offering an overview of Gutmann's favorite subjects, including portraits, genre scenes, landscapes, urban views, and several nudes. In both *Two Towers, New York* (fig. 47) and *Bird's Eye View, Paris* (fig. 34), Gutmann addressed the current fascination with the shape and structure of the modern, high-rise city. Paris and New

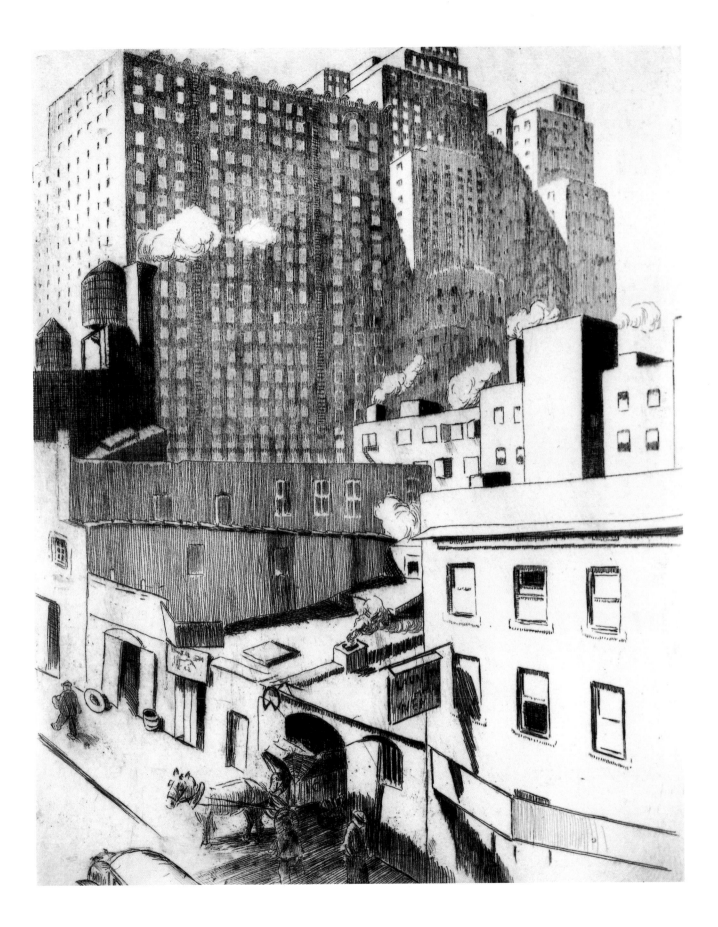

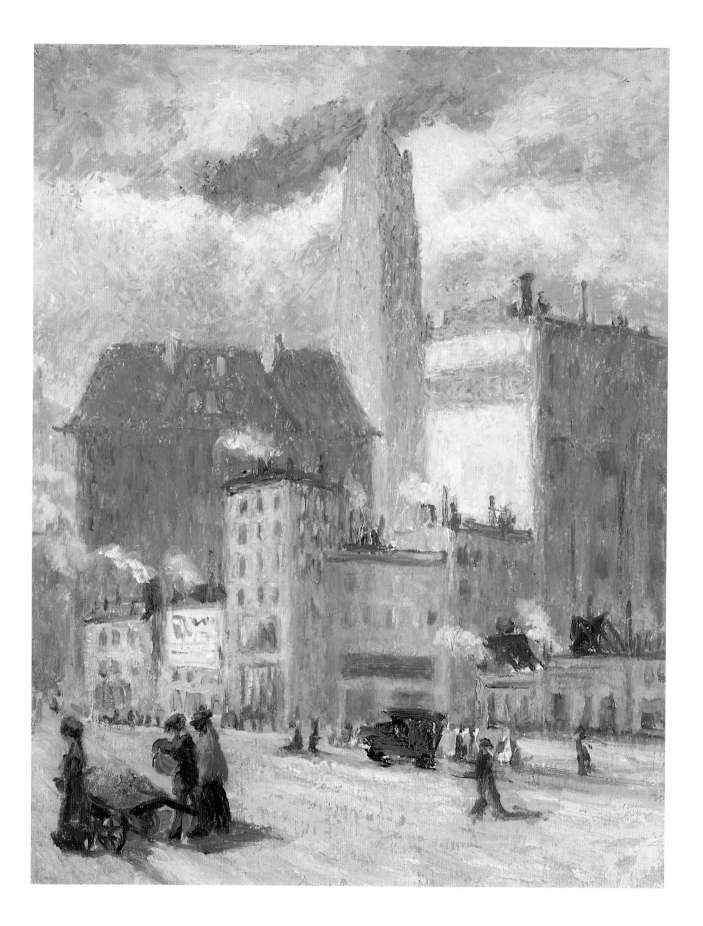

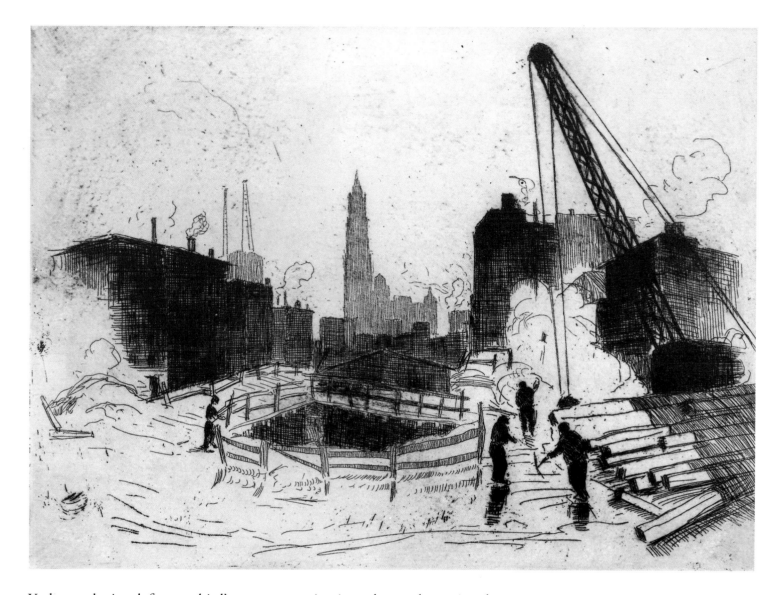

50. DIGGING SUBWAY, NEW YORK CITY, *n.d.*
Etching, 7 x 8⅞ in. (17.8 x 22.5 cm)
DeVille Galleries, Los Angeles

York are depicted from a bird's-eye perspective in order to dramatize the breadth of the cityscape, as if being seen from the vantage point of another tall building. Manhattan was becoming a popular subject among pictorial photographers and modernist painters such as Alfred Stieglitz, A.L. Coburn, John Marin, and Max Weber, who saw the city as an emblem of the vibrancy and excitement of the new, technological age. Gutmann's city paintings, however, are closer in spirit and style to older Impressionist cityscapes than they are to modernist views of the urban environment; he uses pastel hues and small brushstrokes, and emphasizes the play of light. Gutmann explored the city in greater depth in a series of etchings that recall realist interpretations by graphic artists such as Martin Lewis and John Taylor Arms. His city pictures mark an unusual, brief detour in his oeuvre; they link him to younger urban artists such as Weber and Marin, who were beginning to attract considerable attention.

Opposite:
49. EAST SIDE FLOWER VENDOR, N.Y., *n.d.*
Oil on canvas, 22⅛ x 18⅛ in. (56.2 x 46 cm)
Private collection

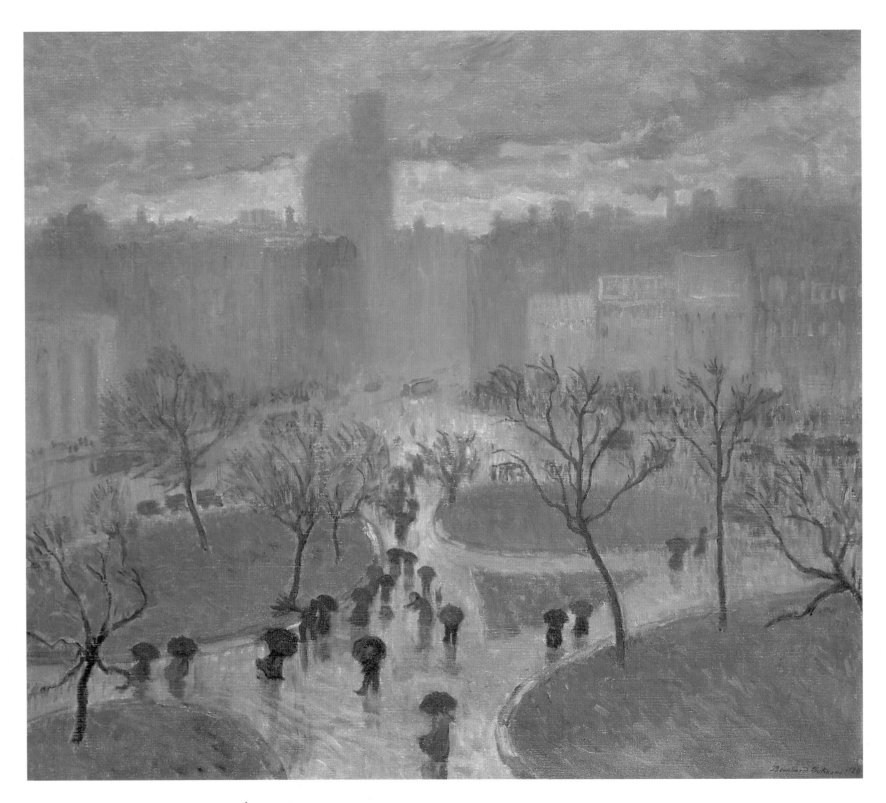

51. UNION SQUARE DURING STORM, *n.d.*
Oil on canvas, 33 x 37 in. (83.8 x 94 cm)
Michael Feddersen

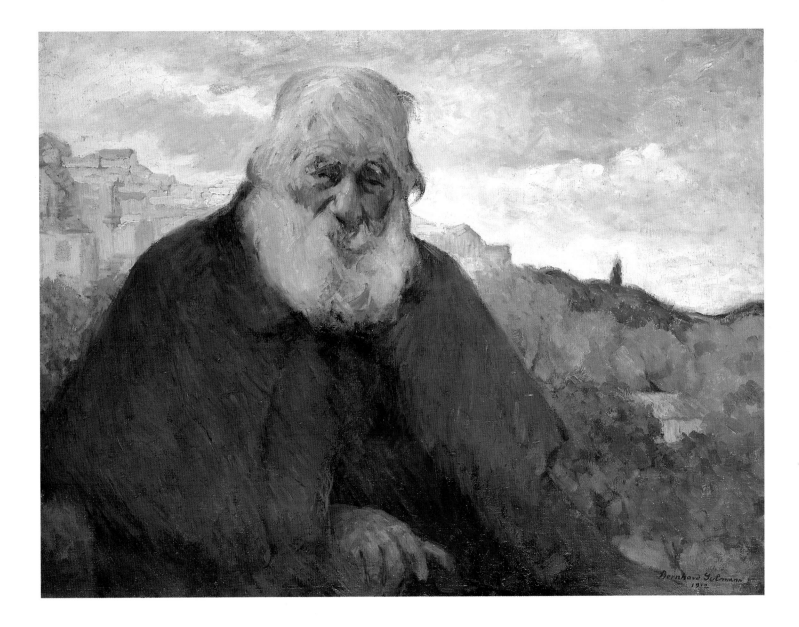

Old Shepherd—Bordighera (fig. 52), one of Gutmann's works that was illustrated in the *International Studio* article, is a departure from Gutmann's emotionally distanced images of Paris and New York. This large painting, which hovers between a portrait and a genre scene, expresses a deep sympathy for the aging man. The grizzled peasant looks exhausted from years of physical toil; his rough, triangular shape blends into the hillside so that he literally becomes part of the landscape. This theme of rural work—and of the toll it extracts from the poor—contrasts sharply with the artist's own comfortable life. But Gutmann valued hard work, both physical and mental, and thus may have seen the old man as a symbol of venerable age and universal experience. *The Old Shepherd* also represents Gutmann's vision of life as a struggle against the inevitable wear of time.

52. OLD SHEPHERD BORDIGHERA, *1912*
Oil on canvas, 25¾ x 32⅛ in. (65.4 x 81.6 cm)
Private collection

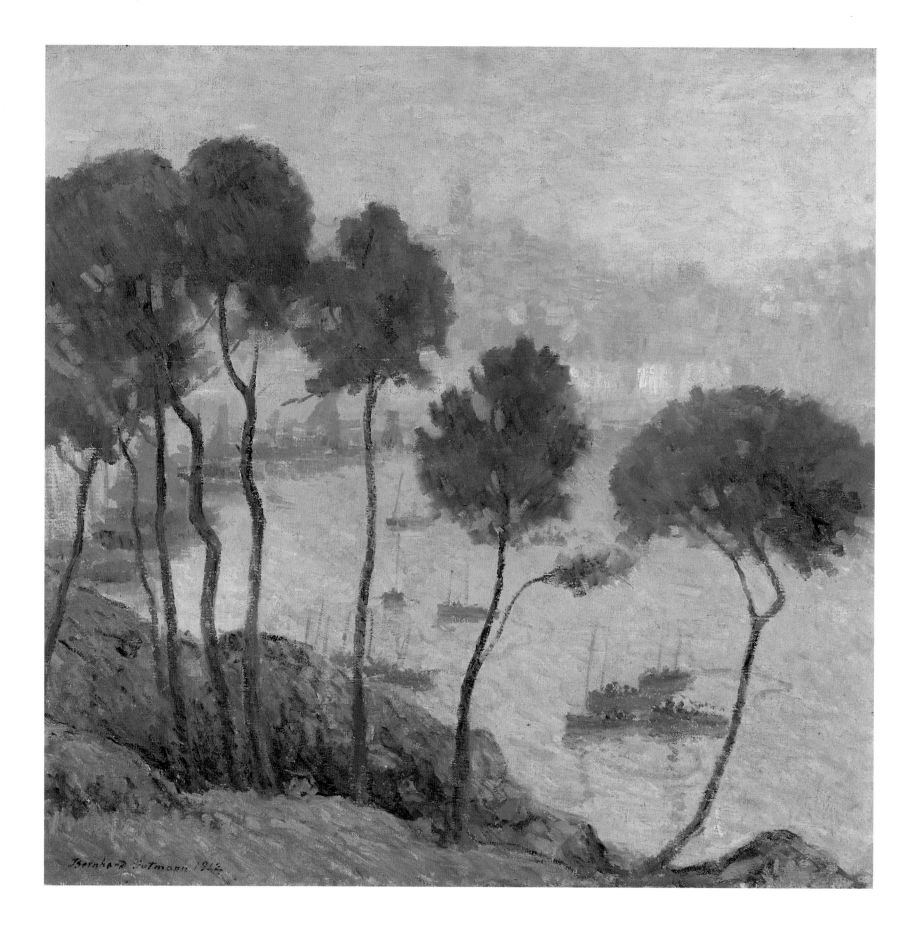

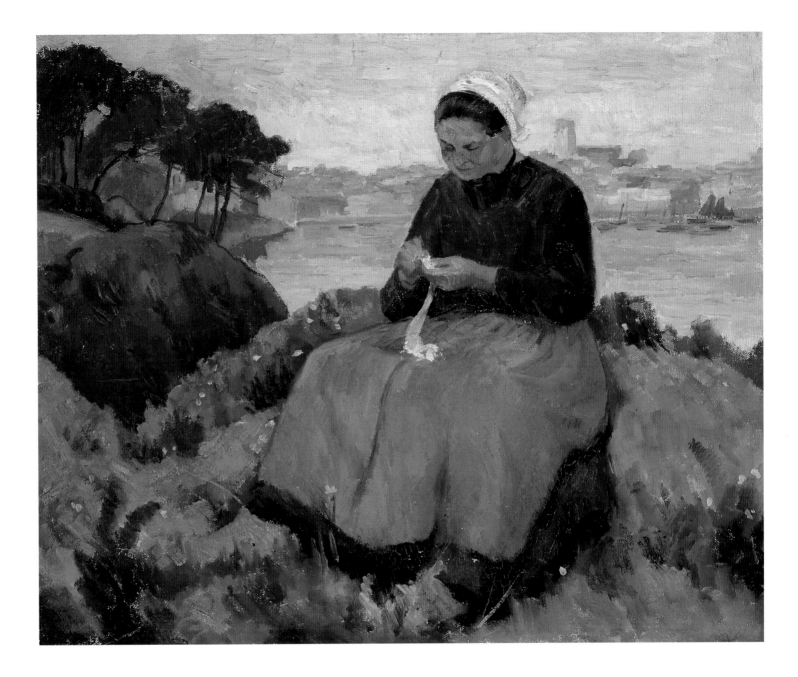

Harbor from the Hill (fig. 53), which was illustrated in the *International Studio* article as *Blue Mist,* reveals important aspects of Gutmann's working methods. In the composition, a screen of trees descending a hillside offers a glimpse of a town beyond a harbor full of boats. This captivating and complex landscape exists in several variations, in one case acting as the backdrop to a Breton peasant woman crocheting (fig. 54). A preparatory drawing for this work, now in the estate of Dorothea Gutmann Mollenhauer, bears the simple inscription "Douarnenez."[10] The title *Blue Mist* suggests a soft, Impressionist treatment of the scene, such as the one in *Harbor View* (fig. 55), a painting of this same subject with a slight variation in the configuration of the trees.

54. OLD LACEMAKER, BRITTANY, *n.d.*
Oil on canvas, 18 x 21¼ in. (45.7 x 54 cm)
Private collection

Opposite:
53. HARBOR FROM THE HILL, *1912*
Oil on canvas, 27⅞ x 27⅞ in. (70.8 x 70.8 cm)
Lyn and Michael Citron

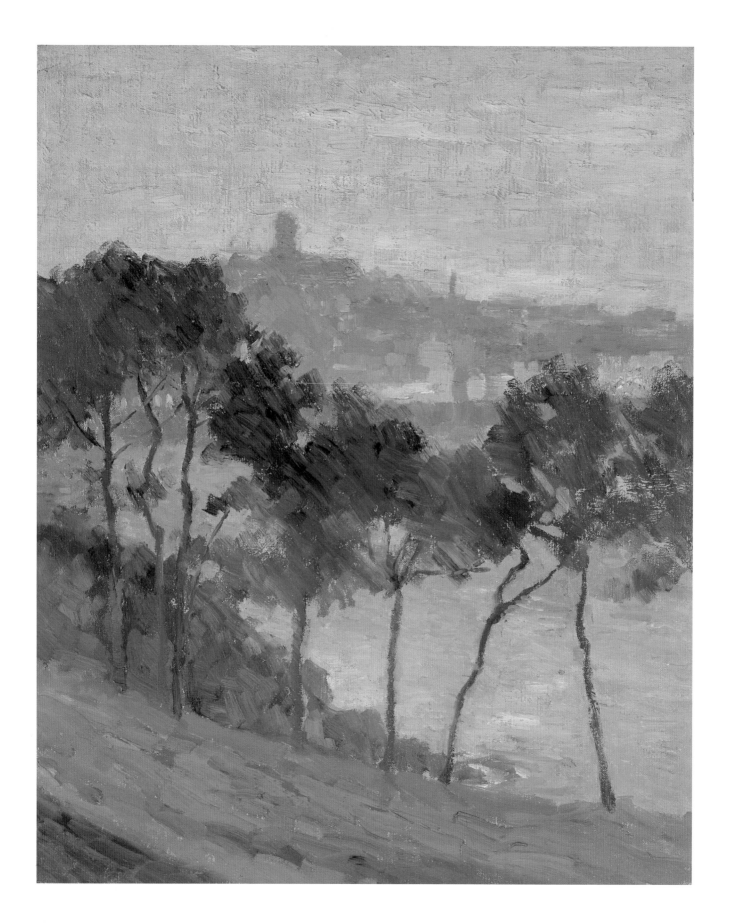

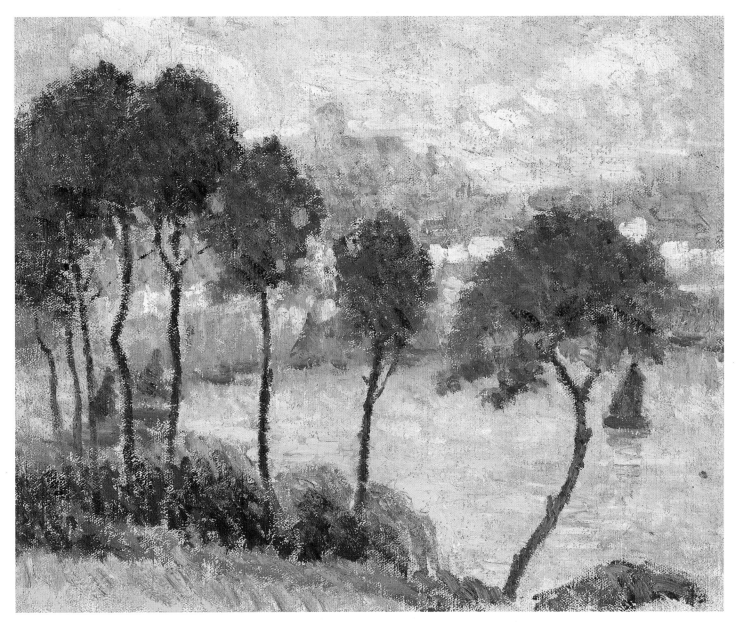

And there is a smaller oil sketch of this view rendered in looser strokes of brighter colors (fig. 56).[11] Gutmann obviously tried several variations on this striking motif in order to produce different moods: the hazy vista is more poetic and introspective than the more dynamic, vividly colored one. Gutmann was evidently searching for the appropriate tones to suit the image in a variety of interpretations. Although the brochure from the exhibition does not provide any dates, Gutmann was in Douarnenez in 1910 and probably began this series then. As was his usual practice, he made the sketches on location, then completed the final paintings in his Paris studio.

Gutmann's *Nude with Parrot* (fig. 57) was identified in the exhibition brochure simply as *A Nude,* and was mentioned in several reviews of the show. The mournful female figure reclining on a bed and staring at a parrot, who

56. AFTERNOON, *n.d.*
Oil on canvas, 13 x 16 in. (33 x 40.6 cm)
Private collection

Opposite:
55. HARBOR VIEW, *n.d.*
Oil on wood, 18 x 14½ in. (45.7 x 36.8 cm)
Private collection

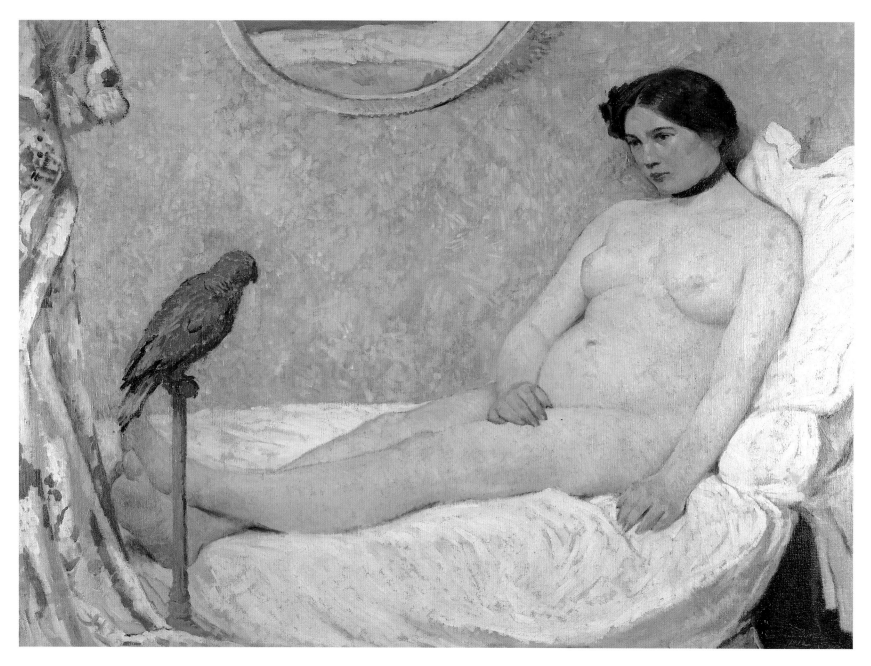

57. NUDE WITH PARROT, *1912*
Oil on canvas, 37 x 49 in. (94 x 124.5 cm)
Joseph Ambrose

sits on a perch at her feet, recalls the subject, pose, and shadowless technique that Edouard Manet used in *Olympia* (1863), as well as the theme of Gustave Courbet's *Nude with Parrot* (1866). However, Gutmann's large-scale interpretation of this subject represents a more demure response to the subject than the earlier works by the well-known French artists Courbet and Manet. Gutmann used a large canvas for this traditional studio subject, indicating how important he considered this work, but he did not make an extensive exploration of the genre. Nudes do not constitute a major facet of his work, although he continued to paint them throughout his career—*Dark Dreams* (fig. 111) and *Nude with Drapery* (fig. 109) are two late examples.

> In landscape he is unmistakably more at home and there on occasion he paints a capital picture, as in *Evening Bordigerra* [*sic*] (No. 16) which stays in the mind as a good composition and a shrewd study of broken lights.[12]

The brochure lists two paintings as *Evening Bordighera*, as well as a work called *Morning Bordighera*. The subject is an Italian hill town that Gutmann visited for several months in 1912 just prior to his return to the United States. It's easy to see why this compelling image of a haunting architectural structure framing a blazing green and yellow sunset so impressed this commentator.[13] The critic for the *Brooklyn Daily Eagle* identified Gutmann's scene of fishing boats in the harbor of Douarnenez as his favorite painting in the exhibition. Gutmann's landscapes and seascapes are truly the most graphically striking and impressive of his works; it is intriguing to speculate about why Gutmann ignored the praise these paintings garnered from contemporary critics when he chose his submissions for other exhibitions. The reviewer for the *New York Tribune* gave a particularly inspiring assessment of Gutmann's display at the Arlington Art Galleries:

> His work, first and last discloses ability and a fine, buoyant spirit. He is, we believe, of the type that grows, and his paintings in the future will be looked for with interest.[14]

In 1914 Gutmann was represented in the Corcoran Gallery of Art's biennial exhibition by *Breton Baby*,[15] and he exhibited a portrait of his daughter Elizabeth at the National Academy of Design. Although the academy had been the most prestigious exhibiting organization in the United States during the nineteenth century, by the late 1890s it was considered staid and old-fashioned, even by the American Impressionists. Yet Gutmann's work, so appealing and versatile, was evidently acceptable in many diverse arenas. Moreover, in Silvermine, Gutmann had met the English-born artist Hamilton Hamilton (1847–

58. EVENING, BORDIGHERA, *n.d.*
Oil on wood, 7¼ x 9½ in. (18.4 x 24.1 cm)
Private collection

1928), whose contacts as a member of the National Academy may have facilitated Gutmann's inclusion in the show there. As a gesture of friendship, Gutmann painted Hamilton's portrait (fig. 60) that year, depicting the older artist in an elegant brocaded chair that was among Gutmann's many lavish studio props.[16] Hamilton had studied with John Ruskin at Oxford, and his aesthetic philosophy would have been sympathetic to Gutmann's view of art as an instrument and expression of beauty. Their friendship and professional association lasted until Hamilton's death in 1928.

Gutmann continued his active exhibition schedule the following year, receiving more favorable reviews. In January his work was included in a small group show of seven painters and two sculptors at the MacDowell Club in Manhattan, an artists' organization founded in 1906. Like the Salmagundi Club, where Gutmann was a member, the MacDowell Club had strong ties to various New York galleries and encouraged the sale of members' works. Despite the relatively small scale of the exhibition, Gutmann's work was overlooked in a review of the show, but descriptions of work by other participating artists indicate that they were similar to Gutmann's in style and subject. His painting *Downhill* was featured in the Art Institute of Chicago's 1915 annual exhibition.

When he moved to Silvermine, Gutmann joined a select group of local artists known as the Knockers because of the biting critiques they gave each other's work. The Knockers met in the studio of Gutmann's neighbor, the sculptor Solon Borglum. Gutmann's acceptance by this exclusive group is evi-

59. BORDIGHERA, SUNSET, *1912*
Oil on canvas, 23¼ x 31¼ in. (59.1 x 79.4 cm)
Private collection

dence of his reputation and his standing in the local artistic community. In September Gutmann exhibited *Bashful,* a recent portrait of his daughter, and *Carnations in White Vase* (fig. 61) in the eighth annual Knockers exhibition, held in Borglum's studio, where the group had been exhibiting since 1908. That Gutmann submitted a child's portrait and a still life—"safe" and popular images—may indicate that he was hoping to attract attention or sales.

Gutmann participated in the most important international art exhibition of 1915. The Panama-Pacific International Exposition in San Francisco celebrated the opening of the Panama Canal and the phoenixlike revitalization of San Francisco that had taken place following the devastating 1906 earthquake. Unlike the more radical Armory Show of 1913, the Panama-Pacific Exposition was a showcase for American Impressionism. As William Gerdts explains in an essay on American Impressionism:

There Impressionist painters from Old Lyme to San Diego were out in force, and some artists such as Hassam, Twachtman, Tarbell, and Chase were given whole rooms to themselves. By this time Impressionism was the dominant mode throughout the country though more so in some areas, such as much of the Northeast, the Midwest, Utah and California, than in the South or the Northwest. Regional distinctions would seem to be based on subject matter rather than style.[17]

Gutmann's submission, listed in the catalog as *A Nude,* was probably *Nude with Parrot.* His decision to send the nude may have been prompted by the attention it received in New York, or his own belief in the importance of the work, despite the rather negative reaction that it had drawn from the New York critics. Nudes were clearly still very popular and well received: Frederick Frieseke's (1874–1939) *Summer,* an erotic nude improbably luxuriating in dappled sunlight under a tree, won the grand prize for painting and was one of the few paintings illustrated in the exhibition catalog.[18] The catalog listed Gutmann's birth in Hamburg and his training at Düsseldorf and Karlsruhe, thus presenting him more as a German than as an American artist at a time of rising anti-German sentiment. Gutmann would later overcome the negative shadow cast by his German heritage by aiding in the war effort for the Allied cause.

In 1915 Bernhard and Bertha moved their family into Gray Rocks, the large white house in Silvermine that became their permanent home and source of comfort. Building the house inspired Gutmann's creative instincts; both the house and the gardens provided subject matter for his work during the remainder of his life. He painted portraits of the house as he did the members of his family, and used the interior and exterior in a variety of settings and interpretations. *The Old House* (fig. 62) presents an evocative glimpse of the house under a protective canopy of massive trees, and *Gardens, Silvermine* (fig. 63) captures the expansive beauty of the gardens. *On the Terrace* (fig. 64) is an intriguing combination of landscape and still life: the view sweeps down from the terrace across the lawn and garden, yet instead of depicting flowers growing naturally in the landscape, Gutmann shows them cut, tamed, and artfully arranged in a vase on the table. The image calls attention to the element of artifice that is an intrinsic part of creating a work of art—as in a painting or a cultivated garden designed for display.

Whereas Europe fulfilled Gutmann's wanderlust, Connecticut represented stability for him. His home in Silvermine was his Eden, isolated from the cares of the world. Ascetic German that he was, he reveled in the opportunity to swim during all seasons in the dammed pond on his property, which also became a subject of his paintings (fig. 66). In addition to their Connecticut home, the Gutmanns had access to the Goldmans' Adirondack camp in Keene

Opposite:
60. HAMILTON HAMILTON, *1919*
Oil on canvas, 32 x 26 in. (81.3 x 66 cm)
Private collection

Valley (fig. 65). The Gutmanns visited frequently, and the Adirondacks provided the artist with a different, more rugged landscape to paint than the rolling hills of Connecticut.

In Silvermine, Gutmann designed a private sanctuary filled with exotic artistic trappings—the perfect working environment for an artist who saw himself as a successor to the nineteenth-century academic studio painters with their traditions and practices. In a memoir written late in her life, Dorothea Gutmann Mollenhauer described her father's studio and his working method:

My father's studio looked nothing like a workroom. It was one of the most elegantly appointed rooms of the house—nor did Dad wear a smock or old clothes. When he went into work in the morning he would simply turn back one corner of the Persian rug and roll one of his two easels into place and all was set. His was like a Renaissance studio, with treasures collected from all countries and ages, and he loved using all of them in his paintings: an Aubuisson [*sic*] couch, ancient Egyptian musical instruments, Chinese porcelains, Gob[e]lin tapestries and carved Renaissance chairs, etc. With all this his big black etching press faded into the background as a grand piano will in a large, elaborate drawing room.[19]

63. GARDENS, SILVERMINE, *n.d.*
Oil on canvas, 15 x 17¾ in. (38.1 x 45.1 cm)
Michael Feddersen

Opposite:
64. ON THE TERRACE, *1916*
Oil on canvas, 38 x 33 in. (96.5 x 83.8 cm)
Lyn and Michael Citron

65. TALL BIRCHES, KEENE VALLEY, *n.d.*
Oil on wood, 13¾ x 10½ in. (34.9 x 26.7 cm)
Private collection

Opposite:
66. SUNLIT POOL, *n.d.*
Oil on canvas, 28¼ x 28¼ in. (71.8 x 71.8 cm)
Joseph Ambrose

Gutmann's studio was truly an aesthetic enterprise, for it served as both muse and locus of inspiration. Decorated like a drawing room, with elegant carpets, furniture, bibelots, and pictures, it was a self-conscious work of art. It also represented the fulfillment of Gutmann's youthful dreams about the artistic life as expressed in his first painting, *Leisure Hours in the Studio.* Gutmann's working method reflected the precision and care of his well-appointed studio; his finished paintings demonstrate the concern for craft, finish, and polish stressed by the German schools where he first learned and adopted the values of the academic tradition.

The spring after he moved into his Connecticut house, Gutmann exhibited some of his Brittany paintings, along with *The Breakfast Room* (fig. 67), in a show sponsored by the Allied Artists of America at the Fine Arts Galleries in New York, along with most of his Silvermine colleagues. The critic for the *New York Globe* said he was

impressed by the predominance of colorful and high keyed pictures. This is the trend of the younger painters, of which the society is largely composed. The dark interiors of the past—the browns and dingy tones —are being superceded by the bright sunlight of outdoors. It would be hard to define the salient characteristics of the exhibition, but there is no note of what is now termed "modern art."[20]

Gutmann's abandonment of the dark Düsseldorf style for sparkling color and light clearly allied his work with that of his Impressionist-inspired colleagues. None of the Silvermine group, it appears, were interested in the new, more abstract "revolutionary" style of the emerging modernists.

The Breakfast Room was singled out in another review of the exhibition as the most studied of Gutmann's work. It was Gutmann's first major homage to his new home, as well as a synthesis of the major themes he was exploring and a reprise of *In the Garden,* his entry in the Armory Show. This multilayered work is at once a family portrait of Bertha and six-year-old Elizabeth, an elegant domestic interior, a still life of flowers, and a view of a landscape seen from indoors.[21] The presence of the artist is implied by the extra plate, glass, and empty chair placed between the adult and the child. The painting describes the domestic joy that defined this phase of Gutmann's life in Connecticut. In addition, the subject matter and the emphasis on patterns of sunlight and sparkling color link this painting to contemporaneous works by other American artists working in the Impressionist vein.

The Breakfast Room was a major touchstone in Gutmann's career. He exhibited it frequently, and it remains in the artist's family. It was included in Gutmann's one-person show at the Folsom Galleries in 1920 (when it received a mention in the *New York Globe*), and was exhibited in 1926 as *The Breakfast*

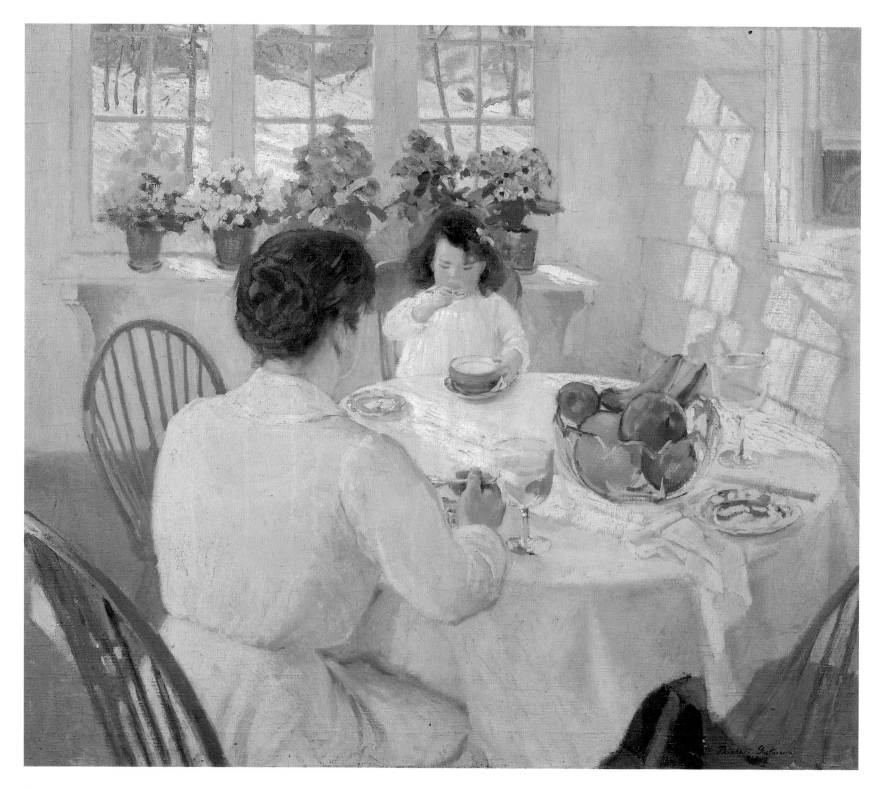

67. THE BREAKFAST ROOM, *1916*
Oil on canvas, 33¼ x 37¼ in. (84.5 x 94.6 cm)
Theodore Lehmann II

Hour. In February 1933 *The Breakfast Room* was featured on the cover of *Literary Digest.*[22] This painting may have also been the work that Gutmann submitted to the annual exhibition at the Art Institute of Chicago in 1916, the same year it was first shown in New York; the listing in the Art Institute's catalog identifies Gutmann's entry as *The Sun Parlor.* In many ways this painting offers a summation of Gutmann's artistic ideas.

His daughter is taking sustenance from food, as the artist receives aesthetic nourishment from the scene before him. The event takes place during winter, and the figures are indoors, yet the room is flooded with glorious natural light that streams in through the large windows of the sun porch. The jagged patterns of light reflected onto the side wall of the room indicate the passage of time, and despite the dormant season, brilliant red geraniums are flowering nearby. The combination of interior and exterior views serves as a metaphor for the artist's perspective; he is engulfed in a reflective, contemplative state as he actively observes and records the outside world. The child represents Gutmann's future, and the luscious bowl of fruit is a sign of the abundance of his family's life. Despite the rather obvious symbolic overtones of so simple a scene, depictions of children eating, popularized by Bessie Pease Gutmann for the Gutmann and Gutmann printing firm, found many eager buyers.

The innocence and simplicity of childhood continued to intrigue Gutmann, and he returned to this theme in another portrait of Elizabeth seated in a large armchair, eating from a bowl. Here the elegant brocaded chair, more magisterial than it appears in Gutmann's portrait of Hamilton Hamilton, dwarfs the child, so that the image emphasizes the role of nourishment in transforming the child into an adult. In a letter to Elizabeth dated May 1, 1917, Gutmann sent her a drawing of this portrait, noting that it was the favorite painting from among a group of works he had recently exhibited in Ohio.

In April 1917 Gutmann participated in the first annual exhibition sponsored by the Society of Independent Artists, an organization that included a number of the more progressive modern artists who had become notorious since the 1913 Armory Show. Conceived as a challenge to juried exhibitions such as those held by the traditional National Academy of Design, the Society of Independent Artists (which Gutmann joined) opened their exhibitions to all participants for a nominal entry fee. Their credo was "No jury, no prizes." Thus the range of style, subject, medium, and especially quality was vast. Marcel Duchamp once again provided a scandal by submitting a urinal, entitled *Fountain* and signed "R. Mutt." A furor ensued over the suitability of the entry: it was deemed unseemly, if not obscene, and was thought to be offensive to female viewers. The artist's participation in the creation of the work was also questioned. The urinal mysteriously disappeared after being hidden behind a curtain to avoid undue offense. The removal of the work

68. BALLERINA, *n.d.*
Oil on canvas, 18 x 15 in. (45.7 x 38.1 cm)
Private collection

sparked a heated philosophical controversy concerning the role of the artist and the true nature of art, questions which Gutmann and his Impressionist colleagues did not deem worthy of acute investigation. They believed that painting was an art derived from nature and were not interested in pushing the boundaries or definitions of art itself. Although Gutmann's work had advanced beyond pure academicism, it was far more conservative than the avant-garde productions of the more radical members of the Independents, such as Duchamp and Max Weber. Nevertheless, the Independents exhibition encouraged the juxtaposition of wildly disparate works of art to demonstrate the breadth of art being produced in the United States. The New York critics, at this point, still firmly supported the traditionalists, with only a few rare exceptions.

The coexistence of a broad range of styles, themes, media, and subjects characterizes not only the independent exhibitions at the beginning of the century but the twentieth century as a whole. The burgeoning—especially toward the middle of the century—of the middle class, with its subsequent increase of disposable income, facilitated a plethora of artistic endeavors, with different types of works appealing to various interests. While the avant-garde attracted and still attracts major media attention and gallery and museum space today, traditional painters of narrative subjects and colorists concerned with the theories of Impressionism have continued to flourish.

The following year, Gutmann's "outdoor nude with decorative landscape" was noted in the press as one of "a few paintings and pieces of sculpture [that] stand out and relieve the monotony"[23] in the Society of Independent Artists' next exhibition. Gutmann's two entries were listed as *Two Creeds* and *Falling Leaves,* neither of which immediately suggests a figurative work. It is possible that Gutmann made a substitution or addition to the show, and while there are no specific descriptions of the nude that he exhibited, *Nymphs with Crows* (fig. 70) is a likely candidate. An outdoor sequel to *Nude with Parrot,* it is richer in color and freer in spirit than the earlier, more artificial indoor nude, and would have been better suited to the lively Independents exhibition. A critic for the *New York Globe* assessed the exhibition in a manner that would have appealed to Gutmann:

> The inevitable joker is represented and one notes touches of Cubism, Futurism, vorticism and all the other isms as well as the plain academic, but what weighs sorely upon the visitor is the preponderance of efforts by half baked artists and amateurs and those who seemingly never painted before but take themselves seriously and buoyed up by the knowledge that paying a fee will entitle them to space have "expressed" themselves on canvas or in the plastic medium.[24]

Opposite:
69. BABY ELIZABETH, *1914*
Oil on canvas, 32 x 26 in. (81.3 x 66 cm)
Private collection

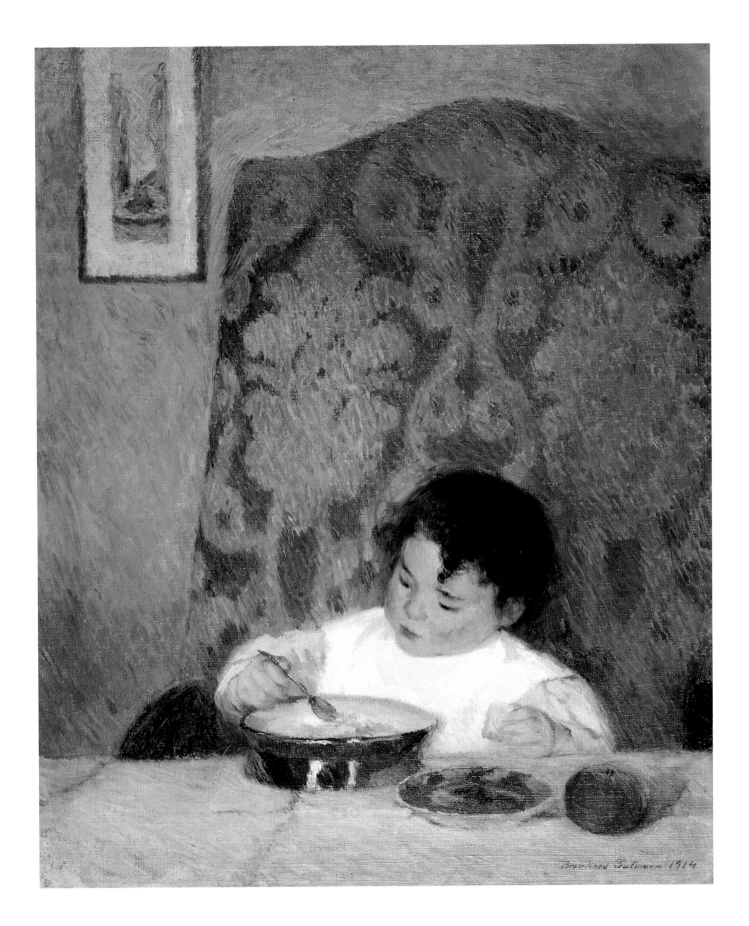

70. NYMPHS WITH CROWS, *n.d.*
Oil on wood, 10⅜ x 14 in. (26.4 x 35.6 cm)
Private collection

During 1917 and 1918, while the United States was at war with Germany, it was politically inadvisable to speak German or to have German ties. The guns of August 1914 had been a signal to the Gutmanns that they had left Europe at the right time and that Bernhard had chosen wisely in becoming a United States citizen. Even though many members of the Gutmann family were still in Germany, the artist proclaimed a patriotic allegiance to his adopted country and contributed generously to the war effort. In 1918 he donated what a journalist for the *New York Globe* described as a notable painting and typical Gutmann work to the Great Allied Bazaar, where 175 paintings were sold to benefit the Allied cause.[25]

Gutmann was probably also the motivating force behind a production put on by the junior members of the Silvermine Players on August 17, 1918, at his home, Gray Rocks. Two original plays were performed as a benefit for the Red

71. ROLLING LANDSCAPE, *1912*
Oil on canvas, 25½ x 31½ in. (64.8 x 80 cm)
Private collection

72. HETTY GOLDMAN, *n.d.*
Oil on canvas, 24 x 20 in. (61 x 50.8 cm)
Joseph Ambrose

73. KNIFE AND APPLES, *n.d.*
Oil on canvas, 13¾ x 12¾ in. (34.9 x 32.4 cm)
Joseph Ambrose

Cross, for which Bertha's sister, Hetty Goldman, was then working in Greece. Gutmann himself loved all aspects of the theater, and he designed the costumes and properties for both productions. His daughter Elizabeth played a leprechaun in the performance entitled "s'liveD neD tocsaM," a mirror reversal of "Devil's Den Mascot." The puzzling title was presumably inscribed on the play leaflet to arouse the curiosity of the young audience.

On Saturday, September 18, 1918, Gutmann painted a "liberty loan" hourglass and a portrait of Uncle Sam in front of the Town Hall in New Canaan to record contributions to the war debt.[26] Gutmann painted the work on-site in order to entice donations, and his community service made him a well-respected citizen of New Canaan.

Gutmann exhibited with the Independents again in 1919, submitting works entitled *Black and White* and *Sun Spots,* neither of which have been definitively identified in his existing oeuvre. It is frequently difficult today to determine even the subjects of Gutmann's work from the scant information of the titles and the lack of dates. Early in 1919 Gutmann's *Flowers* (fig. 74) was included in the sixth exhibition of the Allied Artists of America, another organization he had joined. Of the 316 paintings and twenty-two sculptures shown at the Fine Arts Galleries on Fifty-seventh Street, Gutmann's work was singled

74. STILL LIFE/ROUND BOWL WITH
FLOWERS, *n.d.*
Oil on canvas, 33 x 37 in. (83.8 x 94 cm)
Private collection

out by W. G. Bowdoin in the *New York World* as "an attractive bit of still life, which is painted in high but well chosen colors. The copper of the container is well done."[27] Gutmann's still lifes continued to attract favorable commentary throughout his career, and he became highly regarded for the range and virtuosity of his floral paintings.

On November 5, 1919, Gutmann's second daughter, Dorothea Hetty, was born. With the end of World War I Gutmann was setting his sights on Europe again; much as he delighted in his Connecticut home, Gutmann craved more variety in his life. He had firmly established himself as a reputable painter with a following among dealers, critics, collectors, and fellow artists. Now he wanted to explore the world and expand on his amalgamation of Impressionist and Post-Impressionist techniques.

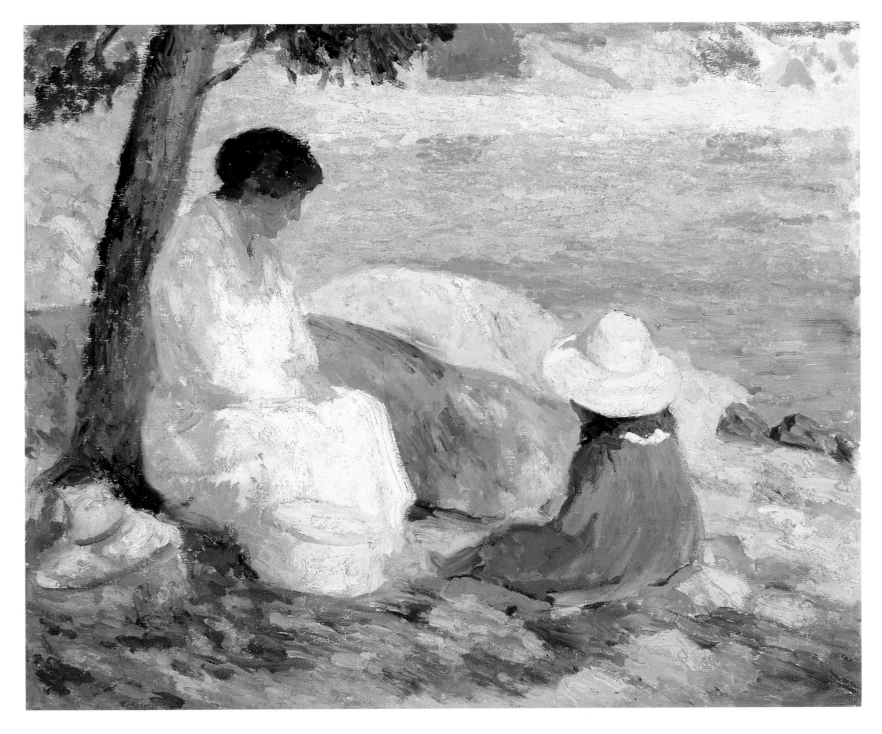

75. WOMAN AND CHILD BY THE SEA
(MALLORCA), *n.d.*
Oil on wood, 15 x 18⅛ in. (38.1 x 46 cm)
Private collection

4 *The Wander Years*

NINETEEN TWENTY was a banner year for Bernhard Gutmann: he was fifty years old, the father of two daughters, and as an artist, his star was ascending. In the thirteen years since his marriage he had achieved a national reputation as a painter, had moved into a beautiful home, and was surrounded by loving family and friends. Yet his fifties brought out a restlessness in Gutmann, a discontent with the peaceful orderliness of his life. To alleviate his boredom, he began taking numerous trips that provided him with new subjects to paint,[1] and since Gutmann's subject matter was largely determined by his locale, his travels provided him with new landscapes, rituals, and exotic characters to depict. During the 1920s Gutmann's oeuvre veered between scenes of home and abroad—the safe and secure versus the exotic and foreign. Gutmann's fascination with the unfamiliar is most vividly illustrated in his paintings of ritual processions in Spain and of dancers, street musicians, and ancient temples in Egypt.

In January 1920 Gutmann was given another one-person exhibition at the Folsom Galleries, a show that earned him four reviews in the New York papers. Critics praised Gutmann's use of brilliant color, and they were particularly impressed by his flower paintings. The reviewer for the *New York Globe* admired "Dahlias, phlox, peonies and other familiar friends of the summer garden, in an entertaining variety of arrangements."[2] A notice in the *New York American* read:

> Two are exceptionally good—"Flox" [*sic*] whose waxen quality harmonizes with the lacquer-like screen background, and "Flowers in a Brass Bowl," whose colors are flowing and supple. In "Sunlit Curtain" the art-

(detail)
86. THE IMITATION ARAB (GUTMANN IN FLORIDA), *c. 1921–22*
Movie still

Opposite:
(detail)
76. TOLEDO ROOFTOPS, *n.d.*
Oil on wood, 15 x 18⅛ in. (38.1 x 46 cm)
Private collection

119

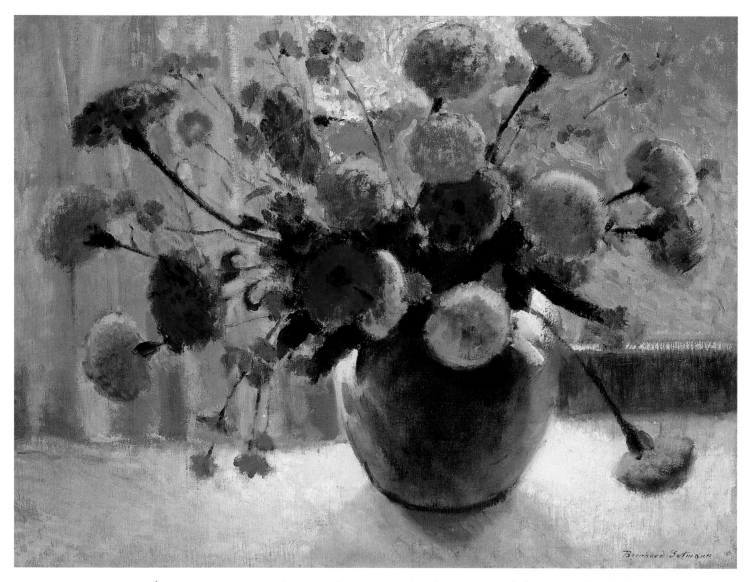

77. VASE OF ZINNIAS, *n.d.*
Oil on canvas, 18¾ x 24 in. (47.6 x 61 cm)
Private collection

ist must be congratulated on accomplishing a difficult feat in handling light. On a table is a porcelain bowl filled with flowers, bathed in the softly glowing rays that filter through a curtain.[3]

Sunlit Curtain was singled out by each of the critics as the best painting in the exhibition. The reviewer for the *New York Evening Sun* commented, "It has slightly Japanese suggestiveness which raises it above the level of his other flower pieces."[4] Evidently, Gutmann continued to emulate the Impressionist interest in Japonisme that he had adopted during his initial visit to Paris.

Sunlit Curtain typifies the Gutmann still life. The artist frequently positioned a vase of flowers on a table in front of a window, thereby framing the artful arrangement against the natural world outside, although in this instance the landscape beyond is hidden by a curtain. An avid gardener, Gut-

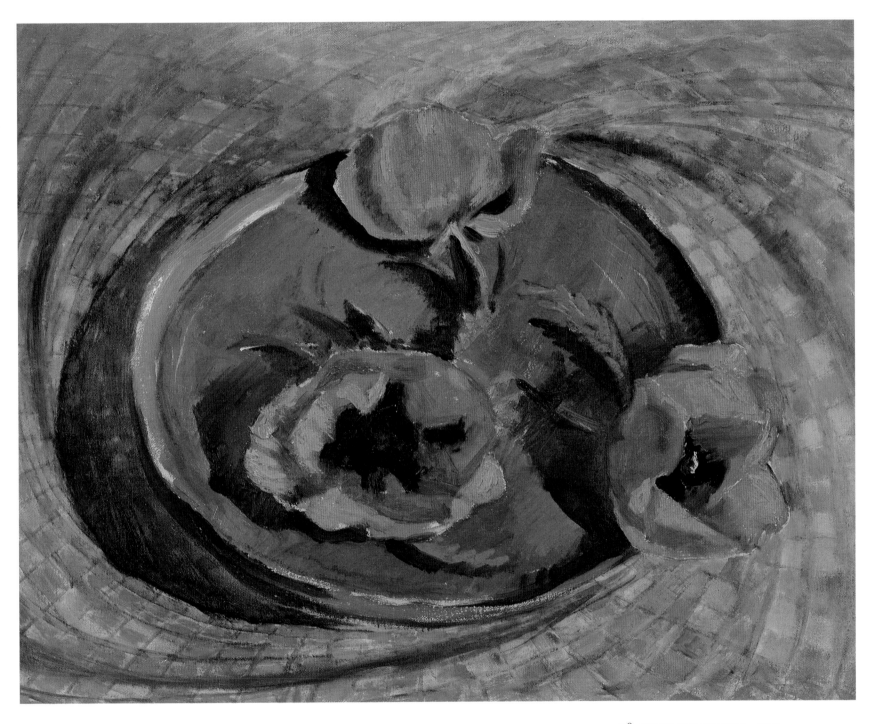

78. WHIRLING POPPIES, *1927*
Oil on canvas, 18 x 22 in. (45.7 x 55.9 cm)
Theodore Lehmann II

79. ELIZABETH PLAYING
WITH HER DOLLS, *n.d.*
Oil on canvas, 12⅛ x 14¼ in. (30.8 x 36.2 cm)
Lyn and Michael Citron

Opposite:
(detail)
80. DOLLS AND TOY CAT IN WINDOW, *n.d.*
Oil on canvas, 16 x 20 in. (40.6 x 50.8 cm)
Private collection

mann grew many of the lush flowers that he painted, though he did not render them as botanical specimens but rather suggested the essential characteristics of specific varieties.

A later still life, *Whirling Poppies* (fig. 78), is also Oriental in flavor, but breaks with the traditional tabletop format. Here three flowers are depicted from above, appearing to spin in a vortex at the center of the canvas. Gutmann's daughter Dorothea explained the effect Gutmann was trying to achieve in *Whirling Poppies*:

When he showed people a painting in which one looks down on poppies in a turquoise bowl against a patterned, swirling background that grows

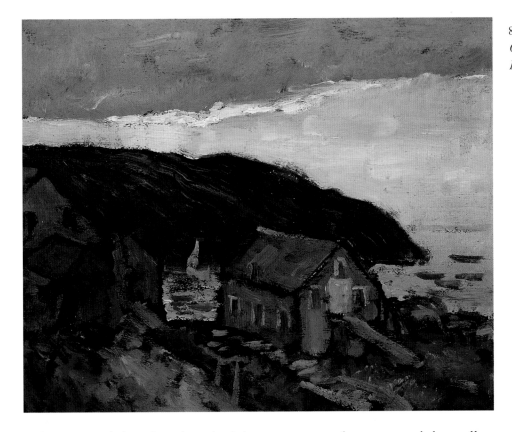

82. SUNSET, MONHEGAN ISLAND, *n.d.*
Oil on wood, 8 x 10 in. (20.3 x 25.4 cm)
Private collection

hazy toward the edges, he asked them to stare at the center and then tell him what happened. The bowl of poppies was said by many as beginning to swirl and produce a dizzying opium-like haze, which was his intention.[5]

These two paintings elucidate the polarities in Gutmann's work. The earlier work is derived from the seventeenth-century still-life tradition, a popular genre that emphasizes the evanescence of life and the fleeting nature of youth and beauty. *Whirling Poppies,* however, offers a more modern vision of nature based on physical sensation; the actual experience of the painting, as well as the image it depicts, is central to the meaning of the composition. While Gutmann produced more traditional than innovative still lifes, he explored both styles; as in other aspects of his work, Gutmann used still lifes to alternate between the old and the new, the familiar and the unusual.

Gutmann also used still-life compositions to investigate the nature of artifice, and to draw comparisons between the animate and the inanimate. His favorite subjects for these works were dolls and toys, either his daughters' or his own collection of antique dolls. In a particularly engaging composition, *Dolls and Toy Cat in Window* (fig. 80), the lifeless dolls and toy cat are set against a cold winter landscape that is temporarily as motionless as the stuffed toys, but poised to explode into spring. Gutmann also juxtaposed the animate

Opposite:
81. WOMAN, MONHEGAN ISLAND, *n.d.*
Oil on wood, 10 x 8 in. (25.4 x 20.3 cm)
Joyce and Christian Title

Page 126:
83. PICNICKERS, *1912*
Oil on canvas, 29 x 32 in. (73.7 x 81.3 cm)
Private collection

Page 127:
84. ELMS AT SUNSET, *1913*
Oil on canvas, 28 x 28 in. (71.1 x 71.1 cm)
Private collection

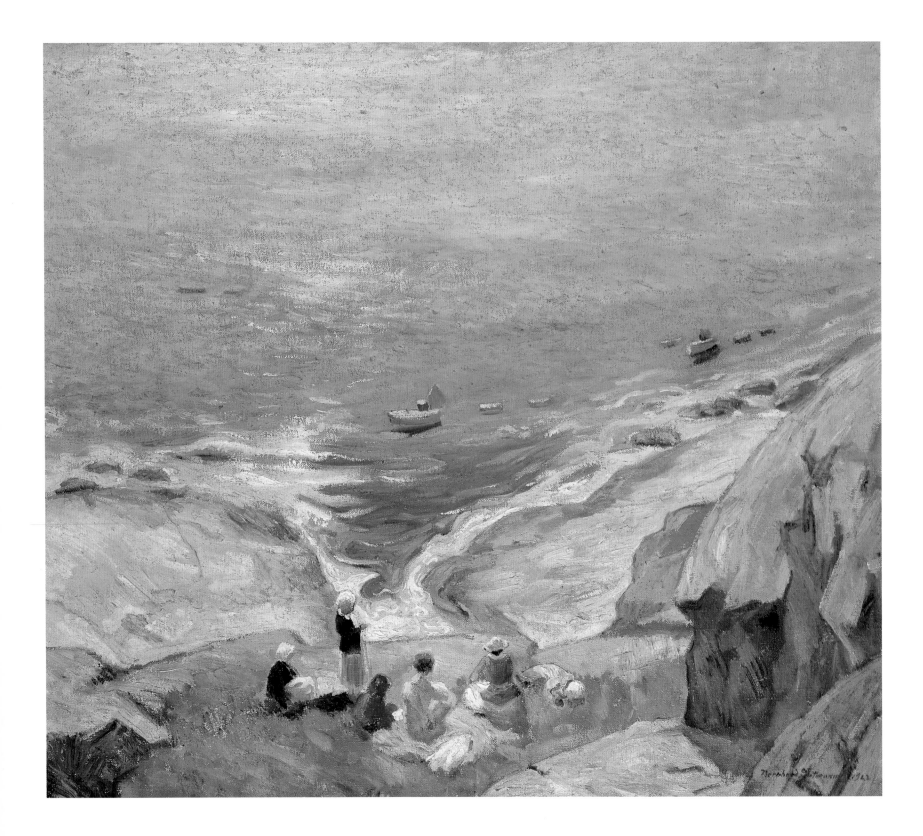

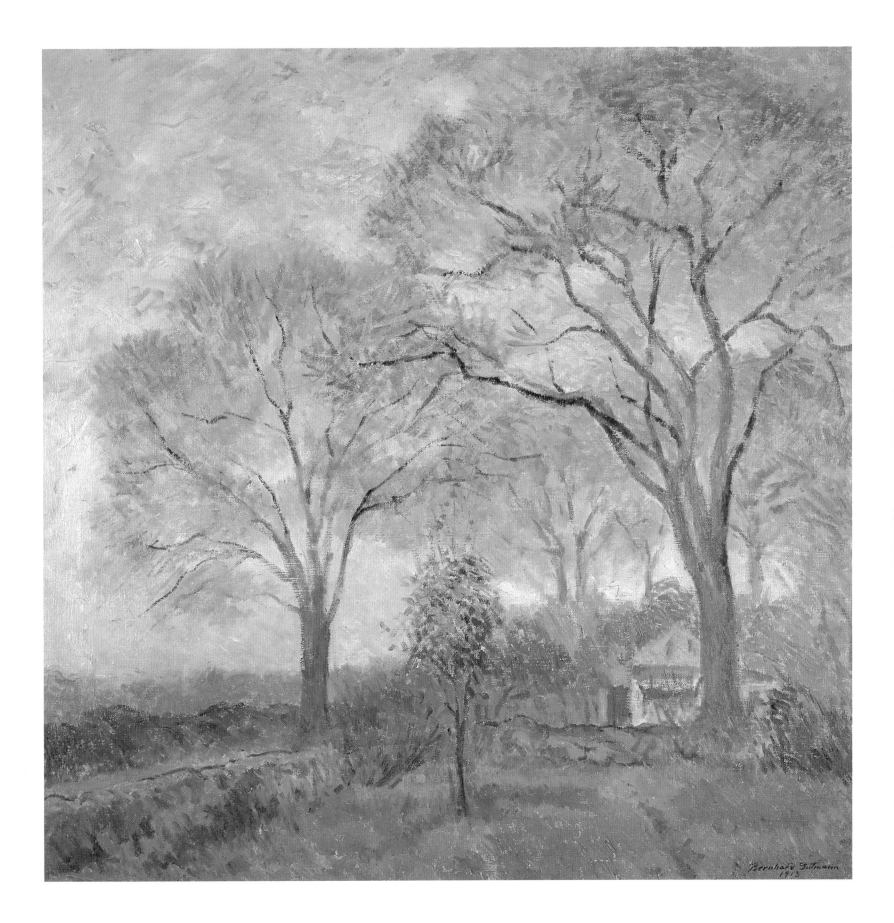

Bernhard Gutmann
1913

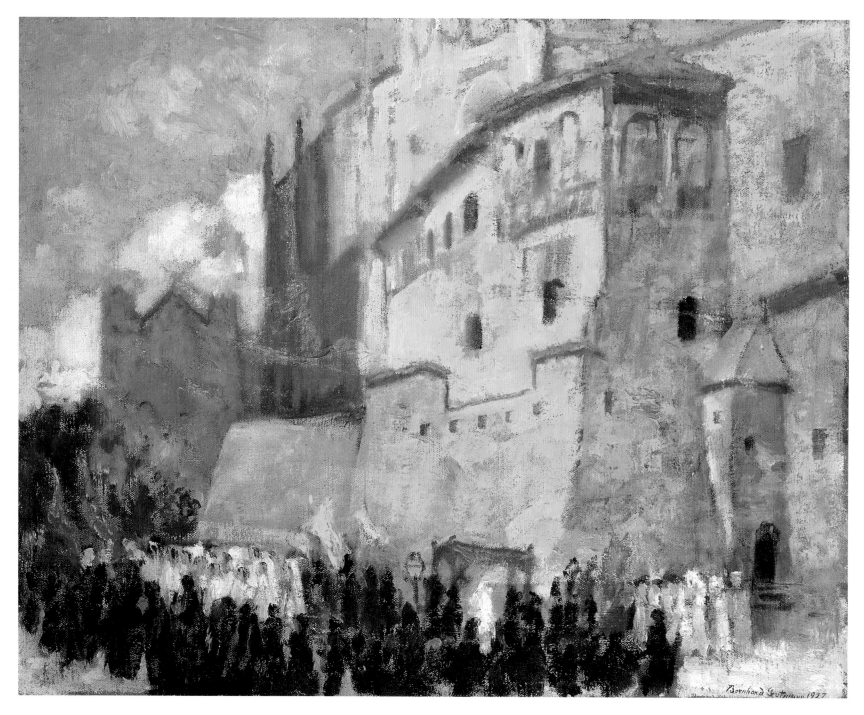

85. CATHEDRAL PROCESSION, *1927*
Oil on canvas, 18 x 22 in. (45.7 x 55.9 cm)
Private collection

and inanimate in a captivating portrait of his daughter with her dolls, *Elizabeth Playing with Her Dolls* (fig. 79).

During the early 1920s Gutmann's excursions took him to Monhegan, Maine, and to Florida, where he found a rich variety of new landscapes to paint. He was especially drawn to the rocky coast of Maine, and his Monhegan paintings resemble some of the works that he later produced in Spain. Movie stills of a historical costume drama that was being filmed in Florida during Gutmann's visit show the artist dressed in Arab clothing (fig. 86), looking somewhat like Rudolph Valentino in *The Sheik*, the cinematic rage of 1921. Popular as a source of inspiration for nineteenth-century salon paintings and stage plays, costume dramas appealed greatly to Gutmann; he was an avid thespian and had a studio full of exotic objects from around the world, as evidenced in his studio portraits across the decades. Gutmann got a real taste of the Near East in 1929 when he went to Egypt on an archaeological expedition; he was thoroughly enchanted with the land and culture he found there.

In 1922 Gutmann and his fellow Knockers purchased a barn on Silvermine Road to use as a classroom and exhibition space. Two years later the group incorporated as the Silvermine Guild, a nonprofit educational arts organization similar to the Lynchburg Art League. The painter Charles Reiffel was elected their first president. Reiffel was succeeded by Daniel Putnam Brinley, an Impressionist who had lived in Paris from 1905 to 1908, and who had exhibited at Alfred Stieglitz's Gallery 291 in 1910. Connecticut Impressionist Howard Hildebrandt followed Brinley, and Gutmann took over as president in 1925. From its inception, the organization required candidates for admission to submit a work of art to a jury of members. Today the membership has swelled to 800, and the guild supports an art school, three galleries, and extensive community programs.

Leaving his wife and daughters in Connecticut, Gutmann escaped to Spain in December of 1922. After a sojourn in Alicante, he took up residence on Mallorca, an island off the eastern coast in 1923. Gutmann was alone in Palma, the capital of Mallorca, until October 1923, when he was joined by Bertha and their younger daughter, Dorothea. Elizabeth was sent to boarding school in Switzerland for the school terms of 1923 and 1924 while the rest of the Gutmann family was in France and Spain. Just twelve years old, Elizabeth was lonely at school, but she received a steady supply of letters from her father relating the family's exploits and occasionally describing the sights he was painting.

Spain unleashed Gutmann's passion for color and reawakened his sense of wonder. His paintings became brighter, richer, and livelier in Mallorca; his second European sojourn brought about a tremendous burst of creativity. Gutmann's imagination was captured by the rugged island landscape and its

86. THE IMITATION ARAB (GUTMANN IN FLORIDA), *c. 1921–22*
Movie still

87. BERNHARD GUTMANN IN SPANISH COSTUME, *n.d.*
Photograph

88. MALLORCA, HILLS AND HARBOR, *n.d.*
Oil on wood, 10½ x 13¾ in. (26.7 x 34.9 cm)
Private collection

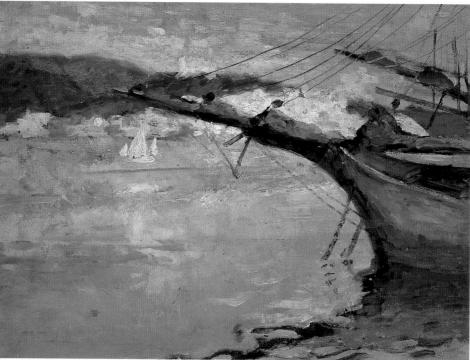

inhabitants. He was enchanted by religious processions and rituals he witnessed and was inspired by the dramatic configuration of Palma. The pinnacled towers of Palma's cathedral and the rounded bay of the harbor below appear in many of Gutmann's Mallorcan paintings, delineating the powerful juxtaposition of culture and nature the artist found there.

In a letter to Elizabeth, Gutmann included a sketch of a coastal view, which, he said, he was planning to turn into a painting. "The coast on the side of the island where I am is very wild and very paintable,"[6] he told her. Just as Winslow Homer had been enthralled by the rocky coastline of Maine, and Claude Monet had been captivated by the coast of France, so Gutmann was enchanted by the Spanish coast. Gutmann was not as concerned with the movement of crashing waves as Homer was, nor did he find as much excitement in recording changes in the weather and light as Monet had, although Gutmann had emulated Monet's misty atmospheric effects in some earlier French landscapes. Rather, Gutmann's coastal Spanish landscapes emphasize the abrupt juncture between land and sea; the solidity of the rocks contrasts sharply with the fluidity of the water. These mesmerizing compositions are animated by dramatic shapes, rich colors, and deep space.

Cultural events and local rituals were particularly fascinating to Gutmann, who greatly enjoyed the lively festivals and community celebrations. According to Dorothea, her father was more likely to be actively engaged in the festivities than sketching or observing events from the sidelines.

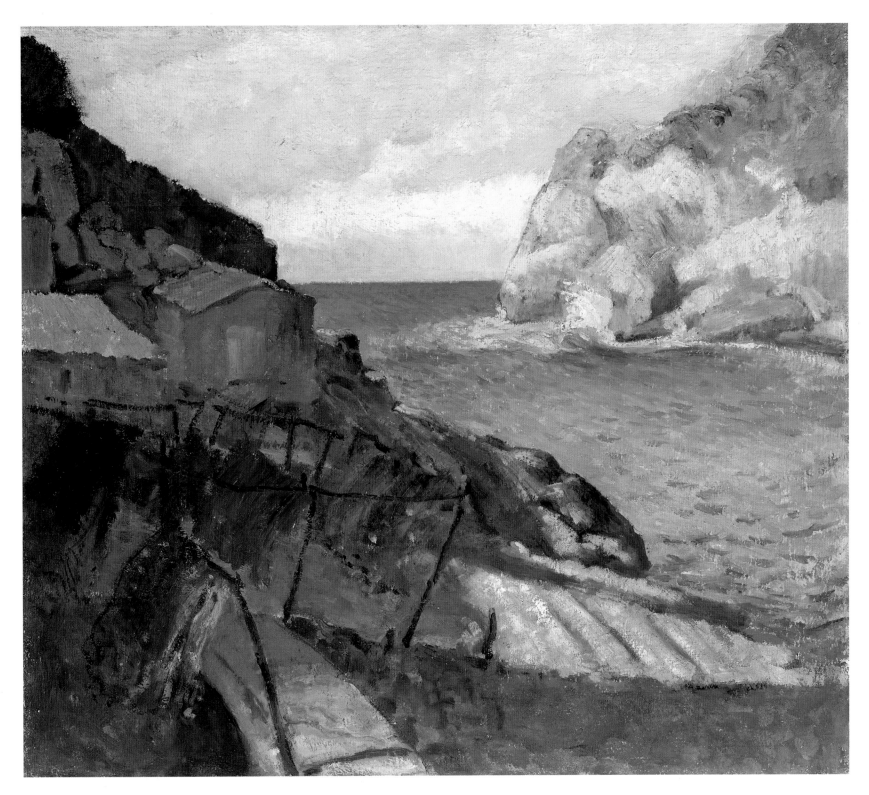

89. ROCKY COAST, *n.d.*
Oil on canvas, 23¼ x 25¼ in. (59.1 x 64.1 cm)
Private collection

90. ADOBES IN SPAIN, *n.d.*
Oil on wood, 8 x 10 in. (20.3 x 25.4 cm)
Joyce and Christian Title

91. DANCING PEASANTS (MALLORCANS DANCING), *n.d.*
Oil on canvas, 29 x 32 in. (73.7 x 81.3 cm)
Lyn and Michael Citron

A rare moment along a coast road inspired one of Gutmann's most haunting and memorable paintings, *Dancing Peasants (Mallorcans Dancing)* (fig. 91). He described the scene in a letter written to Elizabeth just before he began the painting:

A few days ago we were walking along the road, when coming to a twist in the road we heard castagnettes and clapping of hands. When we got a little nearer we saw some young men and women dancing and it looked very nice, they dance around one another coming nearer and nearer to one another, without ever touching. It was very charmingly done and I shall try to paint a picture of it if I can. The Mediterranean and the mountain were in the background, it really was picturesque.[7]

The bold simplicity of the composition, the graphic pattern of dancers silhouetted against the sky, and the noisy revelry suggested by the figures recall the same sense of liberating freedom that Matisse captured in a 1909–10 series of dance paintings.

Gutmann found the local religious festivals equally engaging. He practiced no faith and looked past the religious aspects of these rituals, but was enthralled by their pageantry. Gutmann regaled Elizabeth with stories about a

92. SEVILLE IN SPRINGTIME, *n.d.*
Oil on wood, 15 x 18 in. (38.1 x 45.7 cm)
Private collection

Opposite:

93. PROCESSION, *n.d.*
Oil on wood, 13¾ x 10⅜ in. (34.9 x 26.4 cm)
Private collection

local festival he believed to be in honor of Saint Anthony, whom he referred to as the patron saint of animals:[8]

> The priest stood in a prominent place and all the donkeys and mules were ridden by him while he sprinkled mules and riders with holy water, while three devils, one large one and two small ones danced around a little boy dressed up as St. Anthony. The large devil wore a large false face with horns and his costume was painted all over with flames. His mask was firy [*sic*] red and he scared all the children.[9]

Religious processions depicted as glorious colorful pageants are a frequent

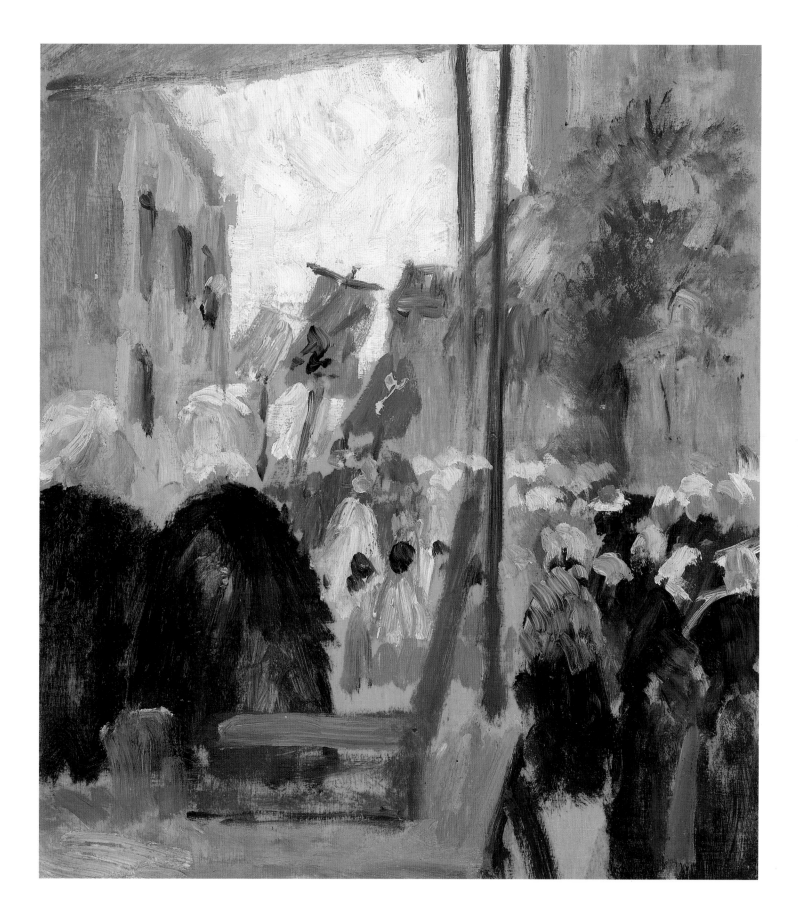

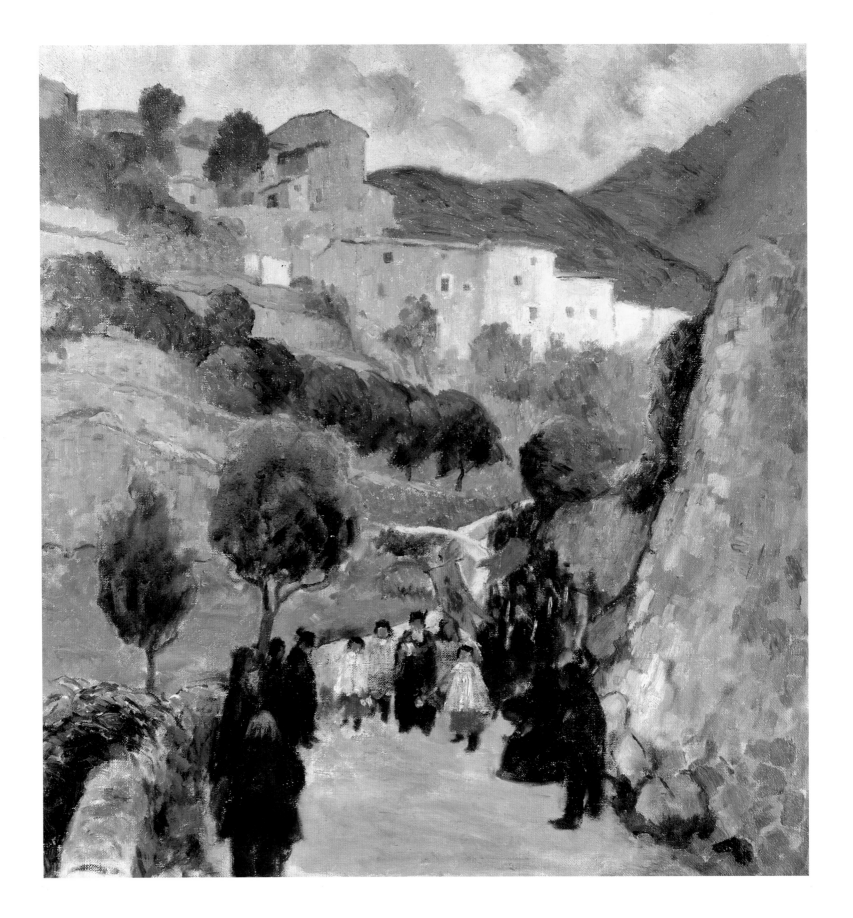

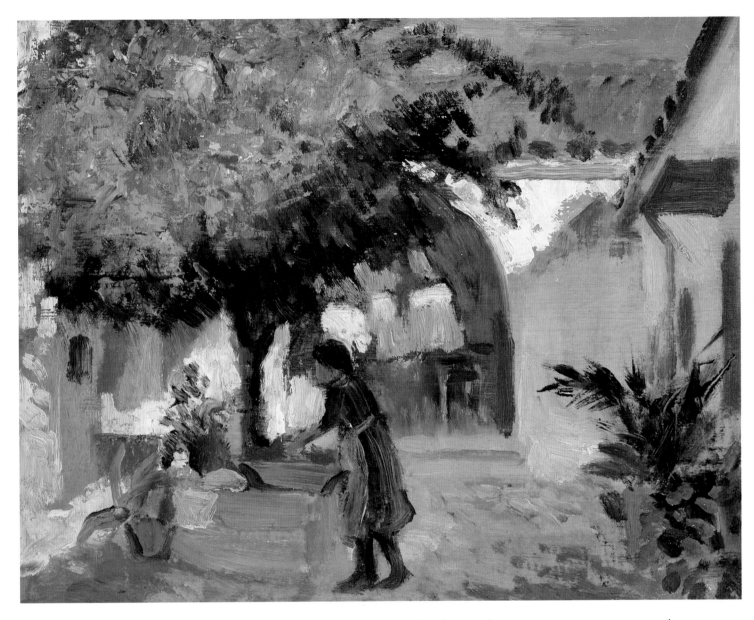

subject of Gutmann's Spanish paintings. They emphasize the rich colors and waving flags that enlivened the austere Mallorcan landscape and architecture. The events in the paintings usually take place at a distance, so that the individual features of the participants are not discernible. Gutmann was primarily interested in capturing the excitement and holiday spirit of the occasion at hand.

While on Mallorca, Gutmann painted a *Baptism of Christ* for the small church of Saint John the Baptist in the hill town of Deya. Although currently obscured behind the baptismal font and partly obscured by the darkness of the church, this painting offers a lively example of Gutmann's eclectic mix of traditional and modern elements. While the large blocks of color and simple, flattened shapes reflect Post-Impressionist devices,[10] the stylized figures are

95. SPANISH COURTYARD, *n.d.*
Oil on wood, 8 x 10 in. (20.3 x 25.4 cm)
Joyce and Christian Title

Opposite:
94. PROCESSIONAL, MOUNTAIN PATH, SPAIN, *n.d.*
Oil on canvas, 25 x 23 in. (63.5 x 58.4 cm)
Private collection

also reminiscent of the work of the popular late nineteenth-century French muralist Pierre Puvis de Chavannes (1824–1898).

In the spring of 1924, the Gutmanns traveled north to Paris, where they were reunited with Elizabeth and with Bertha's parents. They took up residence in an artist's retreat at 65 boulevard Arago, where Gutmann transformed many of his Spanish sketches into finished paintings. Gutmann had a one-person exhibition at the renowned Bernheim-Jeune Gallery on the elegant rue du Faubourg-Saint-Honoré, which was known for promoting work by the French Impressionists. On the occasion of the exhibition the critic Honoré Broutelle published an article in the *Revue des Indépendants*,[11] praising Gutmann's use of vivid color, the lushness of his compositions, and his Impressionist eye.

Gutmann returned to the United States in 1925, and was elected president of the Silvermine Guild, the art center he had helped organize three years earlier. In his capacity as president, he introduced the tradition of a premium to be donated to the associate members in exchange for their administrative duties to the group. Gutmann presented eight impressions of his etching *Old Door, Mallorca* as gifts to the original associate members, the friends with whom he had begun the guild.

Although Solon Borglum is credited with founding the guild, Gutmann's stewardship was to leave a lasting mark on the organization. Under Gutmann's leadership the guild sponsored a full schedule of art lectures, critiques, pottery and painting classes, concerts, and Monday evening sketching classes with live models. Gutmann also started the guild's ceramics program and participated in many of the group's exhibitions, as well as in the Silvermine Sillies' summer theatricals. A seemingly tireless contributor to the local art scene, Gutmann also joined the nearby Darien Guild of Seven Arts and submitted works to their exhibitions.

Resettled in Silvermine, Gutmann once again began actively promoting his career in 1926. He exhibited some recent etchings at Wellesley College, and was represented in the eleventh annual Brooklyn Society of Etchers exhibition at the Brooklyn Museum by *Night Funeral, Mallorca* (fig. 101) and *Chimney Pots, Paris*. The subject of the Mallorcan etching suggests Gutmann's increasing concern with darker, more brooding themes. Such somber images would become more prevalent in Gutmann's work over the next decade in a transformation of his earlier interest in religious rituals.

In 1926 Gutmann contacted William Macbeth, the owner of the Manhattan gallery where the Eight—painters Robert Henri, John Sloan, George Luks, and others—held their first group exhibition in 1908. Since Macbeth had been encouraging to Gutmann after his initial return from France in 1912, Gutmann invited the dealer to visit his studio in September 1926 while Gutmann was hosting an open house. The continued association between artist

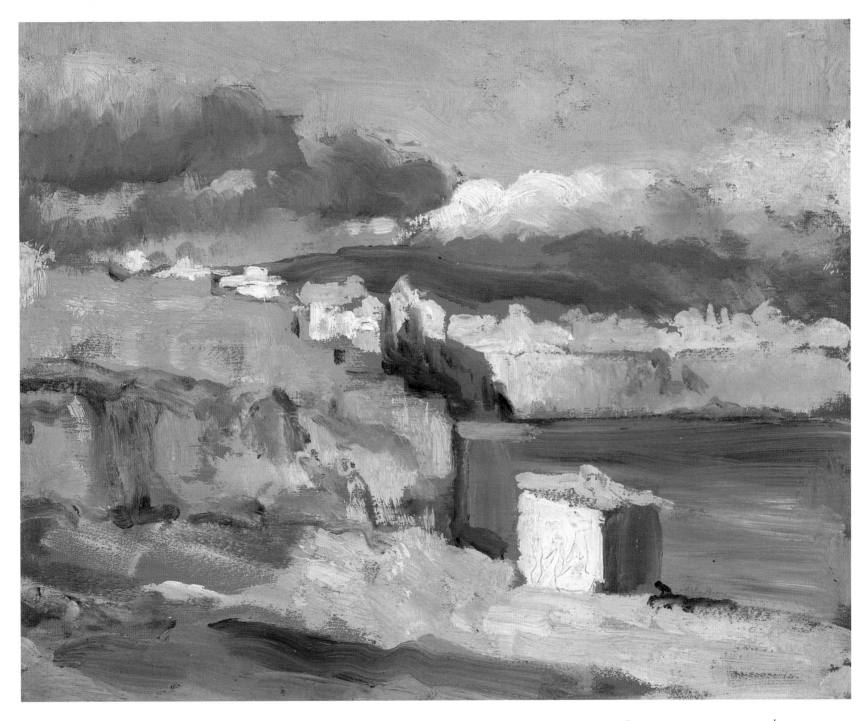

96. STORM OVER PALMA, *n.d.*
Oil on wood, 8 x 10 in. (20.3 x 25.4 cm)
Private collection

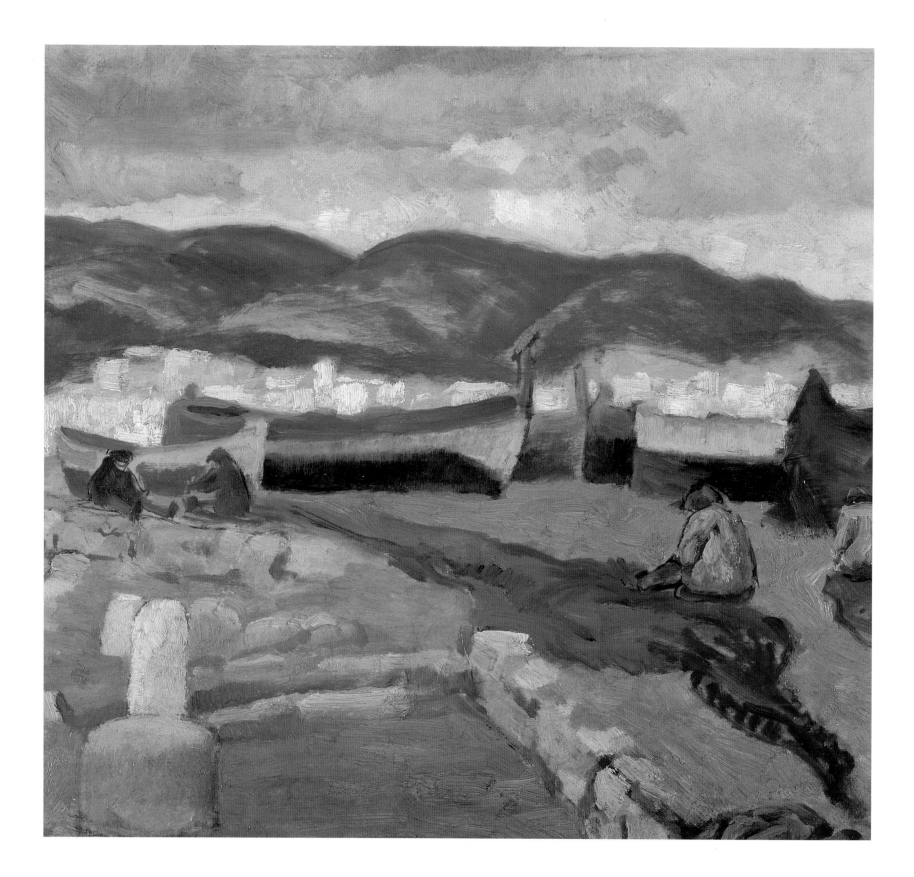

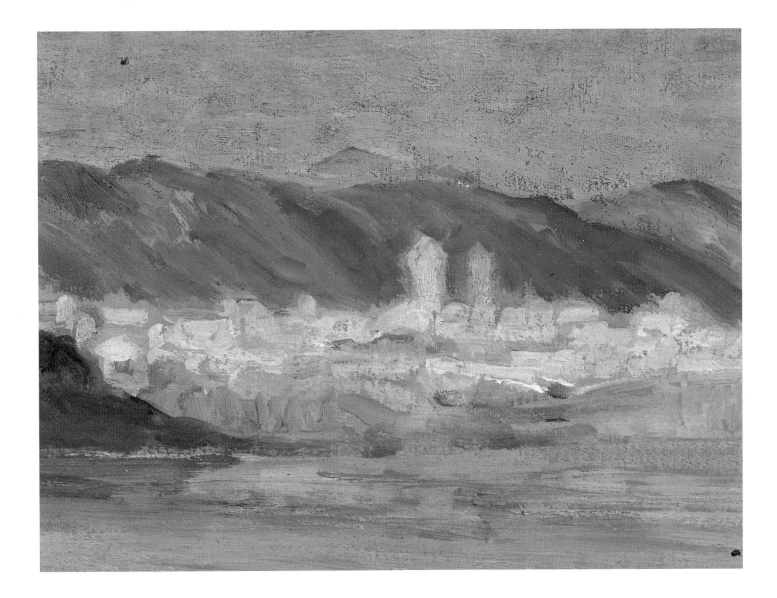

and dealer paid off: Gutmann had a successful one-person exhibition at the Macbeth Gallery in November 1927. Thirteen watercolors and three landscapes of cliffs along the coast of Mallorca were included in an exhibition entitled *Paintings of Mallorca*. These paintings represent the most dramatic and daring elements in Gutmann's oeuvre, and they demonstrate his attraction to striking graphic design and vivid color. Evidently, these works also appealed to the buying public: *Fisherman's House, Esterlensch,* and *Down Hill* (possibly the same as *Downhill,* shown in 1915) were all purchased from the exhibition. A brochure with a translation of excerpts from Honoré Broutelle's article in the *Revue des Indépendants* accompanied the exhibition; Broutelle observed that "each of the works gives a sense of a window opened wide to nature and framing a beautiful sun baked landscape, in which the eye lingers reluctant to turn away."[12]

(detail)
98. SANTA CATALINA, *n.d.*
Oil on wood, 8 x 10 in. (20.3 x 25.4 cm)
Private collection

Opposite:
(detail)
97. SANTA CATALINA, MALLORCA, *1926*
Oil on wood, 14⅞ x 18⅛ in. (37.8 x 46 cm)
Private collection

99. TWO NATURES (SELF-PORTRAIT), *1928*
Oil on canvas, 23 x 25 in. (58.4 x 63.5 cm)
Theodore Lehmann II

Broutelle's comments emphasize the captivating charm of Gutmann's landscapes and the artist's habit of using a window as a framing device to dramatize the event of looking at a scene as an arranged experience. It is the artist's selective eye that frames the view and which leads the viewer into the realm of his imagination. The fiction of painting always emanates from the artist's personal vision and transforms our own expectations of nature. Gutmann was praised by a New York critic who noted, "It is an exhibition that one lingers over longer than many in New York."[13] Another of Gutmann's Mallorcan paintings, *Catalina desde el Terreno,* was exhibited the same year (1927) at the Salmagundi Club, where Gutmann had been a member since he first came back from France in 1912.

In October 1927 Gutmann's floral still life *Autumn* was illustrated on the cover of *Literary Digest;* this publicity gave Gutmann a more extensive audience for his work than any he could develop through gallery exhibitions.[14] This traditional tabletop still life belongs to the conservative mode of Gutmann's painting. That it was chosen—presumably by the editor—to be featured on the cover of a popular magazine reflects the widespread predilection for simple, direct, pictorial illustration that was then typical of mainstream American taste.

A selection of Gutmann's more somber, introspective works were exhibited in September 1928 at the Darien Guild of the Seven Arts. His *Two Natures (Self-Portrait)* (fig. 99) was reproduced in the *Norwalk Hour,*[15] along with a notice advertising a lecture by Gutmann, "From the Artist's Point of View." The Norwalk paper also reprinted a description of the painting from the *New York Times:*

> In 'Two Natures' the artist employs though not immitatively, [*sic*] one of those masks such as Eugene O'Neil [*sic*] finds now and then indispensable. You see a laughing man, all merry upward lines, eyes drawn to slits with unsuppressed fun. A cigarette hangs rakishly. And in his hand he holds a mask upon which with his brush, he places the finishing touches of grimness and despair, while beyond an urban background rocks with disintegration that has proceeded a good deal past the incipient or merely speculative stage. The world is manifestly going to pieces, but does it really matter?[16]

As discussed in the introduction, this painting depicts both the dichotomy inherent in Gutmann's character and the crisis of confidence he was experiencing as a committed painter of the world of recognizable nature who finds himself surrounded by more radical, abstract art movements. Cubist shapes and Futuristic line are employed here as the agents and expression of a destructive force that envelops an artist who is portrayed as being both amused

and despondent about his fate. Gutmann's brother-in-law Ashton Sanborn also commented on this painting in the catalog for the memorial exhibition that he organized for Gutmann in 1938. "In the self-portrait with a mask he turns the barb of whimsical wit upon himself,"[17] Sanborn wrote. While Gutmann's early work expressed the joyous side of his character (though occasional touches of the macabre do appear, as in his postcard image *In the Midst of Life We Are in Death*), his later paintings reveal more of the darker side of his personality.

100. MIRROR SELF-PORTRAIT, *n.d.*
Oil on canvas, 23⅛ x 25¼ in. (58.7 x 64.1 cm)
Private collection

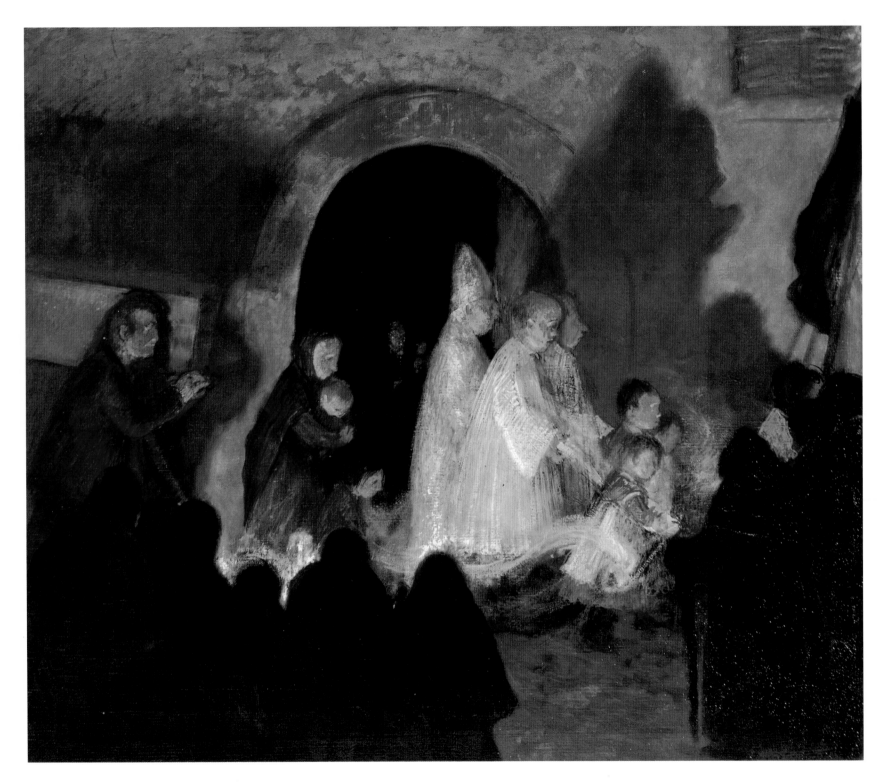

101. NIGHT FUNERAL, MALLORCA, *n.d.*
Oil on canvas, 33 x 37 in. (83.8 x 94 cm)
Joseph Ambrose

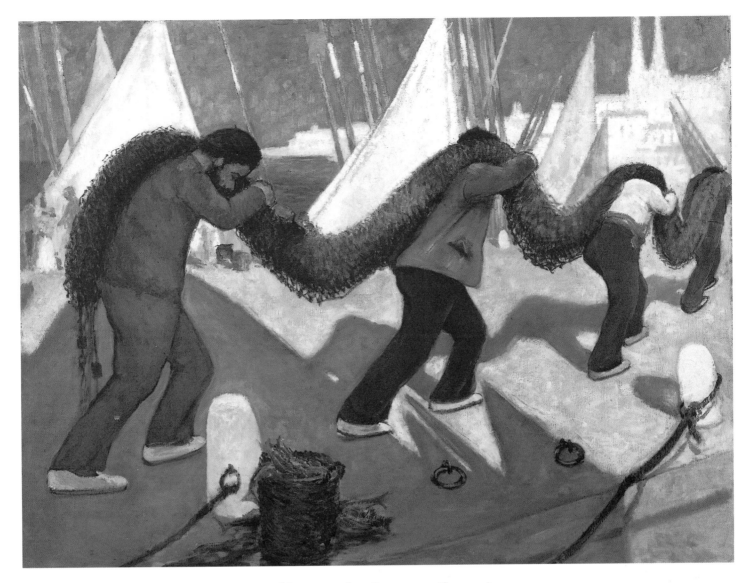

102. DESTINY, *c. 1927*
Oil on canvas, 35 x 45 in. (88.9 x 114.3 cm)
Theodore Lehmann II

Another roughly contemporaneous self-portrait by Gutmann (fig. 100) offers a complex vision of the artist's life as a reflection of his work and his aesthetic philosophy. Gutmann, holding palette and brush, looks warily into and out of a mirror surrounded by books, ceramics, and one of his own paintings of Spain, which floats next to his head. In both of his self-portraits from this period, Gutmann defines himself in terms of his role as an artist, signaling the importance of his vocation to his identity.

Destiny (fig. 102), also exhibited in Darien, is a graphically and philosophically compelling portrayal of four fishermen hauling in their nets against an abstract harbor setting. The boldly simplified figures of the fishermen bending under the weight of their nets are reduced to abstract shapes, which form the undulating pattern that is echoed by the shadows and silhouetted against the triangular shapes of the sails. *Destiny* demonstrates Gutmann's sophisticated understanding of Post-Impressionist pictorial devices in its flattened

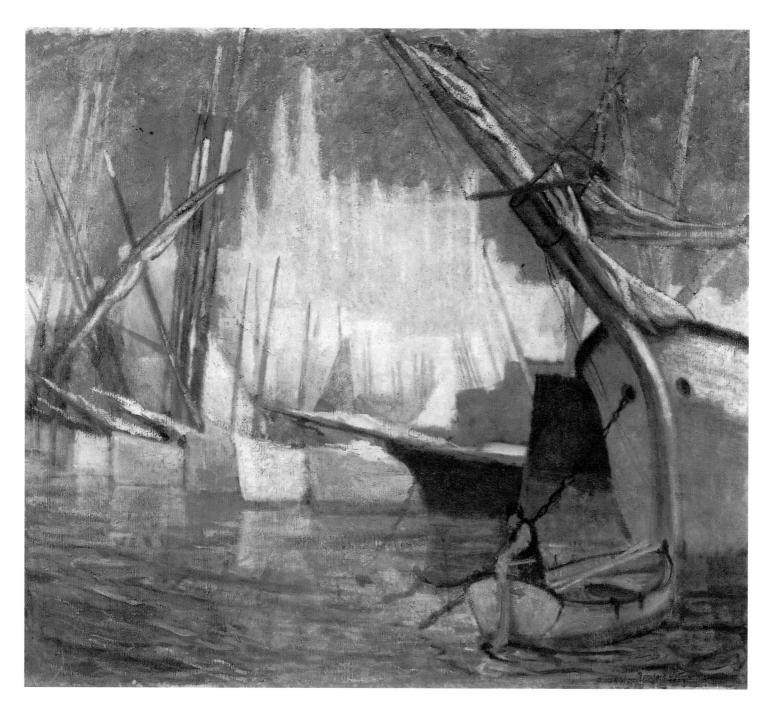

103. CHURCH AND COMMERCE, *n.d.*
Oil on canvas, 42½ x 47 in. (108 x 119.4 cm)
Theodore Lehmann II

shapes of evocative color. The dreariness of the fishermen's unending toil is emphasized by the dark, heavy palette; eternal, deadening labor is portrayed here as man's universal destiny.

Equally haunting is Gutmann's *Night Funeral* (fig. 101),[18] which also appeared in the Darien show. The large scale of this painting reflects Gutmann's increasing interest in imposing compositions, which he used more and more toward the end of his career. This image of a funeral procession combines the pageantry of Gutmann's festival paintings with the gloom of his meditations

on death. The large, menacing shadows and black-clad mourners, who seem to invite the viewer into their space, enhance the melancholy, fatalistic mood of the painting.

The largest painting in Gutmann's oeuvre, *Church and Commerce* (fig. 103), was also exhibited at the Darien Guild.[19] This view of Palma harbor, with ships in the foreground and the cathedral capping the hillside across the water, is similar to other coastal scenes that Gutmann repeatedly depicted. The watery tones of hazy green reflect Gutmann's continued interest in the mistiness of Impressionism. Gutmann wrote about *Church and Commerce* on a sheet of compositional diagrams: "restfulness of church and hustle of commerce — the church framed in and pointed to by the masts and ships." The title also has political implications, for religion and commerce are portrayed here as the dual systems that dominate the world and determine one's place in it.

To celebrate the 1928 golden wedding anniversary of Gutmann's parents-in-law and chief benefactors, the artist made a portfolio of etchings of the Goldmans' children and grandchildren. These delicate and sensitive portraits are some of the most beautiful character studies of his career. They also illustrate Gutmann's deep devotion to his extended American family.

As the 1920s came to a close, so did Gutmann's optimism. The pessimist in him began to take over and to stifle his creative energies. Once the Great Depression had started and Gutmann returned from his last foreign adventure in 1930, he became markedly less productive, and his paintings began to reflect an overwhelming despair.

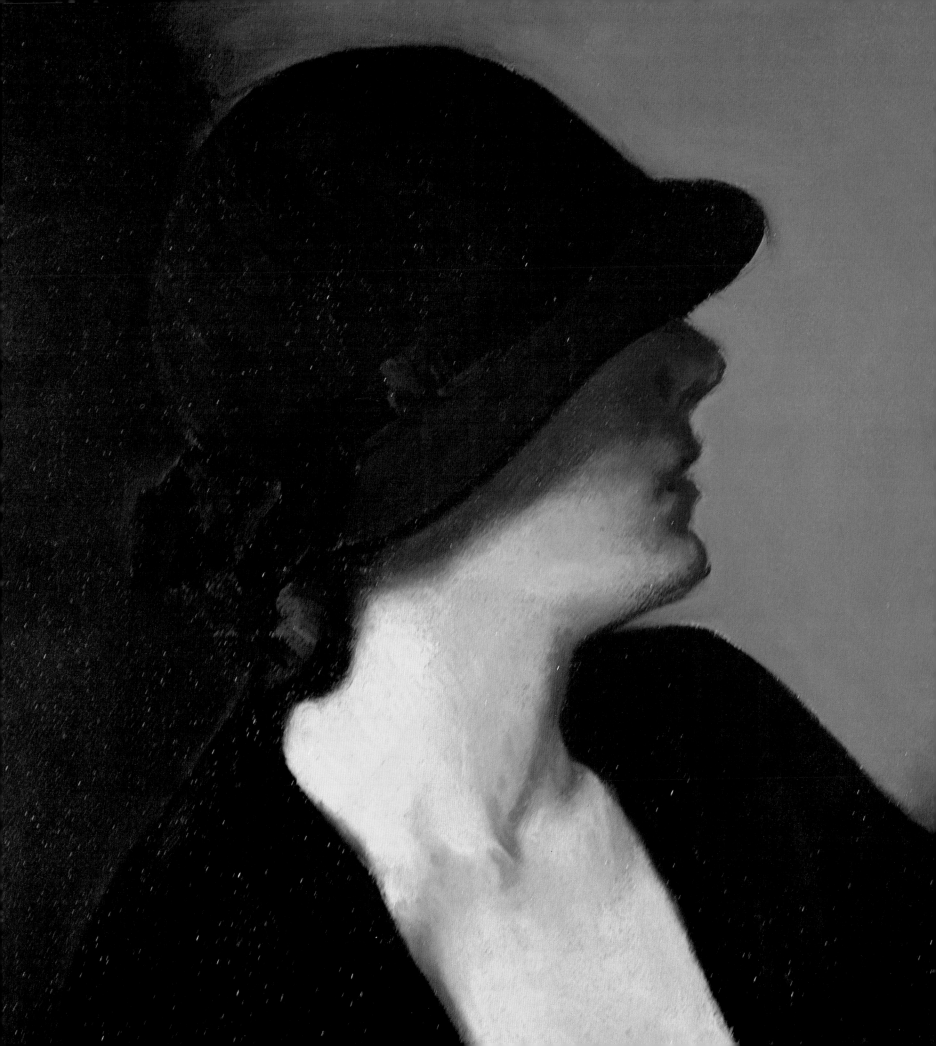

5

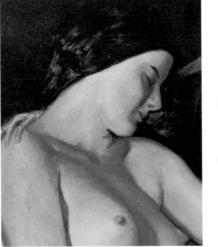

The Final Journey

THE STOCK MARKET CRASH in October 1929 brought serious financial reversals to Julius Goldman and his family. As the entire country sank into the depths of the Great Depression, a crippling sense of anguish deepened Gutmann's latent morbid humor. Although the Gutmanns were far from destitute, maintaining their spacious house in Connecticut, with the services of hired help, and supporting their older daughter's graduate studies in archaeology in Greece strained their resources. The aura of doom that blanketed the country engulfed Bernhard Gutmann in a dark cloud for the few remaining years of his life, and he found it increasingly difficult to work. The meditations on death and decay that had cropped up occasionally in his early work became a pervasive feature of his later creative efforts.

Before the crisis on Wall Street strangled the country's economy, the Gutmanns embarked upon their last foreign adventure. From December 1929 to March 1930, they explored the tombs and temples of Egypt with Bertha's parents, her sisters Hetty and Agnes, and Agnes's husband Ashton Sanborn, who was then secretary of the Museum of Fine Arts in Boston. Hetty, an eminent archaeologist, led the expedition, and Bernhard sketched and filmed a travelogue while Bertha kept a diary of their exploits.[1] Bernhard also made enchanting watercolors of the historic monuments, of a group of street musicians,[2] and of frenzied whirling dervishes which he transformed into a dynamic, almost abstract painting.

In August 1930 Gutmann submitted two of his Nile pictures to the annual black-and-white exhibition at the Silvermine Guild, along with fifteen etchings of New York. John Taylor Arms, who was living in neighboring Greenfield Hill, and whose graphic images of the city are similar to Gutmann's, also

(detail)
III. DARK DREAMS, *1932*
Oil on canvas, 33 x 37½ in. (83.8 x 95.2 cm)
Private collection

Opposite:
(detail)
110. STUDY OF WOMAN IN BLACK, *1932*
Oil on canvas, 32 x 29 in. (81.3 x 73.7 cm)
Joseph Ambrose

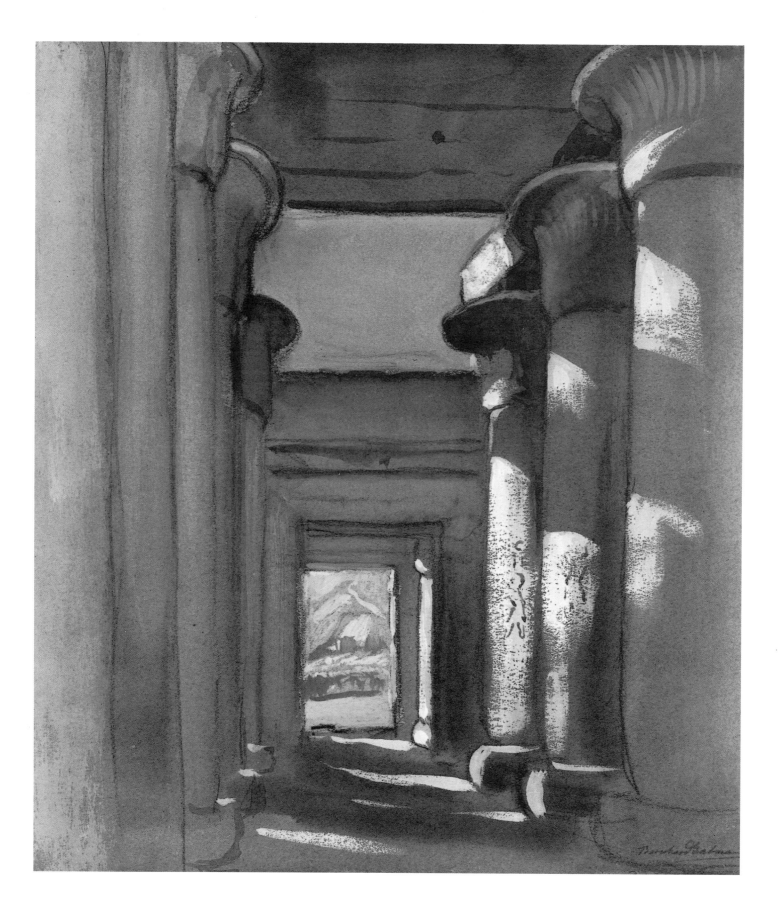

participated in the show. The following January, one of Gutmann's series of New York etchings, *Gramercy Park,* was included in the fifteenth annual exhibition of the Brooklyn Society of Etchers at The Brooklyn Museum. Depictions of the city as a modern landscape of tall buildings appear in this series of etchings that Gutmann produced during the 1920s; they are very different in spirit from his pastoral paintings of the same decade. Gutmann seems to have considered painting and etching two separate but equal art forms, and during the last fifteen years of his life he exhibited his graphic work as much, if not more than, his paintings. One of his portraits from 1932 depicts a printmaker at work (fig. 107). Although not a self-portrait, the painting clearly suggests Gutmann's identification with the figure he has captured on canvas.

On August 26, 1931, a United States copyright was issued to Gutmann for a play entitled *A Return Trip into the Fourth Dimension.* This one-act, four-scene play, featuring two characters who travel into outer space, was probably written for the Silvermine Sillies, the annual three-night artists' frolic that was the highlight of the Silvermine Guild's summer season. As Gutmann's daughter Dorothea noted, "He loved getting involved with the Silvermine Sillies, a skit show put on by the artists of the Silvermine Guild. He'd write skits, act in them, design scenery, the works."[3]

Although the idea of a fourth dimension—in which time is added to height, width, and depth—had generated lively philosophical and scientific dialogues during the early decades of the twentieth century (particularly among the Cubists and Futurists), Gutmann was using the idea as a means of parody. The provocative title of his play makes a serious reference to the fourth dimension, yet the ludicrous scientific discussions are intended as amusing farce. Written tongue-in-cheek, the play proposes that space exploration might offer a feasible means for ending the depression by opening up new markets.

From the fall of 1932 to the summer of 1935, Elizabeth Gutmann, who graduated from Bryn Mawr College in 1932, studied archaeology at the American School for Classical Studies in Greece, following in the footsteps of her renowned aunt, Hetty Goldman. Gutmann's letters to Elizabeth, which his daughter faithfully kept, record his weekly musings on art, life, and politics.[4] Although full of fatherly admonitions to carry enough money to enable her to return home at a moment's notice (because of the increasing political instability in Europe), the letters also offer important insights into Gutmann's character and into the deepening spiritual malaise that was engulfing him as the international situation worsened. His letters are sprinkled with whimsical sketches, especially of Elizabeth's younger sister Dorothea and their terrier dog, "The Professor." They also include profound observations about his work and thoughts about his exhibitions. In addition, while these chatty letters record the activities of the Gutmann and Goldman families and

Opposite:
104. EGYPTIAN TEMPLE, *1930*
Gouache on paper, 15 x 13 in. (38.1 x 33 cm)
Theodore Lehmann II

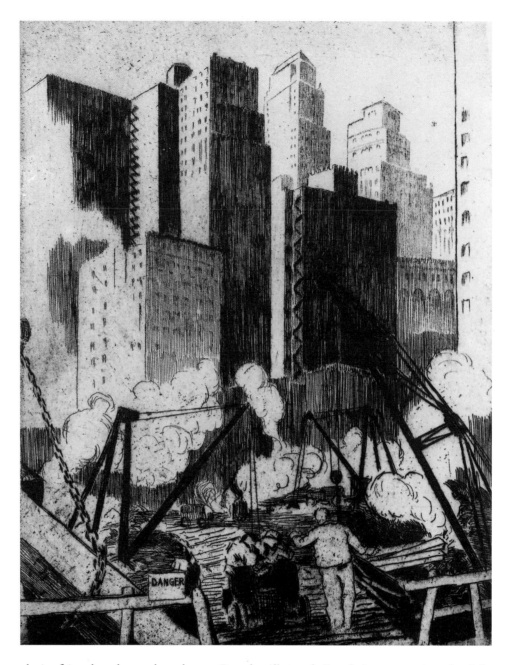

their friends, they play down Bernhard's and Bertha's worsening health, which would soon make orphans of their two daughters.

Gutmann's despair grew as he and his wife were increasingly surrounded by spiritual malaise and physical sickness and death. Bertha's mother, Sarah Adler Goldman, was ill for several years before her death in December 1934. Bernhard and Bertha made frequent visits to New York to comfort her and to lend moral support to Julius Goldman. Several of Bertha's aunts and uncles died within a year of her mother, and around the time of her mother's death, Bertha was diagnosed with pernicious anemia.[5]

It is not clear from Gutmann's letters to his daughter in Greece whether he

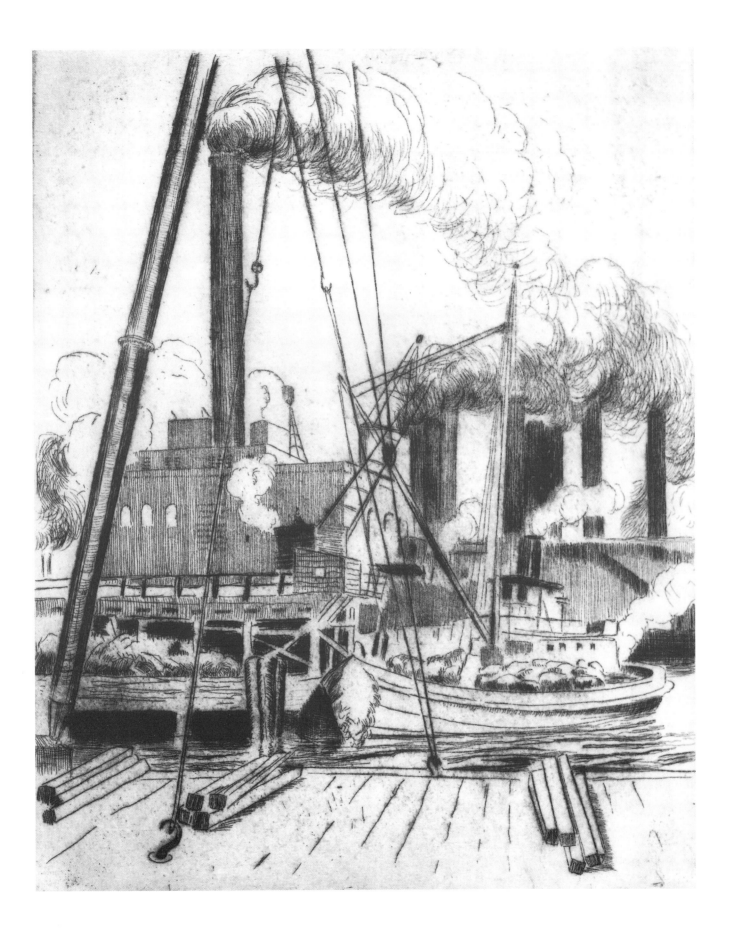

107. WOOD BLOCK PRINTER, *n.d.*
Oil on canvas, 33 x 37 in. (83.8 x 94 cm)
Private collection

was aware of the seriousness of his wife's illness. If so, he carefully concealed any anxiety from Elizabeth. His references to Bertha mention her trips to Boston for treatments, and the progress that followed these junkets. Not long after the onset of Bertha's anemia, Bernhard himself was diagnosed with throat problems, a condition that developed into cancer and became fatal within a year.[6]

Because they needed to economize, the Gutmanns had to stay close to home, and their inability to travel made them even more dispirited. Moreover, Bernhard's anguish was exacerbated by the rise of the Nazis in Germany,

which affected him deeply. He frequently cautioned Elizabeth to be wary of writing anything that could be considered politically compromising to friends and family in Germany.

Gutmann's production slowed considerably during the 1930s, and he frequently found himself under the spell of dark moods and unable to work. Surprisingly, those compositions he did produce include a number of portraits, as well as some allegorical paintings that recall themes he had explored in his youth. Gutmann found the position of the artist during a period of such dire economic and social upheaval to be demoralizing; the precariousness of the art market during hard times dampened his spirits even though he did not have to rely on sales to support himself. He was fortunate enough to have not only financial resources but the support of a gallery at a time when many art dealers were going out of business. In October 1932, Gutmann told Elizabeth that the Ferargil Gallery in Manhattan "intends handling my pictures and etchings. At a time like the present this might not mean much as nobody has any money to buy anything but bread. Conditions are not very cheerful."[7] In the same letter Gutmann wryly noted, "If anything should happen there, that is if anybody should think of buying a picture I am sure he will before or after be run over by an auto."[8] Gutmann's one-person exhibition at the Ferargil Gallery was an honor during the early years of the depression, yet Gutmann was hardly encouraged by his success. During the run of the show he wrote, "So far everything is OK, criticisms, publicity and attendance good, but the rest very doubtful and remains to be seen as there is another week of it."[9]

Several New York papers reviewed Gutmann's show, and some of his watercolors and etchings did sell. A critic writing for *Art News* observed,

> He is a painter with a generous outlook on life and obviously enjoys painting per se. Portraits, flower groups, satirical inventions, circus scenes, landscapes, etc. come from his hand with no apparent effort. . . . As a foreword in the catalog points out, it is perhaps in the field of portraiture that he finds the answer to his aesthetic aspirations.[10]

During the 1920s Gutmann painted portraits of the president of Alfred University, Boothe Davis, and of Professor Charles Fergus Binns (fig. 108), the founding director of the New York State College of Ceramics, who is known today as the father of American studio ceramics. In the painting by Gutmann, the bearded and bespectacled professor is shown examining ceramic vases (now in the collection of the Museum of Ceramic Art at Alfred University), an allusion to his academic expertise and accomplishments. Gutmann's professional portraits were most frequently of artists; his later self-portraits illustrate his own role as an artist, which earlier likenesses of himself did not.

108. PROFESSOR CHARLES FERGUS BINNS,
n.d.
Oil on canvas, 29 x 32 in. (73.7 x 81.3 cm)
Museum of Ceramic Art, Alfred University

Gutmann had painted portraits consistently since his years in art school, and making portraits of the Goldman family was one of the few services that Gutmann contributed toward the support of his family. During the depression he was increasingly drawn to portraiture, perhaps because working in this documentary genre provided him with solace and stability in a time of both personal and international crisis. Gutmann often wrote to his daughter about the people who came to sit for him. His most notable sitter was Judge Benjamin Cardozo of the United States Supreme Court, a family friend who gave the eulogy at Sarah Goldman's funeral. Realizing the potential in marketing a likeness of a famous judicial figure, Gutmann made a large etching of the Cardozo portrait, but was disappointed when he found he was unable to achieve the same degree of likeness in the graphic work that he felt he had captured in the painting. Ultimately, Gutmann seems to have been more attracted to the art of portraiture than to its potential profits; when his daughter asked him if another portrait he was working on was a commission, he responded, "No the portrait is not an order. There is no such thing as an order."[11]

Even in the quiet isolation of Silvermine, Gutmann kept abreast of current events, and he encouraged Elizabeth to keep a diary so that she would develop a better personal grasp of history. His letters to her are full of biting wit about the current political situation. On December 5, 1933, the day that Prohibition

ended, he offered her this observation: "There is not much to say [about] the condition of this little globe[:] hopelessly sick and refuses to take the bottle. Maybe the right nurse has not yet been found. Just this afternoon he got a dose of whisky. Maybe that will help a little."[12] This commentary is accompanied by a sketch of the sick globe in bed being fed a baby bottle by a male figure in hospital attire. In his next letter Gutmann wrote that a group of Silvermine artists had recently organized an exhibition at the Montross Gallery, "Where I have seven pictures which in all likelihood will be back in my studio in 1934."[13]

Gutmann's few paintings from the 1930s are markedly different from, and far more somber in tone than, his earlier work. Even the erotic *Study of Woman in Black* (fig. 110) evokes an aura of sadness in her fragile gesture, shaded countenance, black clothing, and gray surroundings. A nude from 1932 titled *Dark Dreams* (fig. 111) expresses Gutmann's preoccupation with death in a return to the theme of *In the Midst of Life We Are in Death*. Reclining against pillows on a bed, like the figure in *Nude with Parrot*, the unclothed woman touches a rose with her right hand, and is in turn touched on both her knee and shoulder by a skeleton. Here Gutmann expresses his overwhelming sense of loss and futility through the image of the rose, a traditional symbol of love and beauty that dies quickly when cut. A late landscape, *Cemetery at Night* (fig. 112), is Gutmann's final entry in his series of portraits of the places where he lived.

In February 1934 Gutmann was chosen as regional director for the New Canaan, Connecticut, Public Works of Art Project (PWAP), a part of President Roosevelt's New Deal program, designed to reinvigorate the lagging American economy. This was the first of several projects formulated to help artists, a group that had been particularly severely affected by the depression because of the "non-essential" nature of their work. The Public Works of Art Project, which paid artists for decorating public buildings, was funded by the Civil Works Administration, a division of the Treasury Department directed by Edward Bruce. The program lasted only six months, from December 1933 to June 1934, and employed a total of 3,749 artists. Although there were several notable exceptions, such as Arshile Gorky's murals for Newark Airport, most of the government-sponsored works of art were genre scenes celebrating the mythic—and at this point truly fictional—good life under American capitalism. The majority of the paintings were rural or pastoral images; they reflected the populist tendencies in painting that swept the country after Grant Wood's *American Gothic* was exhibited to tremendous popular acclaim at the Art Institute of Chicago in 1930.

Gutmann was privileged to have been chosen as the regional director of the PWAP in an area that had a sizable number of prominent artists. The assignment attests to his favorable political position in the community, as well as to

110. STUDY OF WOMAN IN BLACK, *1932*
Oil on canvas, 32 x 29 in. (81.3 x 73.7 cm)
Joseph Ambrose

his stature as an artist. As he poignantly explained to his daughter, however, Gutmann was ambivalent about the program:

> Of course you may have heard that the government has recognized the perilous position of the artists here and has set aside several million dollars for mural decorations to be done. I was asked by the school board and the selectmen of New Canaan to be chairman of the committee to see that they get the right stuff on the walls. It is a very difficult position because there are so few really good decorative painters and the payment by the government is no great inducement. It pays the house painters more than the artists. The artist naturally gets a little immortality out of it, at least as long as the buildings stand.[14]

Gutmann's tenure as chair of the committee lasted only several months, and he felt that little of substance had been accomplished by it.

Opposite:
109. NUDE WITH DRAPERY, *1925*
Oil on canvas, 32 x 29 in. (81.3 x 73.7 cm)
Private collection

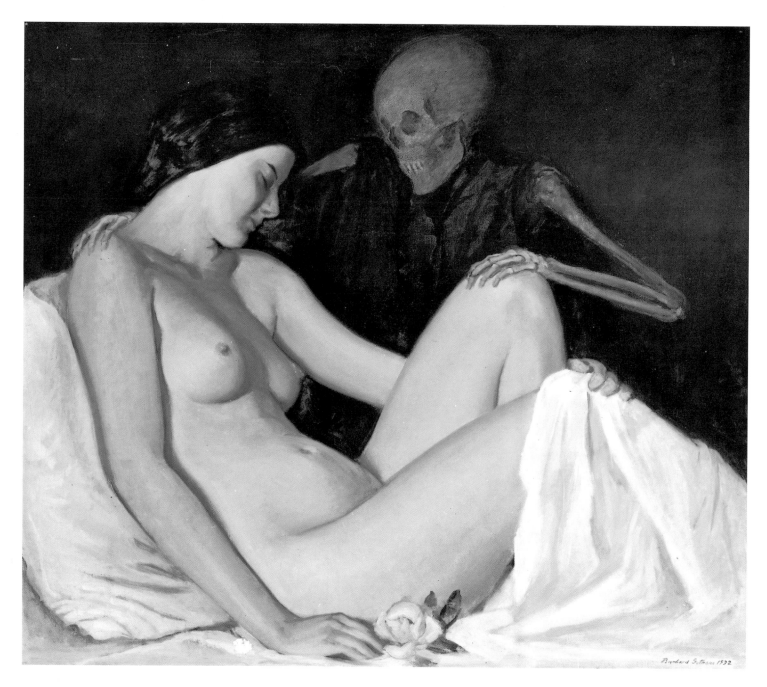

III. DARK DREAMS, *1932*
Oil on canvas, 33 x 37½ in. (83.8 x 95.3 cm)
Private collection

In this same letter Gutmann also described and made a schematic drawing of an unusual political allegory that he had recently painted, confessing his trepidation about this "protest painting." The six-foot-square composition apparently featured Christ crucified on a swastika, surrounded by symbolic figures of Nazis as well as protesting Catholic and Lutheran bishops, a rabbi holding the Ten Commandments, a pile of burning books, and a Valkyrie riding over the smoke. Gutmann exalted, "It is quite impressive as a propaganda picture."[15] The theme of destruction and the bleak mood of the painting is reminiscent of Gutmann's earlier *Destiny* and *Night Funeral;* it also

112. CEMETERY AT NIGHT, *n.d.*
Oil on canvas, 33 x 36¾ in. (83.8 x 93.4 cm)
Theodore Lehmann II

marks a turn in his work toward the political and away from the intimate scenes of personal life that dominate his earlier oeuvre. Drawings for other similarly startling paintings from the same period depict a naked woman being crucified (fig. 113) and a gigantic, swaggering, cigar-chomping male figure trampling on lilliputian vendors and street people.[16] These drawings are similar to the anti-German propaganda posters that proliferated in the United States during World War I, and which would resurface as anti-Nazi polemics during Hitler's takeover of Europe.[17]

A little more than a year before his death in early 1936, Gutmann wrote to his daughter to say that his artistic lethargy had brought on a fit of self-evaluation. He told her he was eliminating work he felt was unworthy of his legacy: "I destroyed any number of drawings and sketches and old lectures that have no meaning any more after the advent of the new movement. Soon I have to start in with the attic and burn all the old pictures that are not up to the mark. There still will be enough to fill a good size gallery."[18] This letter is particularly illuminating, as it demonstrates Gutmann's awareness of the vagaries of the art market and suggests that his depression was amplified by a feeling of inconsequence. Gutmann despaired that his work was not representative of the era in which he lived, that it reflected a sunnier moment, which had now been eclipsed.

On February 5, 1935, Gutmann wrote to Elizabeth in a more optimistic

vein: "I am now trying to find a little studio in New York. I always wanted to do some work there. It is rather late in the day, but I think I can still manage to do something worthwhile."[19] Gutmann found a place in New York at 955 Park Avenue, where he and Bertha could be close to her father and to good medical treatment, which both of them now needed. Gutmann's ambition to "do something worthwhile," however, was thwarted by the cancer that was destroying his health: he died in New York on January 23, 1936, at the age of sixty-six. Bertha survived him by only a few months. Gutmann's youthful dreams of a successful career as an artist in the United States came true, yet at the end of his life he was not fulfilled by the direction his career had taken, and he felt adrift in an anxious world on the brink of war. For most of his life, Bernhard Gutmann had lived well, full of the love and laughter that suffuses the rich body of his work. As he aged, the sunshine of his youth was darkened by the clouds of the depression, which brought pervasive illness, anxiety, and death.

Gutmann rejected the most advanced directions of early modernism, feeling that the contemporary art world, not he, had lost its way. He held fast to his own artistic ideals and his belief in the value of his work. His legacy attests to the validity of his vision; the majority of his paintings capture the spirit of an idyllic, peaceful world that charms us with its serenity, beauty, and vibrancy, while his later works offer meditations on death, decay, and the evils of the Nazi party. A committed and impassioned individual, Gutmann created a fusion of academic, Impressionist, and Post-Impressionist strategies that remains captivatingly original.

A letter written by his wife four years before Gutmann's death presents a perceptive analysis of his struggles and success:

> He overcame the bad habits of the academies, disciplined his own talent which had too early and too constantly brought success, gained knowledge of nature's truths and of himself and made his own discoveries. He became passionately engrossed in expressing the experience — his vision — always contending that an artist's output, if it is not to be largely derivative, must be based on visual experience. There followed years of leaving behind mere observed detail, leaving behind mere nature, of striving for those ever paradoxical qualities: simplicity, structure, volume, color, design. He read much, studied the old masters and the new masters. Though he copied no group and imitated nobody's manner, he studied them all, determined to understand both their aims and accomplishments and to learn whatever he could. Still he followed his own course, painting continuously. If ever he suspected that with knowledge and skill there was coming too great facility, he went back for a time, to his severe study of nature.[20]

Opposite:
113. CRUCIFIED NUDE, *n.d.*
Current location unknown

Catalog

FISHING DOCK, *1909*
Oil on canvas, 15 x 17 in. (38.1 x 43.2 cm)
Private collection

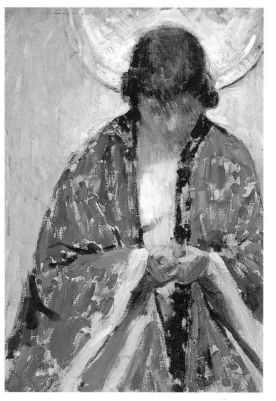

PRINCESS AND THE FROG, *n.d.*
Oil on canvas, 9⅜ x 7¼ in. (23.8 x 18.4 cm)
Private collection

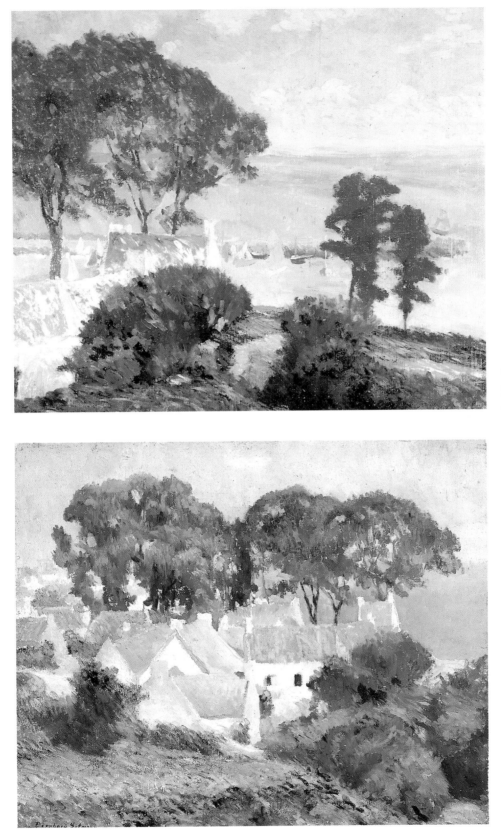

FRENCH JETTY, *n.d.*
Oil on canvas, 18⅛ x 21¾ in. (46 x 55.2 cm)
Private collection

FRENCH HOUSES, *n.d.*
Oil on canvas, 18 x 21¾ in. (45.7 x 55.2 cm)
Private collection

DOUARNENEZ, BRITTANY, *n.d.*
Oil on panel, 7¾ x 9½ in. (19.7 x 24 cm)
Michael Feddersen

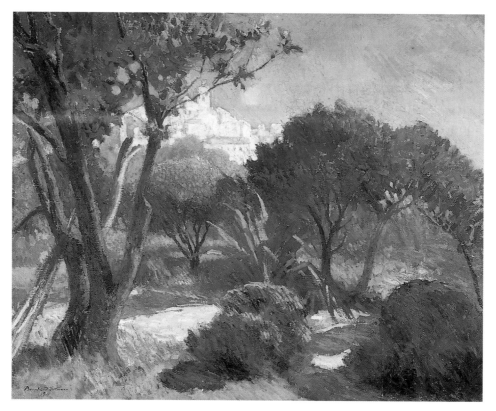

ITALIAN HILLTOP, *1911*
Oil on canvas, 25½ x 31⅞ in. (64.8 x 81 cm)
Private collection

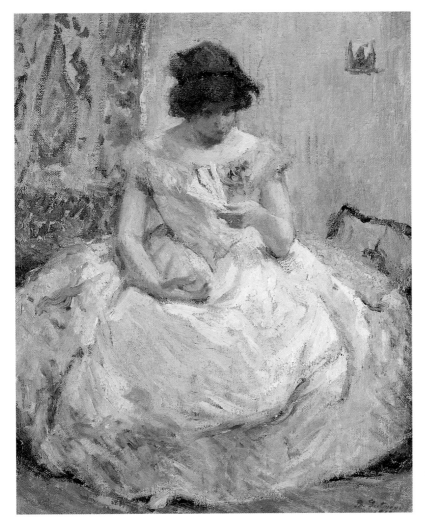

THE DOLL, *1912*
Oil on canvas, 16 x 13 in. (40.6 x 33 cm)
Private collection

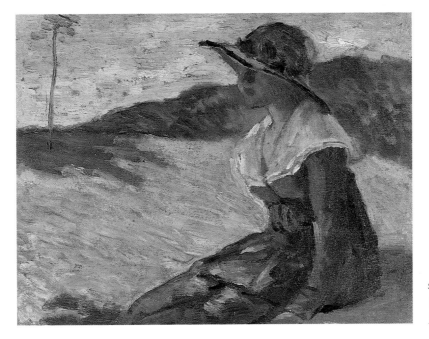

SEATED LADY, *n.d.*
Oil on wood, 8 x 10 in. (20.3 x 25.4 cm)
Private collection

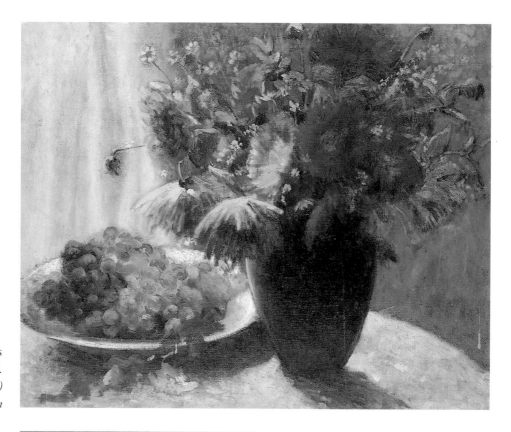

STILL LIFE, CHRYSANTHEMUMS
AND GRAPES, *n.d.*
Oil on canvas, 19⅝ x 23⅞ in. (49.8 x 60.6 cm)
Private collection

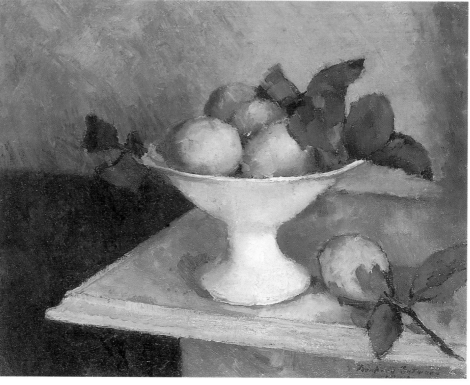

FOOTED BOWL WITH PEAR, *1912*
Oil on canvas, 15 x 18¼ in. (38.1 x 46.4 cm)
Joseph Ambrose

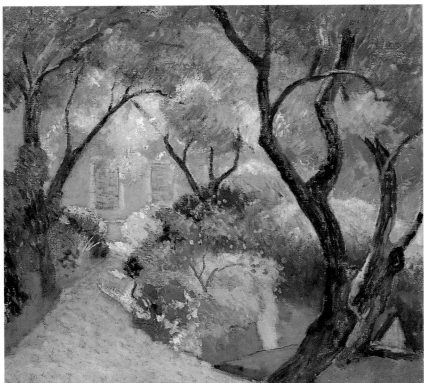

GARDEN PATH, *n.d.*
Oil on canvas, 23 x 25 in. (58.4 x 63.5 cm)
Private collection

ANCHORED IN THE COVE, *1924*
Oil on canvas, 25⅛ x 22¾ in. (63.8 x 57.8 cm)
Lyn and Michael Citron

SPANISH HOUSES, *1926*
Oil on canvas, 29 x 32⅛ in. (73.7 x 81.6 cm)
Private collection

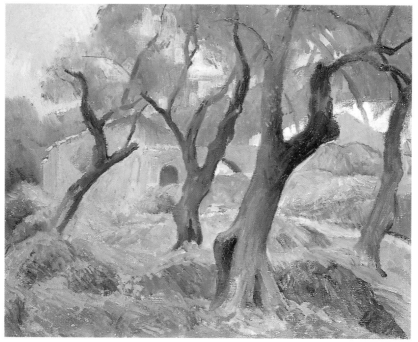

TREES IN SPAIN, *n.d.*
Oil on canvas, 16 x 20 in. (40.6 x 50.8 cm)
Private collection

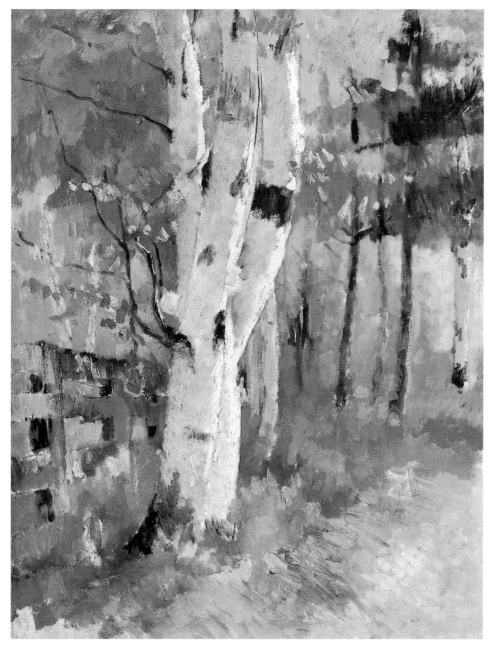

KEENE VALLEY, *n.d.*
Oil on wood, 13¾ x 10⅜ in. (34.9 x 26.7 cm)
Private collection

SKETCH, *n.d.*
Pencil on paper, 8 x 6½ in. (20.3 x 16.5 cm)
DeVille Galleries, Los Angeles

SKETCH, *n.d.*
Pencil on paper, 8 x 6½ in. (20.3 x 16.5 cm)
DeVille Galleries, Los Angeles

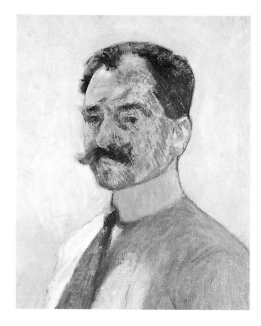

Chronology

1869

Bernhard Gutmann born September 24, Hamburg, Germany; son of Zadig and Elizabeth (Biesenthal) Gutmann.

1890

Studies at Royal Prussian Academy of Art, Düsseldorf.

1891

Attends State Academy of Fine Arts, Karlsruhe.

1892

April–June: visits Rotterdam, Haarlem (Frans Halsmuseum), Amsterdam. Paints out-of-doors, copies Frans Hals, paints cow in stall, life-size portrait of farmer.
Sails to United States on the steamship *Dania,* arriving in New York July 7; settles in Lynchburg, Virginia, with brother Ludwig, an engineer. Electrician for Piedmont Electrical Illuminating Company.

1893

Monday, December 4: petitions for American citizenship in Lynchburg, Virginia.

1894

Produces death mask of Confederate General Jubal A. Early.
Exhibits paintings in bookstore, Seabury, Moore & Co., on Main Street in Lynchburg.
Local citizens ask him to give critiques.

1895

March: forms private art class that becomes the Lynchburg Art League (known in the 1930s as the Lynchburg Civic Art League and by the 1950s as the Lynchburg Art Club).

Becomes first supervisor of drawing, Lynchburg public schools. Teaches drawing and painting, Lynchburg High School; writes manuals outlining course procedures for teaching art.

September: replaces Louise Smith, chairman of the art department, at Randolph-Macon Woman's College (established in 1893). Institutes class in art history.

1896

June 17: takes trip to St. Louis.

June 23: visits Chicago for brother's wedding. Returns to Virginia via Niagara Falls and New York City.

Fall: presents lecture, "Woman in Art," at Randolph-Macon Woman's College.

1897

Completes mural for library of Randolph-Macon Woman's College, *Wisdom Instructing Youth.*

Sunday, February 7: the *Lynchburg News* features Gutmann in an article titled "A Beautiful Painting," noting that "It will be a feature of the library at the college."

May 14: exhibits fifty paintings and more than one hundred studies, including some Lynchburg scenes, at art studio of Randolph-Macon Woman's College.

Paints "A Sister of Charity," a study in pastels.

April 20: receives faculty appreciation for painting.

October 5: writes E. Valentine, prominent Richmond citizen, to encourage institution of Virginia Society of the Fine Arts.

November 4: becomes naturalized American citizen in Lynchburg, showing proof of five years of residence.

Exhibits *Church Interior* at Art Institute of Chicago.

1898

Monday, January 24: Exhibits *Vanitas, Game Called, Solitude, Backyard Bay, A la Plain* [sic] *Air, Shadow,* and *Sunrise on the Ocean,* as well as book illustrations for Mary Tucker Magill's *Virginia History for the Young* in day-long exhibition at Lynchburg Art League.

Designs menus for chafing dish club.

Summer: teaches at Normal School in Charlottesville, Virginia.

November, December: publishes articles on art education in *North Carolina Journal of Education.*

1899

January, March, April: publishes articles in *North Carolina Journal of Education.*

Summer: teaches at Normal School in Charlottesville, Virginia.

Resigns from Lynchburg Art League.

Resigns as supervisor of drawing, Lynchburg public schools.

September: moves to New York.

1900

Establishes residence at 106 East 19th Street, New York City.
Studies at Art Students' League and/or Chase School of Art.

1902

Forms fine-art printing firm Gutmann and Gutmann, with brother Hellmuth.
Resides 19 East 21st Street, New York City.
Publishes six narrative illustrations in P. L. Gray, *In a Car of Gold,* with illustrations by
 Bernard [*sic*] Gutmann; Saalfield Publishing Co.

1903

Resides 223 East 18th Street. Business located at 19 East 21st Street, New York City.
Illustrates volume *Reflections of a Bachelor,* published by Dodge Publishing.
Halloween used as cover illustration for *The Mail & Express.*

1904

Resides 101 West 75th Street. Business located at 28 East 23rd Street, New York City.
Etching signed by President Theodore Roosevelt.
Completes eight covers (at least) for *Evening Mail,* New York: *A Good Slide,* January 9;
 A Rainy Day, April 16; *Mother and Child with Swans,* June 4; *The June Girl,* June 11;
 Helping Grandpa Celebrate, July 2; *Woman with Flowers and Parasol,* July 16; *Among the
 Lilies,* July 30; and *The Little Harvester,* September 10.
Illustrates postcard of automobile attached to balloon dirigible driving over telephone wires
 while onlookers gesture from below.

1905

Publishes metamorphic postcard *In the Midst of Life We Are in Death.*

1906

January: returns to Hamburg for father's eightieth birthday. Visits Berlin, Bremen, Cologne,
 Düsseldorf, and Karlsruhe.
July 14: Hellmuth marries Bessie Pease. Bernhard witnesses marriage.

1907

January 31: marries Bertha Goldman, daughter of Julius Goldman. Wedding trip to Massa-
 chusetts. Newlyweds sail to Europe, visit Germany, settle in Paris.

1908

Drawings of Breton peasants at Pont-Aven and Pont-Croix in sketchbooks.
Exhibition at Macbeth Gallery in New York featuring works by the Eight—Arthur B.
 Davies, Robert Henri, and others—creates a furor over the so-called Ashcan school of
 painting.

1909

Resides in Paris, collects Oriental objects. Includes them in still-life paintings.

1910

August 16–30: exhibits genre, landscapes, still life at 11 bis, rue Boissonade, Paris, with Boris de Romanovsky and E. Murray Mackay.

1911

April 3: daughter Elizabeth born, Paris.
Exhibits *Bébé* at Salon des Beaux-Arts, Grand Palais, Paris.

1912

Spends several months in Bordighera, Italy.
Returns to United States.
Resides 24 East 21st Street in New York City.
Exhibits *The Baby* at 116th annual of the Pennsylvania Academy of the Fine Arts.

1913

Moves to Silvermine, Connecticut.
February 17–March 15: exhibits *In the Garden,* International Exhibition of Modern Art, Sixty-ninth Regiment Armory.
Exhibits *Breton Lacemakers* and *Breton Fishing Boats,* Pennsylvania Academy of the Fine Arts annual.
Exhibits *Fishing Boats,* Art Institute of Chicago Annual.

1914

Reviewed in *International Studio,* February 1914, pp. 205–7.
March 2–14: exhibition, Arlington Art Galleries, 274 Madison Avenue.
Exhibits *Elizabeth,* winter exhibit of National Academy of Design.
Exhibits *Breton Baby,* Fifth Annual Corcoran Gallery of Art Biennial, Washington, D.C.
Exhibits *Evening, Bordighera,* Pennsylvania Academy of the Fine Arts annual.

1915

Exhibits *A Nude;* later called *Nude with Parrot,* Panama-Pacific International Exposition.
Exhibits in group show at MacDowell Club, New York.
Moves into new home in Silvermine.
Work reviewed, "At the MacDowell," *New York Evening Mail,* January 23.
Exhibits *Bashful,* "a portrait of his little girl," and *Carnations* (possibly *Carnations in White Vase,* 1912) in Eighth Annual exhibition of Silvermine Group in studio of sculptor Solon Borglum.
September: Silvermine show reviewed, *New York Sun.*
Exhibits *Downhill* (probably also known as *Down Hill*), Art Institute of Chicago Annual.

1916

Exhibits *The Sun Parlor,* Art Institute of Chicago Annual.
May 3–25: exhibits Brittany peasants and *The Breakfast Room* (also known as *The Breakfast Table* and *The Breakfast Hour*), Allied Artists of America, Fine Arts Galleries, 215 West 57th Street.
Anderson Galleries (March) showcases American modernism.
Exhibits with New Canaan Society of Artists.

1917

April: exhibits *Fall Morning* at Salmagundi Club, New York.

April–May: joins Society of Independent Artists, exhibits *Crocheting* and *The Old Window* in first annual exhibition, Grand Central Palace. Duchamp exhibits urinal, entitled *Fountain,* causing scandal.

1918

April: exhibits a nude at the second annual exhibition of the Society of Independent Artists, 114 West 42nd Street; it is mentioned in April 20 issue of *New York Globe.*

June: donates "typical work" to Great Allied Bazaar. Appears in *New York Globe,* "Art and Artists: Some Notable Pictures at the Great Allied Bazaar."

Designs costumes and sets for the Silvermine Players, to support Red Cross.

September: paints billboard in support of campaign for Fourth Liberty Loan in New Canaan, Connecticut, with "liberty loan" hourglass and a portrait of Uncle Sam.

1919

January–February 10: exhibited *Flowers,* sixth annual exhibition of Allied Artists of America, 215 West 57th Street, New York.

November 5: daughter Dorothea Hetty is born.

Exhibits *Black and White* and *Sun Spots* at the third annual exhibition of the Society of Independent Artists.

1920

January: one-person show at Folsom Galleries, 560 Fifth Avenue, featuring flower paintings.

January: reviewed in *New York American, New York Globe, New York Evening Sun,* and *New York Times.*

1921

Visits Florida, impersonates Arab in costume drama film.

Visits Monhegan Island, Maine.

1922

Founding member, Silvermine Guild of Artists.

December: visits Alicante, Spain.

1923

Fall: settles in Palma, the capital of Mallorca.

November: visits Carcassonne.

1924

Resides in Mallorca.

Spring: moves to Paris.

1925

Exhibits at Bernheim-Jeune Gallery, Paris. Notice in *Revue des Indépendants.*

Returns to Silvermine.

Elected president of the Silvermine Guild of Artists.

March: exhibits *Birches, Peonies, New York House Tops, and The Spinner* to the Lynchburg Art Club.

December 4: exhibits in Lynchburg, Virginia. Delivers lecture, "Individualism in Art" to the Women's Club.

Lynchburg News, Saturday morning, December 10, page 3:

America shares in the renaissance of individualism in art which today is one of the great periods in art, while in other fields standardization and organization prevail. The art trend today is toward appreciation of, and opportunity for, the individual in art as in the day of the Old Masters.

1926

Exhibits etchings at Wellesley College.

December: exhibits *Night Funeral, Mallor[c]a* and *Chimney Pots, Paris* in eleventh annual exhibition of Brooklyn Society of Etchers at the Brooklyn Museum.

1927

October 1: *Autumn* appears on the cover of *Literary Digest.*

November 15–28: paintings of Mallorca exhibited at the Macbeth Gallery, 15 East 57th Street, New York.

1928

September 11: *Norwalk Hour* reproduces *Two Natures (Self-Portrait).*

September 13: lecture, "From the Artist's Point of View," at Darien Guild of the Seven Arts, and exhibition of *Destiny, Night Funeral, The Artist's Family, Drying the Blue Nets, End of the Rainbow, Church and Commerce,* and *Poetry.*

Makes portfolio of etchings of their children and grandchildren for Julius and Sarah Goldman's golden wedding anniversary.

1929

October 29: "Black Tuesday," collapse of stock market.

December 25: leaves for Egypt, stays through March 30, 1930.

1930

Winter: Egypt; creates portfolio of drawings, watercolors, gouache. Makes film of Egypt.

August: exhibits with Silvermine Guild.

1931

January: exhibits *Gramercy Park* at fifteenth annual Brooklyn Society of Etchers exhibition, Brooklyn Museum.

Exhibits *Homo Sum,* Society of Independent Artists.

August 26: patent extended for copyright of *A Return Trip into the Fourth Dimension,* a play in four parts with two characters who travel into outer space and return younger than when they left.

1932

November 20–December 4: solo exhibition at Ferargil Gallery. Shows *Two Natures (Self-Portrait)*. Reviews in *New York Times, Post, Tribune*.

Paints portrait of Mr. Sainsbury, a WWI aviator, and a portrait of Mr. and Mrs. Daggy.

1933

February 25: *The Breakfast Room* appears on the cover of *Literary Digest*.

Exhibits with Silvermine group at Montross Gallery, New York.

Paints portrait of a Mrs. Kirby and of Judge Benjamin Cardozo, makes a large (10 × 13 in.) etching of portrait.

1934

Appointed regional director of the Public Works of Art Project for New Canaan, Connecticut.

Donates painting to Domestic Science Room, Henry W. Saxe High School, Norwalk, Connecticut.

Exhibits *The Blue Teacup* with the Lynchburg Art Club at University of Virginia in Charlottesville.

Inherits seventeenth-century tapestries from Bertha's Aunt Rebekah.

February 13: paints large picture of Christ on swastika.

September 24: receives cigars and cigarette box for birthday.

Visits Museum of Fine Arts, Boston.

Bertha diagnosed with pernicious anemia.

December: Bertha's mother dies.

1935

Rents studio in New York.

1936

Dies January 23, New York City.

1938

February: memorial exhibition at Vanderbilt Art Gallery, American Fine Arts Society, New York. Catalog foreword by brother-in-law Ashton Sanborn, secretary of Museum of Fine Arts, Boston.

Acknowledgments

MY RESEARCH on Bernhard Gutmann's life and work has expanded my personal and professional life by introducing me to a wonderful group of people who have facilitated my search in numerous major and minor ways. My deepest thanks go to Christian Title, whose vision inspired and supported this intellectual endeavor, and to Lyn Lincoln Citron, who introduced me to the joys of Gutmann's work. Their friendship and hospitality, along with that of Lyn's husband Michael Citron and Chris's wife Joyce, has been one of the happiest experiences of this project. My acquaintance with Chris and Lyn was orchestrated by Bill Gerdts, whose life and work have been an inspiration to me and whose long-standing friendship I cherish. I appreciate his confidence and support.

I am fortunate to have had the cooperation of Bernhard Gutmann's two grandsons, Theodore Lehmann II and John Mollenhauer, who provided invaluable insights and material. Ted and his wife Irene kindly opened up their home and family archives to me. John Mollenhauer made it possible for me to see the works in his mother's estate. I cannot thank them enough.

Several devoted collectors were also kind to let me into their homes to see their paintings. Joseph Ambrose of Los Angeles has an extensive collection of Gutmann's work, and was especially helpful in tracking down information. I appreciate all of his help and encouragement. Mr. and Mrs. Norman Gilfinbane and Mr. and Mrs. Lewis Shepherd, all of Los Angeles, kindly allowed me access to their works. Elizabeth Gutmann's friend Jean Milgram provided illustrations of her important painting and Victor Christie lent insight into the work of Bessie Pease Gutmann. I am also grateful to the staff members of Colville Publishers and the DeVille Galleries in Los Angeles, es-

pecially Lisa Warnstedt and Diane Ballard. Special thanks to Abigail Asher for her expert marshalling of the morass of details to get the manuscript to press. Thanks also to Alice Gray for restructuring the text, to John Berry for his creative design, and to Lou Bilka for seeing the book through production.

I owe a debt of gratitude to the many people who provided information to make my work possible and I thank all of them.

My colleagues in the library at Montgomery College, Rockville, Maryland, have been diligent in their search for materials about Bernhard Gutmann. Bonnie Favin's heroic on-line searches were especially important, as were the contributions of Douglas Williams and Linda Fortney. Susan Diller, administrative assistant in the art department, lent invaluable indirect support.

Gutmann's years in Lynchburg were investigated with the aid of: emeritus professor Mary Francis Williams, Mary Ellett, director of the Maier Museum of Art, Ellen Agnew, and professor Mary Anne Doezema, Randolph-Macon Woman's College; Linda Williams, E.C. Glass High School; Louis Averett, Jones Memorial Library; Clifton Potter; Jeanne Kelly Massey; and Richard L. Snell, Lynchburg Art Club.

Archivists and scholars who answered my queries included Linda Ferber, Linda Kramer, and Debra Wyethe, the Brooklyn Museum; Cheryl Leibold, the Pennsylvania Academy of the Fine Arts; Nancy Helle, the Silvermine Guild Art Center; David Dearinger, the National Academy of Design; Althea Huber, the Art Institute of Chicago; Margaret Carney, the Museum of Ceramic Art at Alfred, Alfred University; Hildegarde Cumming, the Benton Museum, University of Connecticut.

As always my friends and family have quickly responded to my requests for information and support, and I could not have succeeded without their help. My special thanks to my intellectual ally Barbara A. Wolanin, who read the manuscript and contributed her editorial and art-historical expertise to its completion; her son Peter Wolanin, who made it possible for me to produce the text by upgrading my computer; Lynn Mallonee, who kindly typed the chronology; my colleague Linda Skalet, who generously scouted out Gutmann's painting in Deya, Mallorca, to bring me slides of it; Liza Kirwin at the Archives of American Art, who responded to my last-minute queries for information, as did Bruce Weber and David Sellin; Elaine Tarleton, who made exhaustive searches in the Library of Congress; Ronald Pisano, who helped with information on William M. Chase and the Art Students League; and my brother Roger Randolph North, who contributed information on German and American history. My greatest debt is to my devoted parents Leona Kappler North and William Randolph North, Jr., who have never failed to fulfill my persistent requests and whose love and confidence has sustained me in all of my endeavors. My gratitude to them is boundless and eternal.

PERCY NORTH

Notes

PREFACE

1. Dorothea Gutmann Mollenhauer refers to it as his death mask in her *Notes*, 1983, p. ii, but it looks more like a carnival mask.

CHAPTER 1

1. Bernhard Gutmann, "Memories from 1869–?" p. 118. This unpublished manuscript—which begins as a social memoir and becomes a journal later on—is copiously illustrated with whimsical drawings that explain or expand the text, and also includes several clippings. Gutmann's letters were often similarly illuminated. The memoir was probably begun in 1892 and appended until 1907, when he married Bertha Goldman. It ends with a note expressing his wish that his wife continue to document his life. The text was transcribed by William Arntz and translated by Adam Rosenbaum in 1993. Private collection.

2. Although Bernhard Gutmann completed the course, he left without receiving his certificate. Gutmann, "Memories," p. 16.

3. Professor Heinrich Lauenstein (1835–1910) was a professor in the elementary class at the Düsseldorf Academy from 1881.

4. Gutmann, "Memories," p. 76.

5. Gutmann, "Memories," p. 84.

6. Karl Theodor Boehme (1866–1892), just three years older than Bernhard Gutmann, was also born in Hamburg. A marine painter at the Karlsruhe Academy, Boehme died at the age of twenty-six the same year that Gutmann emigrated to the United States.

7. "The Art League, an Attractive Exhibition of Pictures by Lynchburg Artists," anonymous clipping appended to Gutmann's "Memories."

8. Gutmann, "Memories," p. 70.

9. In his "Memories," pp. 71–72, Gutmann recounts that a Count Schonborn (?) paid him 100 marks for drawing a portrait of the count's sister from a photograph.

10. Sketches of Hamburg from 1889 are in the estate of Gutmann's younger daughter, Dorothea Gutmann Mollenhauer, Wilton, Connecticut.

11. Born in Detroit, Gari Melchers entered the Düsseldorf Academy of Art in 1877, ten years prior to Gutmann, and set up a studio in Egmond-aan-Zee, Holland, in 1884, where he would have been in residence at the time of Gutmann's painting excursion to Holland.

12. A landscape and genre painter, George Hitchcock was a specialist in painting tulips and pictures of young girls. Born in Providence, Rhode Island, he studied painting in the atelier of the famed Adolphe William Bouguereau in Paris and at the Düsseldorf Academy in 1880. He shared a studio in Holland with Gari Melchers, dividing his time between Paris and Holland until his death in 1913.

13. Gutmann, "Memories," p. 100.

14. Gutmann sailed on the steamship *Dania* with around twenty-five other passengers. In a typical gesture of congeniality, he hand-lettered and decorated the ship's menu for July 7, 1892. A copy of this is in Gutmann, "Memories."

15. Gutmann, "Memories," p. 126.

16. Gutmann, "Memories," p. 128.

17. Gutmann, "Memories," p. 132.

18. Gutmann, "Memories," p. 134.

19. Sketches given by Gutmann to the E.C. Glass High School in Lynchburg. Other sketches by Gutmann of African-Americans dating from around 1893 are in a sketchbook in a private collection.

20. Gutmann, "Memories," p. 164.

21. Ruth Holmes Blunt, *The Lynchburg Art Club and Its Affiliates* (Lynchburg, Va.: Mutual Press, 1962), p. 12.

22. Inexperienced with plaster, Bernhard experimented on his brother Ludwig, but nearly killed him when the paper breathing cone that he had devised collapsed under the weight of the plaster. For the death mask, Gutmann solicited the plaster-making services of a local dentist, who was equally inept. Although the plaster was quite thin, the mask was finally completed. Gutmann, "Memories," pp. 144–45.

23. From an undated newspaper clipping, "General Early's Death Mask," in Gutmann's scrapbook. Private collection.

24. Colonel Lawrence S. Marye, "General Jubal Anderson Early," *Southern Magazine* (Richmond, Va.), July 25, 1894, pp. 465–74. Gutmann's drawings of General Early include a drawing of the death mask, a drawing copied from an 1863 photograph, and an illustration of Early as an old man labeled "Drawn from life."

25. Evelyn Moore and Ruth Holmes Hunt, "Composition, Color, and Sometimes Humor: Artist Bernhard Gutmann of Lynchburg," *Virginia Cavalcade* 31, no. 4 (Spring 1982): 206–15.

26. Bernhard Gutmann, "A New Idea and One That Would Lead to Good Results if Properly Worked Out," undated clipping from *Lynchburg News* in Gutmann, "Memories." The article proposes that there should be an art exhibition open to the public in Lynchburg.

27. An undated manuscript among the Gutmann papers, presumably the text for a public lecture, begins with the assertion that Glass invited Gutmann to lecture on the necessity for drawing since Glass intended to institute a course in drawing in the public school system. This must have been given in 1895, since Gutmann was hired as instructor and supervisor of drawing that fall.

28. Designs for cast-iron candlesticks and railings with floral motifs in the Art Nouveau style are in the estate of Dorothea Gutmann Mollenhauer.

29. The essays were originally scheduled to appear in twelve editions of the *North Carolina Journal of Education*: "Influence of 'Drawing' on Every-day Life," 2, no. 4 (November 1898): 16–18; "Drawing in Primary Grades, II," 2, no. 6, (January 1898 [*sic*—it should be 1899]: 13–15; "Drawing in the Lower Grammar Grades," 2, no. 8 (March 1899): 13–15; and "Drawing in Grammar Grades, IV," 2, no. 9 (April 1899): 10–12 are among the Gutmann papers.

30. For the program, Gutmann articulated his position on the nature and teaching of art:
 The purpose of the School of Art is not only to give students a knowledge of drawing, painting and modeling, but to develop their power of imagination, observation, and appreciation of the true and beautiful. The time of the student is devoted to the study of principles which underlie all true work [*sic*] of art, and their application in well-graded exercises. It is not diverted to making decorations. The method is the same as that used now in the best art schools of the world. Special stress is laid upon the developing of originality in the student through suitable correction and themes of composition which may be executed in any technic [*sic*] or genre.
 Blunt, *Lynchburg Art Club*, p. 15.

31. Gutmann, "Memories," p. 168. "There's an entire little art gallery here as well in which one can find a couple of very good and many average things. It appears that also here only very few people know about real art; it is all business."

32. Gutmann, "Memories," p. 172.

33. Gutmann, "Memories," p. 171.

34. Gutmann, "Memories," pp. 173–74.

35. Gutmann, "Memories," p. 175.

36. Ibid.

37. Bernhard Gutmann, "Woman in Art," lecture for students at Randolph-Macon Woman's College, Fall 1896, handwritten manuscript in the Gutmann papers.

38. Numerous enquiries about this painting have failed to yield any information on its whereabouts.

39. Blunt, *Lynchburg Art Club*, pp. 6–7.

40. Gutmann, "Memories," p. 179.

41. Blunt, *Lynchburg Art Club,* p. 9.

42. Blunt, *Lynchburg Art Club,* p. 26. Gutmann was president of the Silvermine Guild of Artists when he returned to Lynchburg and was hailed as a prominent native son, despite the brevity of his residence in the city. Gutmann retained a special affinity for Lynchburg because it was his first home in the United States.

43. A clipping of "German Student Life" is in Gutmann's "Memories."

44. Gutmann, "Memories," p. 187.

45. Exhibited at the Arlington Art Galleries in 1914 as *Breton Woman with Baby,* it was illustrated as *Old Lady with Child* in W.H. de B. Nelson, "A Painter in Pure Colour: Bernhard Gutmann," *International Studio,* February 1914, p. 206.

CHAPTER 2

1. Gutmann, "Memories," p. 187.

2. Ibid.

3. Neither of these institutions has any record of Gutmann's attendance, but these records are not completely reliable.

4. If the illustration was published, it must have been for a rare special edition. An extensive search has failed to locate it.

5. Gutmann, "Memories," p. 198.

6. Ibid.

7. Gutmann, "Memories," p. 194.

8. Ibid.

9. Gutmann, "Memories," p. 195.

10. Rudolf Herzog, *Im Fasching des Lebens Kunstler Geschichten,* Berlin: Richard Edstein Nach Folger, n.d.

11. Gutmann, "Memories," p. 198.

12. Her handwriting is even more difficult to decipher than his.

13. The building is currently used for the offices of a travel company.

14. Dorothea Mollenhauer, "Notes about Bernhard Gutmann," (typewritten memoir, private collection). Summer 1983, pp. ii–iii. This seems to be a very vivid memory for a young child and it must have become family lore; it is easy to understand why she might not remember his response to Stein's paintings.

15. It is difficult to tell from the date on this painting whether it is 1902 or 1907.

16. In her memoir, Dorothea Gutmann Mollenhauer explained that Gutmann had collected Japanese prints in Paris, "at the same time as the French Impressionists." Although the French Impressionists had begun acquiring Japanese prints at least fifty years before Gutmann, he was following a sanctioned tradition of collecting non-Western objects.

17. Gutmann's contemporary, American modernist Alfred Maurer (1868–1932), won national awards for his similar early paintings of elegant women in beautiful interiors before his conversion to Fauvism in 1907.

18. Also known as *Paris Morning, November 27, 1911.*

CHAPTER 3

1. A letter from Gutmann to William Macbeth, director of the Macbeth Gallery, February 11, 1913 (Archives of American Art, reel NMC7, frame 181), indicates that the dealer suggested to Gutmann that he submit works to these exhibitions.

2. Dorothea Gutmann Mollenhauer described her father's discussions about modern art long after the Armory Show in "Notes about Bernhard Gutmann" (typewritten memoir in two sections, private collection), October 9, 1984, pp. 4–5: "If the visitors were artists, the show of recent works would inevitably end in an animated discussion of how terrible the present state of the art world was—Dadaism—Futurism—all the isms. People had forgotten what a work of art was, the public was ignorant, the critics were ignorant."

3. Her attire includes a white cap reminiscent of the bonnets worn by the Breton children Gutmann had painted in France.

4. *Breton Lacemakers* is now in the collection of the Terra Museum of American Art. It was the first of Gutmann's works to be purchased by a museum.

5. A photograph similar to this painting indicates that Gutmann used photographs as well as small oil studies as memory cues for the paintings he created in his Paris studio. Gutmann papers.

6. Beginning in the 1890s, Connecticut was an important center for American Impressionist activity. Although rural and pastoral, it was still close enough to New York to allow artists to spend the day visiting the city's museums and galleries. J. Alden Weir's farm, which has become a national landmark, is in Wilton. There were also flourishing art centers in Old Lyme and New Canaan, and John Twachtman had a summer school in Cos Cob until his death in 1902.

7. "Exhibition of Paintings by Bernhard Gutmann, Arlington Art Galleries, 274 Madison Avenue, March 2–March 14, 1914."

8. W. H. de B. Nelson, "A Painter in Pure Colour: Bernhard Gutmann," *International Studio,* pp. 205–7.

9. This painting was illustrated in *International Studio,* where it was referred to as *Five Girls by the Sea.* The titles changed even between the exhibition brochure and the article on Gutmann in the same year. It is not surprising, then, to find even later title confusions.

10. Later paintings of the same scene have been mistitled *Marseilles.*

11. Formerly referred to as *Afternoon, Marseilles.*

12. Critics from the *New York Evening Post* (March 7, 1914) and the *Brooklyn Daily Eagle* (March 4, 1916) were more charitable: the *Post* critic described "a large 'Nude' that was painted with apparently no shadows, a decided feat in itself," while the *Daily Eagle* stated that "in his most ambitious painting, a nude figure, Mr. Gutmann shows that he is not at all unwilling to attack a most difficult subject and complete it to the best of his ability."

13. *Evening, Bordighera* was also exhibited at the 118th annual exhibition at the Pennsylvania Academy of the Fine Arts in 1914. There is a Pennsylvania Academy of the Fine Arts label on the back of the painting owned by Theodore Lehmann II.

14. Undated clipping from the *New York Tribune* among the Gutmann papers.

15. This may also have been the painting that Gutmann exhibited at the Pennsylvania Academy of the Fine Arts in 1912.

16. The chair appears in numerous Gutmann paintings, including portraits of Elizabeth and a painting of a ballerina.

17. William H. Gerdts, "American Impressionism," in Norma Broude, ed., *World Impressionism: The International Movement, 1860–1920* (New York: Harry N. Abrams, 1990), p. 66.

18. In the exhibition catalog, Frieseke's nude is illustrated on the page facing Gutmann's entry.

19. Mollenhauer, "Notes," 1984, p. 2.

20. Untitled clipping from *New York Globe,* 1916, among the Gutmann papers.

21. Mollenhauer, "Notes," Summer 1983, p. 1b: "The sunny dining room was the only major room in the house that didn't have any pictures at all. It was really more like a glazed dining porch, two walls being glass while the inner walls were white clapboard like the outside of the house."

22. Untitled clipping from *New York Globe,* January 1920, among the Gutmann papers. *Literary Digest* 115, no. 8 (February 25, 1933).

23. "Art and Artists: A Visit to the Independent Artists Exhibition," *New York Globe,* April 20, 1918.

24. Untitled clipping from *New York Globe,* April 26, 1918, among the Gutmann papers.

25. "Art and Artists: Some Notable Pictures at the Great Allied Bazaar," *New York Globe,* June 6, 1918.

26. "$211,200 Our Goal for Fourth Loan," *New Canaan Advertizer,* September 28, 1918.

27. W.G. Bowdoin, "Allied Artists of America Hold 6th Annual Show," *New York Evening World,* January 23, 1919.

CHAPTER 4

1. An illustrated letter from Gutmann, dated January 13, 1920, proposes a rationale for Gutmann's wanderlust. In the letter he depicts himself simultaneously holding a bottle in the mouth of a baby in a cradle and painting a picture of a baby bottle on a canvas at an easel. A tag attached to the picture says "still life," a designation for the baby bottle as well as for the artist. The letter describes the chores foisted on the Gutmanns by their newborn baby, despite the presence of several servants, including a nursemaid who is depicted enjoying Gutmann's favorite activity, skating.

2. Untitled article from *New York Globe,* January 23, 1920.

3. Untitled article from *New York American,* January 5, 1920.

4. "Gutman [*sic*] Paintings at Folsom Galleries, Brilliant Color in Canvases by Silvermine Painter," *New York Evening Sun,* January 30, 1920.

5. Mollenhauer, "Notes," October 9, 1984, p. 1.

6. Letter from Bernhard Gutmann to Elizabeth Gutmann, June 13, 1924?

7. Letter from Bernhard Gutmann to Elizabeth Gutmann, June 13, 1924?

8. Saint Anthony, who was tempted by demons in the guise of lascivious women, is not the patron saint of animals.

9. Letter from Bernhard Gutmann to Elizabeth Gutmann, January 17, 1924.

10. Information courtesy of Dr. Linda Skalet, who photographed the painting in Deya.

11. Honoré Broutelle, "Chronique artistique B. Gutmann," *Revue des Indépendants,* 7th ed., 1925, pp. 158–59.

12. H. Broutelle, *Paintings of Mallorca by Bernhard Gutmann* (New York: Macbeth Gallery, 1927).

13. Clipping from unknown publication, "Art Exhibition: Bernhard Gutmann Paintings Shown at Macbeth Gallery New York city [*sic*]. Several Sold," November 1927, among the Gutmann papers.

14. Bernhard Gutmann, *Autumn,* illustration in *Literary Digest* 95, no. 1 (October 1, 1927).

15. "Artist in Two Natures," *Norwalk Hour,* September 11, 1928.

16. *New York Times,* September 9, 1928. Reprinted in "Artist in Two Natures," *Norwalk Hour.* Dorothea Gutmann Mollenhauer referred to it as his death mask in her "Notes," 1983, p. 2, but it looks more like a carnival mask.

17. Ashton Sanborn, *The Works of Bernhard Gutmann: Memorial Exhibition* (New York: Vanderbilt Gallery, 1938).

18. Also known as *Evening Shadows, Processional.*

19. A label from the exhibition is on the stretcher of the painting, although this work was not mentioned in the newspaper review.

CHAPTER 5

1. Bertha's diary relates the names of the sites they visited and the people they met.

2. A portfolio of watercolor drawings of the musicians, which appear to be preparatory drawings for a painting to have been finished later in his studio, is in the estate of Dorothea Gutmann Mollenhauer.

3. Dorothea Gutmann Mollenhauer, "Notes," October 9, 1984, p. 1.

4. The letters are in the collection of Elizabeth's son, Theodore Lehmann II.

5. This was probably leukemia.

6. From this vantage point it is ironic to know that Gutmann was especially pleased with the gifts of cigars and a cigarette box from his wife and daughter for his birthday in 1934.

7. Letter from Bernhard Gutmann to Elizabeth Gutmann, October 3, 1932.

8. Ibid.

9. Letter from Bernhard Gutmann to Elizabeth Gutmann, November 28, 1932.

10. "Around the Galleries," *The Art News* 31 (December 3, 1932): 6.

11. Letter from Bernhard Gutmann to Elizabeth Gutmann, March 18, 1933.

12. Letter from Bernhard Gutmann to Elizabeth Gutmann, December 5, 1933.

13. Letter from Bernhard Gutmann to Elizabeth Gutmann, December 14, 1933.

14. Letter from Bernhard Gutmann to Elizabeth Gutmann, February 13, 1934.

15. Ibid. This painting has not been located.

16. These three drawings are in the estate of Dorothea Gutmann Mollenhauer.

17. Dr. Barbara A. Wolanin noted their similarities to propaganda posters.

18. Letter from Bernhard Gutmann to Elizabeth Gutmann, November 6, 1934.

19. Letter from Bernhard Gutmann to Elizabeth Gutmann, February 5, 1935.

20. Draft of letter from Bertha Gutmann to a Miss Lambert, September 25, 1932.

Bibliography

UNPUBLISHED SOURCES

Gutmann, Bernhard. "Memories from 1869–?." Unpublished memoir / journal written in German, copiously illustrated, includes several clippings, probably begun in 1892, last entry 1907. Text transcribed by William Arntz and translated by Adam Rosenbaum in 1993. Private collection.

———. Letters to Elizabeth Gutmann. Collection of Theodore Lehmann II.

Gutmann, Bertha Goldman. Diary of Egyptian travel, December 1929 to March 1930. Collection of Theodore Lehmann.

Mollenhauer, Dorothea Gutmann. "Notes about Bernhard Gutmann." Typewritten memoir in two sections, summer 1983 and October 9, 1984. Collection of John Mollenhauer.

ARTICLES BY BERNHARD GUTMANN

"Influence of 'Drawing' on Every-day Life." *North Carolina Journal of Education* 2, no. 4 (November 1898): 16–18.

"Drawing in Primary Grades." *North Carolina Journal of Education* 2, no. 5 (December 1898): 6–8.

"Drawing in Primary Grades," II. *North Carolina Journal of Education* 2, no. 6 (January 1898 [*sic*—it should be 1899]): 13–15.

"Drawing in the Lower Grammar Grades." *North Carolina Journal of Education* 2, no. 8 (March 1899): 13–15.

"Drawing in Grammar Grades, IV," *North Carolina Journal of Education* 2, no. 9 (April 1899): 10–12.

BOOKS AND ARTICLES ILLUSTRATED BY BERNHARD GUTMANN

Gray, P. L. *In a Car of Gold.* Saalfield Publishing, 1902.

Kildare, Owen. The Talmud Man from Wilna. *Pearsons,* December 1905.

Magill, Mary Tucker. *Virginia History for the Young.* Lynchburg, Va.: J. P. Bell, 1897.

Marye, Colonel Lawrence S. General Jubal Anderson Early. *Southern Magazine* (Richmond, Va.), July 11, 1894, pp. 465–74.

Reflections of a Bachelor. New York: Dodge Publishing, 1903.

Stoddart, Alex McD. "His First Day." *Pearsons* 14, no. 4 (October 1905): 328–33.

GENERAL SOURCES

Beyerle, Frances Adams, and Janet Shaffer. *A Legacy of Learning: The Lynchburg Public Schools, 1871–1986.* Lynchburg, Va.: Lynchburg School Board, 1987.

Blunt, Ruth Holmes. *The Lynchburg Art Club and Its Affiliates.* Lynchburg, Va.: Mutual Press, 1962.

Boyle, Richard J. *American Impressionism.* Boston: New York Graphic Society, 1974.

Broude, Norma, ed. *World Impressionism: The International Movement, 1860–1920.* New York: Harry N. Abrams, 1990.

Broutelle, Honoré. "Chronique Artistique B. Gutmann," *Revue des Indépendants* 7 (1925?).

———. *Paintings of Mallorca by Bernhard Gutmann.* New York: Macbeth Gallery, 1927.

Christie, Victor J. W. *Bessie Pease Gutmann: Her Life and Works.* Radnor, Pa.: Wallace-Homestead, 1990.

Cornelius, Roberta D. *The History of Randolph-Macon Woman's College.* Chapel Hill: University of North Carolina Press, 1951.

Domit, Moussa. *American Impressionist Painting.* Washington, D.C.: National Gallery of Art, 1973.

Gerdts, William H. *American Impressionism.* New York: Abbeville Press, 1984.

Hall-Duncan, Nancy. *The Enlightened Eye: Impressionism in Connecticut.* Greenwich, Conn.: Bruce Museum, 1993.

Lesko, Diane, and Esther Persson, eds. *Gari Melchers: A Retrospective Exhibition.* Saint Petersburg, Fla.: Museum of Fine Arts, 1990.

Lowrey, Carol, "Further Reviews: Impressionists and Art Rebels." *Apollo* 36 (November 1992): 337–38.

Moore, Evelyn, and Ruth Holmes Blunt. "Composition, Color, and Sometimes Humor: Artist Bernhard Gutmann of Lynchburg." *Virginia Cavalcade* 31, no. 4 (Spring 1982): 206–15.

Nelson, W. H. de B. "A Painter in Pure Colour: Bernhard Gutmann." *International Studio* (February 1914): 205–7.

Pickvance, Ronald. *Gauguin and the School of Pont-Aven.* San Diego: Museum of Art, 1994.

Pisano, Ronald G., and Bruce Weber. *Parodies of the American Masters: Rediscovering the Society of American Fakirs, 1891–1914.* New York: Berry Hill Galleries and the Museums at Stony Brook, 1993.

Preato, Robert R., Sandra L. Langer, and James D. Cox. *Impressionism and Post-Impressionism: Transformations in the American Mode, 1885–1945.* New York: Grand Central Art Galleries, 1988.

Prince, Paula. *Sweet Dreams: The Art of Bessie Pease Gutmann.* New York: Harmony Books, 1985.

Sanborn, Ashton. *The Works of Bernhard Gutmann: Memorial Exhibition.* New York: Vanderbilt Art Gallery, 1938.

Sellin, David. *Americans in Brittany and Normandy.* Phoenix: Phoenix Art Museum, 1982.

Skalet, Linda. "The Market for American Painting in New York, 1870–1915." Ph.D. diss., Johns Hopkins University, Baltimore, 1980.

Weinberg, H. Barbara, Doreen Bolger, and David Park Curry. *American Impressionism and Realism: The Painting of Modern Life,* New York: Metropolitan Museum of Art, 1994.

Williams, Mary Frances. *Catalogue of the Collection of American Art at Randolph-Macon Woman's College: A Selection of Paintings, Drawings, and Prints.* Charlottesville: University Press of Virginia, 1977.

Index

(Page numbers in *italic* refer to illustrations.)

Photography Credits